THE MUSEUMBOOK

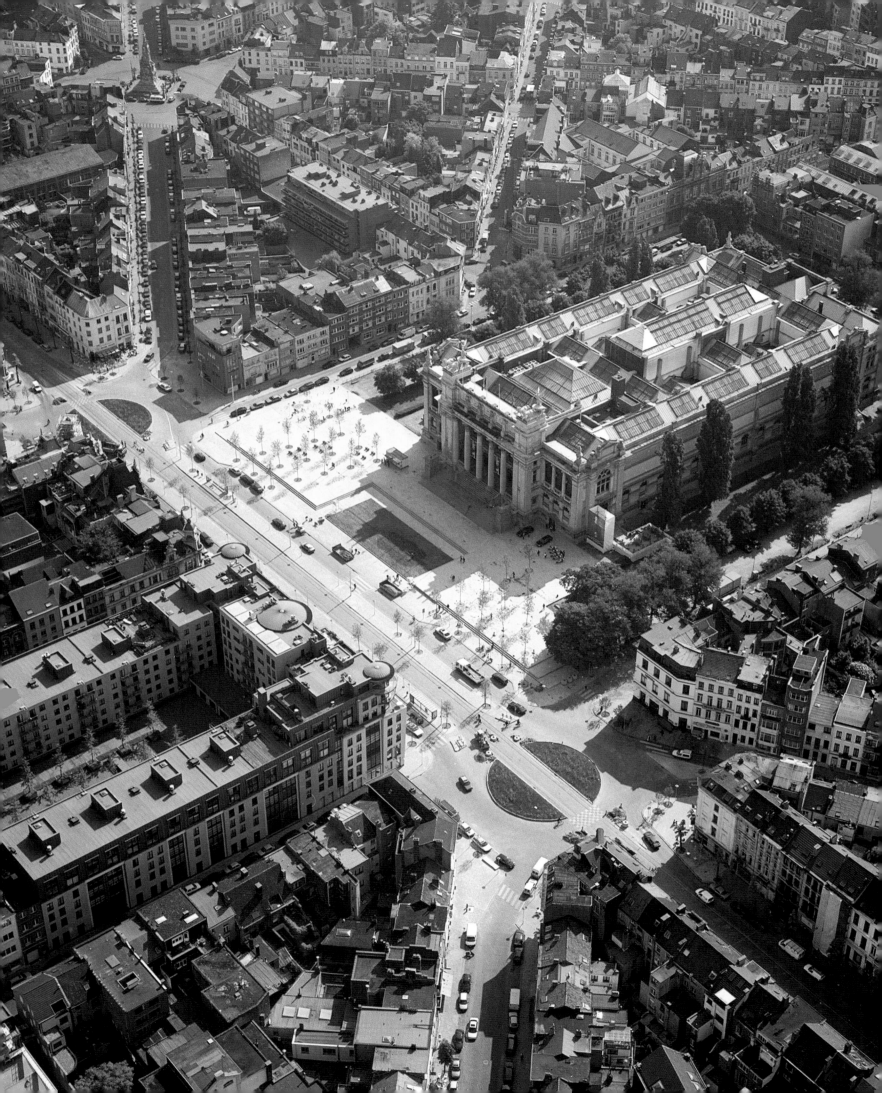

THE MUSEUMBOOK
HIGHLIGHTS OF THE COLLECTION

KONINKLIJK MUSEUM VOOR SCHONE KUNSTEN ANTWERPEN

MINISTERY OF THE FLEMISH COMMUNITY

SNOECK

Publisher
Koninklijk Museum voor Schone Kunsten
Leopold de Waelplaats
B - 2000 Antwerp
Telephone + 32 (0)3 238 78 09
Fax + 32 (0)3 248 08 10
E-mail postmaster@kmska.be
www.antwerpen.be/cultuur/kmska

This edition was realized in collaboration with Uitgeverij Snoeck, Ghent.

General direction: Dr Paul Huvenne
Concept and realization: Els Maréchal
Editing: Dr Hans Devisscher
Translation: Irene Schaudies
Design: Elisabeth Vanden Brande
Coordination Snoeck Publishers: Rudy Vercruysse, Maria-Helena Winderickx
Printing: Snoeck-Ducaju & Zoon, Gent

Photo credits: KMSK unless otherwise indicated
© G. Coolens p. 2, René Gerritsen pp. 34, 35, Toon Grobet p. 6, Hugo Maertens pp. 216, 218, 244, 252, Peter Maes pp. 12, 13, 14, 15
P. Alechinsky, K. Appel, R. d'Haese, G. De Smet, J. Ensor, L. Frederic, G. Grosz, G. Minne, A. Mortier, C. Permeke, R. Raveel, A. Servaes, L. Spilliaert, J. Van Beers, F. Van den Berghe, G. Van de Woestyne and Ossip Zadkine: © Sabam Belgium 2003
R. Magritte: © C. Herscovici – Sabam Belgium 2003
P. Delvaux: © Fondation P. Delvaux, St-Idesbald – Sabam Belgium 2003

Sofie Van Loo (pp. 96, 108, 210, 240) is collaborator of Gynaika at the Koninklijk Museum voor Schone Kunsten

The spelling of the artists' names in this publication is comparable to that preferred in RKDartists, the databank of artists' names in the Rijksbureau voor Kunsthistorische Documentatie in The Hague. In general, the preferred names of the RKD have been used throughout.

Depot publisher: D/2003/0012/22
Depot museum: D/2003/2683/6
ISBN publisher: 90-5349-441-3
ISBN museum: 90-77148-05-1

Foreword

The collection of the Koninklijk Museum voor Schone Kunsten Antwerpen is in its origins a child of the French Revolution. The works of art which were then confiscated, wherever possible, from the churches, cloisters, palaces and institutions of the *ancien régime* finally found their resting place in the depots of the local academies. When Willem I remembered Antwerp with a Royal Academy in 1817, it immediately had at its disposal a collection of European stature. Because the churches of Antwerp had once been hung full of masterpieces by Rubens and the renowned school of painting out of which he came. The collection grew in tandem with the extraordinary economic bloom that Antwerp experienced in the decades that followed. Twice in a span of fifty years the inhabitants of Antwerp built a new temple for their museum, and the collection grew by means of purchases and bequests to nearly a hundred times what it had been originally. However, it would never achieve the art-historically encyclopedic character of the museums that owed their existence to the systematically built-up princely collections of the eighteenth century.

The artistic treasures of the Koninklijk Museum are much more a reflection of artistic tastes during the period of its nearly two-hundred years of existence, which range from a persistent preference for Rubens across the visionary predilection for the European primitives of Sir Florent van Ertborn to the passion for Ensor of the Franck family, from the close ties to Rik Wouters of doctor Van Bogaert to the inspired predilection for the Flemish expressionists of former curator Walther Vanbeselaere. In addition, one may not lose sight of the fact that until the 1960s the Koninlijk Museum was also a museum of contemporary art in a city which had always considered the arts to be of paramount importance.

For this reason the collection 'limited' itself predominantly to South-Netherlandish or Flemish art – though with a few international masterpieces sprinkled throughout – and it testifies not so much to a considered collecting policy as an unsurpassed taste in art and sense of quality. When the colleagues gathered a few years ago to determine how such a collection could be more effectively structured by means of a collecting plan and how it could best be made accessible to a contemporary public, the need to make a museum book made itself felt fairly quickly. It had to be eminently readable, nice to look at, and limited to one hundred twenty masterpieces that together would give some idea of the collection.

Els Maréchal took this assignment upon herself. She was the person best cut out for the job by reason of her proven track record and her great love for the museum. Because of her considerable experience in the education department – of which she moreover had the leadership for many years – she knew better than anyone else in-house how best to open the collection to the public. It is typical of her as a colleague that she did not turn the museum book into a one-woman show, but rather involved nearly the entire scholarly team in the project. It was by no means the easiest path, but the often enthusiastic deliberations and the many perspectives generated by the discussions that took place around the project were an enormously enriching experience for the entire museum team. It is to the credit of Els Maréchal that, in addition to her own contributions, she was able to bring such quantity and variety together to form a beautiful whole.

This brainchild of hers also testifies to the sense of quality and thoughtfulness that have graced her entire career. I would like to make use of the present opportunity to congratulate and thank her for these. My thanks also go out to all the colleagues who dedicated themselves to the creation of this book; to Dr Hans Devisscher for his careful editorial work and to Rudy Vercruysse, who on behalf of Snoeck invested the best of his skill in this splendid book.

Dr Paul Huvenne
General Director

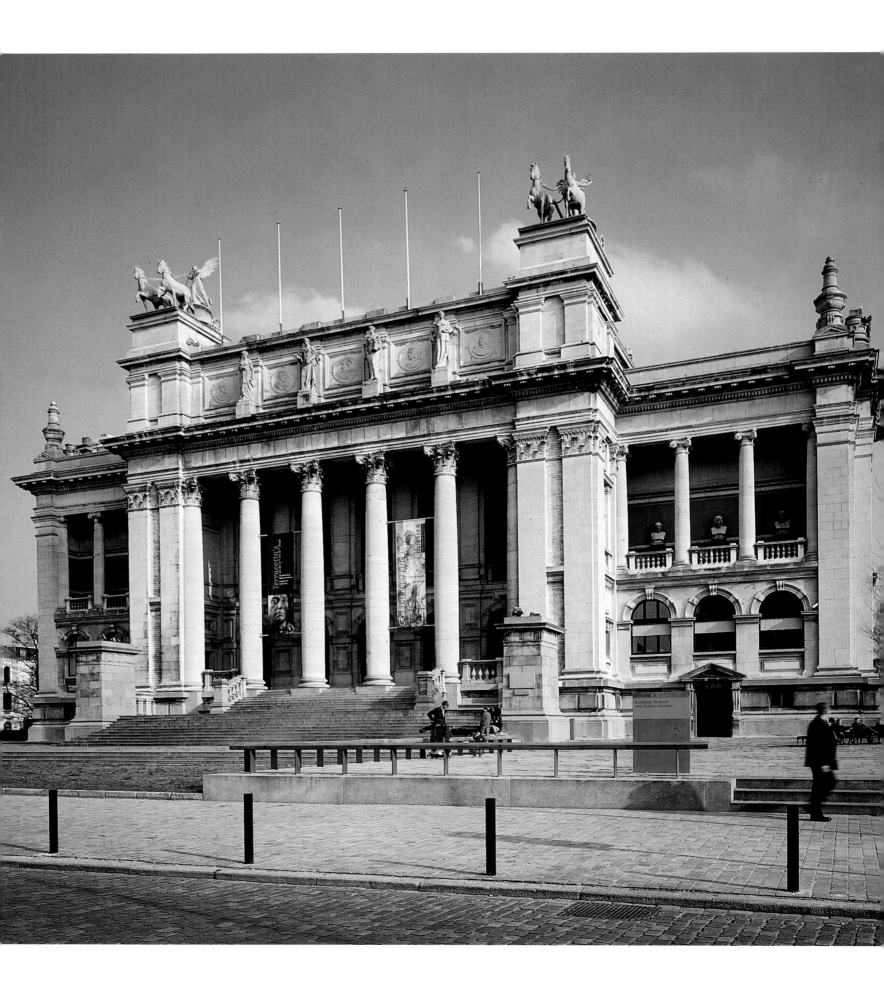

Introduction

Growth of a collection

The Koninklijk Museum voor Schone Kunsten in Antwerp contains paintings, sculptures and drawings. The oldest works, four unique panels by Simone Martini, were probably created around 1339; the newest are situated around 1970. The art works span a period of seven centuries. Today, the museum possesses more than 7,000 works of art, 3,300 of which are paintings, 400 sculptures, and 3,600 drawings and prints. Important ensembles of the Flemish Primitives, Peter Paul Rubens and the baroque, Henri De Braekeleer and the Flemish expressionists typify this institution. The museum has the most important Ensor collection in the world and the largest assemblage of works by Rik Wouters. In addition to art works from the Southern Netherlands, which form the great majority of the collection, there are also a number of notable 'foreign' high points, among which are paintings by Jean Fouquet, Titian and Modigliani, and sculptures by Ossip Zadkine and Auguste Rodin. By means of permanent loans, purchases and gifts, the collection today is growing slowly but steadily.

The museum building itself was inaugurated in 1890 and is thus more than one hundred years old, but the collection itself, at least the nucleus of it, is much older. Since the end of the fourteenth century, the Antwerp painters, goldsmiths, glaziers and sculptors had a professional association or guild with a patron saint, meeting hall, chapel, and of course a treasury. Around the middle of the fifteenth century, the painters united in a separate guild with St Luke as their patron saint. This occurrence formed to some extent the basis of the initial core of the museum's collection. The painters had their own hall for gatherings and celebrations, called the 'Schilderskamer' or 'Painter's hall', which was decorated with works that were donated by members of the guild. No less a figure than Durer was received in 1520 with great festivity. The drawing that he gave the guild on that occasion, unfortunately, has not been preserved. In 1633, Rubens gave the guild of St Luke the painting *Our Lady with the parrot* out of recognition for his selection as dean. The work is presently in the museum.

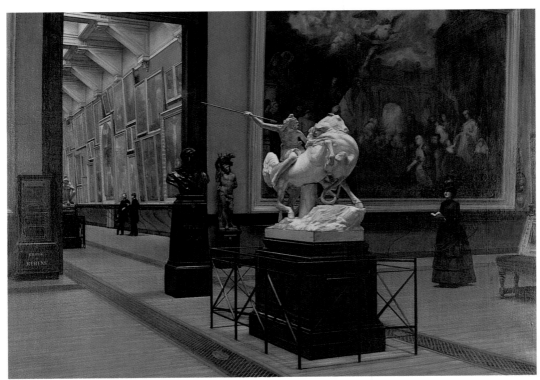

Hendrik Van Dyck painted what was at that time the museum of the Academy on Mutsaertstraat in 1886. The marble Amazon by August Karl Kiss, the wooden St Sebastian and the portrait of Peter Paul Rubens by Georg Petel are clearly recognizable

The Academy grew out of the guild in 1663 under the impulse of David Teniers the Younger, formerly dean of the guild of St Luke and court painter to Archduke Leopold Wilhelm. The city government made free part of the stock exchange and gave that space to the Academy so that it could install a lecture hall and a new painter's hall in it. Artists went to work to decorate the 'hall' in a suitable manner. Jacob Jordaens and Theodoor Boeyermans provided ceiling paintings that are still found in the museum. Monumental marble portraits of the governors of the Spanish Netherlands, who were favourably inclined toward the Academy, also had a place in the hall of honour, among which were portrait busts made by Artus Quellinus I and Willem Kerrickx. The works of art in the painters' hall formed the necessary study material for budding painters, hence for the first time a collection was formed with a pedagogical goal. When the guild of St Luke was disbanded in 1733, the works from its art collection were remitted to the Academy.

Under the French administration numerous art works from the painter's hall, the city hall, churches and monasteries were stolen by the occupier and taken to Paris, where the formed part of the Musée Central, which was housed in the buildings of the Louvre. Upon their return in 1815, part of them ended up in the museum of the Academy, which would later become the Koninklijk Museum voor Schone Kunsten. In this exciting story there is thus a clear link between the guild and the Academy and the Academy and the Museum. Thus for a long time the director of the Academy was at the same time curator of the Museum. Museum and Academy were housed in the old cloister of the Franciscan friars on Mutsaertstraat. In the beginning of the nineteenth century, the Antwerp Academy acquired the status of Koninklijke Academie van Beeldende Kunst, or Royal Academy of Fine Arts. Starting in the middle of the nineteenth century, interest in the art of their own times grew in the Academy. In 1852, on the initiative of the Academy, a 'Museum of academicians' was established. A limited number of prominent artists from home and abroad were taken up in the academic corps, including Jacques Louis David and Jean Auguste Ingres. They were asked to provide an art work for this Museum and a self-portrait for the Academy's portrait gallery. By means of this initiative, a notable collection of important academic artists of the nineteenth century could be assembled. For this reason, the collection of the Koninklijk Museum includes works by a number of German artists like the then-renowned sculptor Christian Rauch and his student August Kiss, for example, or the 'Nazarenes' Friedrich Overbeek and Friedrich von Schadow. Around twenty years later, in 1873, the Academy also decided to purchase paintings, sculptures and drawings at the Triennial Salons. These salons, held until the Second World War, were organized by the *Koninklijke Maatschappij tot aanmoediging der Schone Kunsten*, or *Royal Society for*

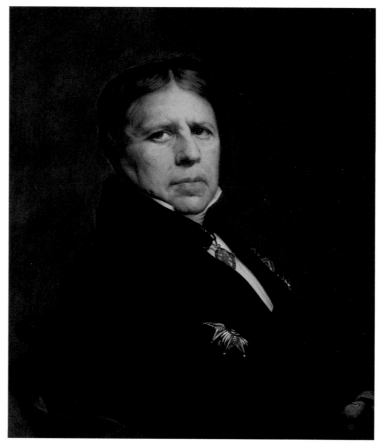

Jean Auguste Ingres, member of the academic corps, gave this self-portrait to the Antwerp Academy. It is inscribed, above to the right: "J. Ingres painted by himself, for the Celebrated Academy of Antwerp"

the promotion of the Fine Arts, an organization founded in 1788 with the intention of encouraging artists by organizing exhibitions and contests, on the one hand, and on the other by stimulating interest for the arts among the citizens. The purchases, which occurred with allowances from city and state, had a strongly national character.

Over the course of the years the status of the Museum was adjusted. According to a royal decree it was made independent of the Academy in 1895 and in 1928 it became a state institution, which meant that the state appointed and paid the personnel. The Museum was only incorporated in 1931. The purchasing policy was gradually expanded. Thus in the 1950s a few pictures by Italian innovators were bought, among other things. Given the prices on the current art market, it is becoming increasingly more difficult, if not impossible, to buy works of the highest quality. In the last five years a great deal of effort has been invested in the maintenance and, where necessary, restoration of the existing collection.

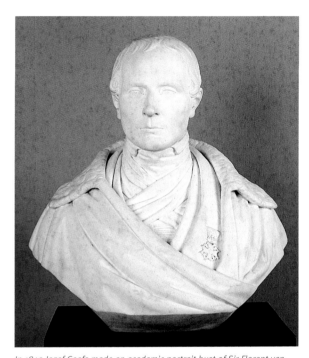

In 1849 Jozef Geefs made an academic portrait bust of Sir Florent van Ertborn, who enriched the museum with an unsurpassed collection of panels from the fourteenth until sixteenth centuries

In the beginning of the nineteenth century, the museum had assembled a collection of chiefly sixteenth- and seventeenth-century works of very high quality. This limited collection was considerably enriched in 1841 with a bequest from Sir Florent van Ertborn (1784-1840). This art-lover was governor of the province of Utrecht, but under the Dutch administration he had been mayor of Antwerp for eleven years, from 1817 to 1828. By testament, he made over his collection of masterpieces from the fourteenth to the sixteenth century to the museum. The 141 objects in this bequest, including works by Jan van Eyck, Rogier van der Weyden, Gerard David, Hans Memling, Quinten Massijs, Joachim Patinir, Simone Martini, Jean Fouquet and Antonella da Messina, form the core of the museum's collection of old masters. Many of these paintings, often purchased abroad by Van Ertborn, returned in this way to their land of origin. A blood-relation of Van Ertborn, baroness Adelaïde Van den Hecke-Baut de Rasmon (1787-1859), followed his noble example and in 1859 bequeathed dozens of works to the museum, mainly by Dutch painters of the seventeenth century, including Jacob and Salomon van Ruysdael.

Of the many gifts and bequests by private individuals, a fascinating list can be made, but various associations have also favoured the museum. With the organization of exhibitions and cultural activities but above all with generous gifts, they wanted to attract the attention of the public and at the same time place the institution in the spotlight. The society *Artibus Patriae*, under the high patronage of the royal couple of Belgium, has looked after the interests of the museum since 1864. Art-loving families joined the society in order to contribute to the expansion of the museum collections. They were mainly interested in old master painting, but also had an eye for modern national patrimony and gave works by Henri De Braekeleer, Nicaise De Keyser and Xavier Mellery, among others.

For the collection of nineteenth- and twentieth-century art, particularly the work of Belgian artists, the importance of the patronage of the Franck family can hardly be underestimated. In 1905, *Kunst van Heden* (Art of Today) was founded, an association of art-lovers and artists in which the three brothers Franck played a prominent role for many years. *Kunst van Heden* sought to organize exhibitions and enrich the museum with modern art. They paid tribute to Henri Leys and Henri De Braekeleer as original Flemish artists. They had a warm interest in autochthonous impressionism whereby it – just like Flemish expressionism – is well represented in the museum's collection. At their annual salon in 1914, work by Jakob Smits and Rik Wouters as well as ninety-six works by Vincent van Gogh were on view. In 1920, the museum received eight works by Jan Stobbaerts donated by a group of museum friends, among whom were François and Charles Franck. The year after that a group of museum friends, again including the Francks, made the museum a present of an equal

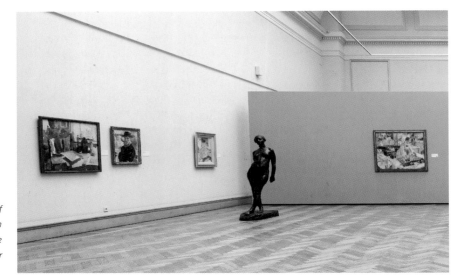

The museum owes its unique collection of works by Rik Wouters to Dr Ludo van Bogaert-Sheid, passionate admirer of the painter

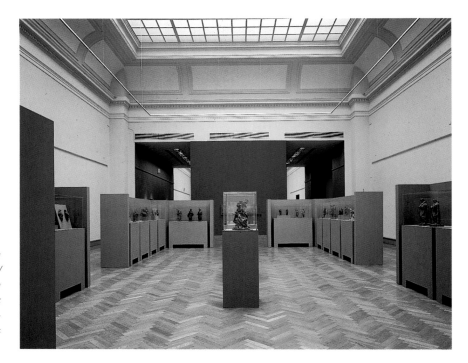

By means of a permanent loan from the Koning Boudewijnstichting / Fondation Roi Baudouin, the museum is able to make available to the public a collection of terracottas from the seventeenth and eighteenth centuries

number of paintings by James Ensor. When the association *De Vrienden der Moderne Kunst*, or *The Friends of Modern Art*, was formed under the aegis of *Kunst van Heden* in 1925 for the purpose of making Antwerp familiar with modern art, the Franck family was once again among the participants. The association purchased works from domestic and foreign artists and subsequently gave them to the museum so that new names could be added to the museum catalogue.

The gift of baron Dr Ludo van Bogaert-Sheid is of extraordinary significance. He showed his generosity in 1974 when he determined by notarial act that a number of masterpieces from his collection would be made over to the museum upon his death. Van Bogaert, an eminent neurologist, was a great admirer of Rik Wouters. On his death in 1989 the museum acquired dozens of paintings, drawings and sculptures by Wouters. A number of paintings and sculptures by old masters that had adorned his house belonged to the same gift. These were not masterpieces, but they were a nice acquisition and have posed a number of problems for the experts because no single attribution is secure and there is no accompanying documentation.

The permanent loan of the Van Herck collection is a completely different story. The collection of terracottas and drawings from the seventeenth and eighteenth centuries was purchased by the Koning Boudewijnstichting / Fondation Roi Baudouin with the support of the Nationale Loterij / Loterie nationale. The terracottas were entrusted to the Koninklijk Museum, the drawings to the Stedelijk Prentenkabinet. This piece of Antwerp heritage, only known to intimates, was scientifically inventoried, researched and where necessary restored on the orders of the Koning Boudewijnstichting / Fondation Roi Baudouin.

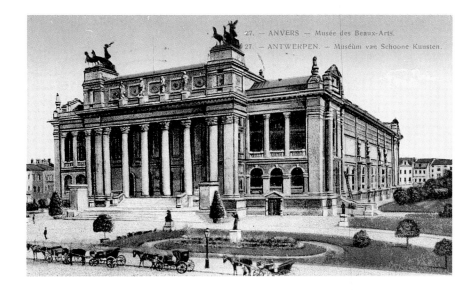

The new museum in Antwerp's south side, built by Jacques Winders and Frans Van Dijk, was officially inaugurated in 1890

Building of the present museum

In the year 1870 the collections consisted of approximately three entities: the Van Ertborn bequest, the works returned from France in 1815, and the collection of contemporary art by the members of the academic corps and purchases from the Triennial Salons. The museum in the Royal Academy did not have the necessary space at their disposal to present all of the important art works to the public. Even the renovations and expansions by Pierre Bourla were not sufficient to show the works to advantage. A fire in the neighbourhood in August 1873, in which the museum was threatened but ultimately spared, demanded an appropriate and responsible reaction. For this reason the city of Antwerp decided around 1880, under the administration of mayor Leopold de Wael, to erect a new building. An appropriate location was sought and the city opted for the south side of town, where plots of land had come free after the demolition of Alva's Citadel and where a new quarter with a harbor was to be created. The plans show that the proposed museum was allotted a central spot in the end, although the building was originally situated at various other places. The competition made out for the museum building was won by the architects Jacques Winders (1849-1936) and Frans Van Dijk (1853-1939). Both had to combine their projects and distil an acceptable compromise from the result. Study trips to Germany, Austria and the Netherlands were organized to gain inspiration from the recently established large museums there.

Construction on the stately museum building in an eclectic style, seen as a temple for the arts, was begun in 1884. Six years later, on August 11, 1890, the new museum was officially inaugurated and put in use. Paintings by old and modern masters were brought together in twenty-three rooms on the upper floor. They hung next to and on top of one another in close rows, without much account having been taken for stylistic periods, dimensions or colouring. Thus, the entire Van Ertborn bequest was crammed together in a not altogether large gallery. The central ceremonial hall, now exclusively reserved for the work of Rubens, showed works by Anthony van Dyck, Jan Fijt and Frans Snijders. The lower floor consisted of two spaciously-arranged galleries that extended over the whole length of the building, on the north and south sides, and that were connected by two diagonal galleries. In the northern gallery the collection of sculptures was set up and in the southern gallery, engravings and photos of Rubens' paintings lay in glass cases.

The fame of the fine arts

In the original plans for the museum building, façade sculptures were emphatically present. The architects received orders to reduce significantly the part played by façade sculptures. Nevertheless, they still remain strikingly present in the building's appearance today. The sculpture was supposed to make clear what the building's function was. Thus symbolic representations of the various branches of the arts were added to the front of the building: architecture, painting, sculpture and engraving. In between them, the most important artists – Jan van Eyck, Quinten Massijs and Peter Paul Rubens – were portrayed on medallions. In the loggia, portrait busts of eleven important Antwerp, Flemish and European artists rub shoulders in a brotherly way, among them Michelangelo, Raphael and Rembrandt along with Vorsterman and De Waghemaecker. On the side façades, large female figures represent the most important periods in art history. Attributes and clothing reveal which artistic trend is concerned. On the north side Egyptian and Byzantine art are represented; on the south side, gothic art and modern Flemish art. The rear façade, which represents the Flemish neo-renaissance, received a symbolic relief depicting Antwerp as the protectress of the arts. The front façade was festively crowned by two bronze teams of horses by Thomas Vinçotte. They represent the triumph of the arts, portrayed by a female figure standing erect in a triumphal chariot drawn by two horses, proudly holding a laurel wreath in the air.

The execution of the many façade sculptures provided work for a whole multitude of sculptors. It was expected of them that they would strictly adhere to the dimensions and materials specified. Almost everything was determined by the architects. The twenty-three sculptors who worked on the various façade sculptures for many years had almost no input on the plans. Hence, there was no question of realizing their personal vision. Many of the designs executed in plaster that were presented to the architects for approval are now preserved in the museum.

The glory and renown of the arts is also celebrated in the interior. In the vestibule hang large oil paintings with *The fame of the Antwerp school of art* as their subject. Nicaise De Keyser was director of the Academy from 1855 to 1879, and thus also curator of the Museum of Antwerp. He received the honour of executing this monumental cycle. This complex whole comes from the time when Academy and Museum were still housed under the same roof, and they originally adorned the entrance hall of the museum on Mutsaertstraat. In a series of thirty-nine paintings, Nicaise De Keyser illustrates the history, character and international renown of the Antwerp school. The three principal works depict first *Allegorical figures of the city of Antwerp, the gothic and the renais-*

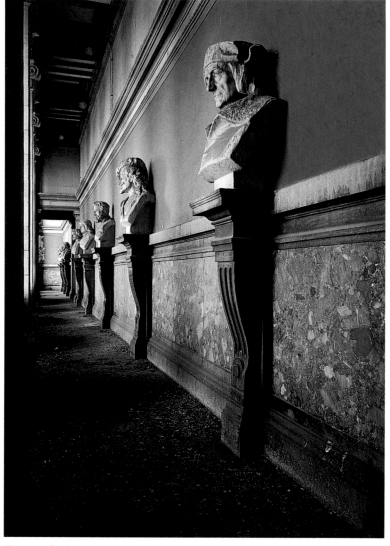

The many façade sculptures clearly indicate the building's function. Hence, portrait busts of Antwerp, Flemish or European artists stand in the loggia

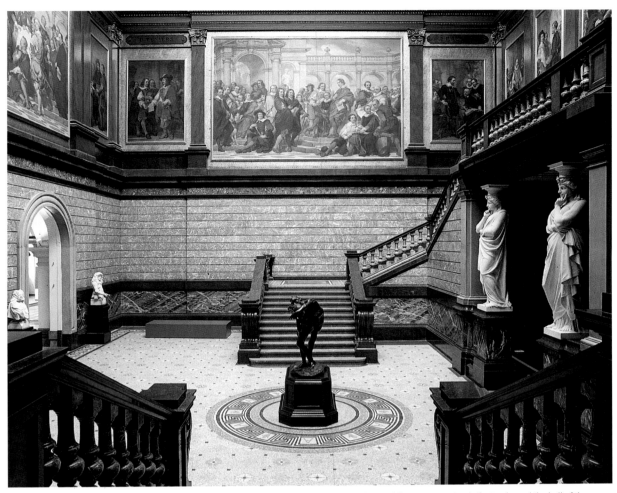

Initially this complex whole, consisting of a series of oil paintings by Nicaise De Keyser, The fame of the Antwerp school of art, adorned the hall of the museum on Mutsaertstraat. In designing the new museum, the architects were asked to provide a place for the monumental works in the stairwell, where they exercise a great power of attraction on visitors today

sance, surrounded by artists, then *Painters and engravers* and finally *Painters and sculptors*. All of this is surrounded by twelve scenes in which the climax of Antwerp art history is portrayed in picture form, together with the influences that Antwerp painters were affected by and in turn gave forth. On the twenty-four vault paintings, the history of the Antwerp school is further treated in the form of allegories and emblems.

The commission to paint the history and aura of the Antwerp school of art was entirely in keeping with the art policy of the time. The state lavished considerable amounts of money on the execution of murals in public buildings that set down its own grandiose past in paint. The initial impetus for the decoration of the museum hall came in 1859, but the actual execution took place between 1862 and 1872. When the architects Winders and Van Dijk received the commission for designing a new museum, they were asked to take into account the monumental works of De Keyser, which were supposed to have a place in the stairwell. It was presumed that all visitors entering the museum would do so via the art works by De Keyser. They thus received a sort of visual introduction before they went up the stairs to the 'holy of holies', the high central Rubens gallery. The series of paintings was installed in 1890 and even today exercises a great power of attraction on visitors, certainly after the completion of a thorough restoration in 1999, when even the architectural framework was refurbished.

A contemporary and therefore evolving museum policy

Almost as soon as the new museum building at Leopold de Waelplaats was put in use, lack of space was a problem. That problem remained a constant in the history of the museum. Exhibition rooms were converted into office space. Interior courtyards were transformed into exhibition rooms. One made the most of what space there was available, and the museum building underwent many adjustments and periodic modernizations over the course of its history. The twenty-three galleries of 1890 grew into sixty-seven in 1925. The ideal museum dating from 1890 no longer answered to the wishes of the public and the museological demands of the staff. Already in 1927, the curator Cornette wrote, on the occasion of the just-completed renovations: "The museum is a living organism. Changes in the arrangement of the collections is one of the signs of its vitality. ... Moreover, account should be taken of shifts in the concept of beauty, with the development of the critical spirit, with the refining of taste." He continued: "To us, it does not seem superfluous to draw the public's attention to the desirability, no, to the necessity, of enlarging the museum in the near future. In spite of the considerable works that have now been carried out, within a short time the space will be insufficient to give a proper place to new works." In 1950 head curator Walther Vanbeselaere called for attention to the same problem when he wrote in the *Jaarboek*: "How sharply the increasingly painful lack of space imposes itself will be evident from the number of works that the museum has had to lend out on a long-term basis. ... The problem of the expansion of the existing Museum and of the building of a new museum for the modern section is now becoming more urgently than ever a need." In the head curator's report on the year 1978, Gilberte Gepts wrote: "It is a fact that the Museum will not be able to reach the end of this century in an optimal condition so long as expansion outside its walls is not placed in view."

Until now, no answer has been given to this regularly repeated call for expansion, notwithstanding that since 1925, a plan has existed whereby the museum would be provided with lateral wings. But restorations and alterations were carried out on the infrastructure more than once. A thorough modernization took place in 1977 on the occasion of the Rubens year. The Rubens exhibition drew 660,000 visitors, which up until now is a historic record. In 1990 the building was once again thoroughly taken in hand and refurbished on the occasion of its centennial. The excavated basement acquired new functions, a print cabinet was created and new depots were added. In order to satisfy contemporary norms for a modern museum, where cultural heritage can be interacted with in a respectful way, it was necessary to work on the climate control, the depots, the fire-safety, the documentation centre and archive, the library, the print cabinet, the facility provisions, the accommodations needed for the public and the office space for the personnel. Necessary changes do not always seem to be for the better, as in the case of the transfer of restoration atelier to the depot and the moving of the museum atelier. The well-equipped and favourably located museum atelier, which had been right next to the entrance, was forced to make way for the cloakroom during the heavily-visited Van Dyck exhibition of 1999. Key tasks like restoration and activities for children are still organized as effectively as possible, albeit in less-appropriate accommodations. A good infrastructural solution for these vital museum activities is still awaited.

The Koninklijk Museum voor Schone Kunsten Antwerpen, with its valuable works, housed in a unique 19th-century museum building, is able to share the benefits of the reinvigoration of Antwerp's south side. The renaissance in the neighbourhood accompanied the establishment of the Fotografiemuseum and the Museum voor Hedendaagse Kunst.

Restorations and alterations to the museum have been carried out regularly, but expansion is yet to come. The sculpture depot dates from 1977

The museum galleries draw natural light from glass saddle roofs. Because of recurring problems with condensation water, the skylights were provided with double-layered glass with an ultraviolet filter in 1987

Art galleries in old warehouses, cafes, restaurants of all sorts and trendy shops reacted to this initiative. The new layout of the museum plaza by architects Paul Robbrecht, Hilde Daem and Marie-José Van Hee gave the museum a new impulse, by which it once again became the heart of the neighbourhood. A new public has discovered the neighbourhood *and* the museum.

By fitting in socially, it has become an attractive and dynamic museum. Core activities like the optimal display of the collection and the realization of exhibitions have been maintained. But there is more. The museum continues to stimulate the modern museum visitor because it functions as a point of contact that is open to original realizations and projects like concerts, theatrical performances, educational activities, that has an eye for literature and poetry, where there is a place for seminars on museum-related subjects like conservation and restoration. In short, it sensitises the community to art in the broad sense of the word. For this reason it has evolved from a self-supporting organism into a valued partner for many national and international institutions. With new flexibility and openness of content, it works together with city and provincial institutions. This 'trusted house' has made the transition to the twenty-first century with a permanently self-renewing identity now that it has become a house with many rooms.

Els Maréchal

Simone Martini

Siena 1284 - Avignon 1344

Mary, Calvary, Deposition, Gabriel
Panel, respectively: 23 x 14 cm, 23 x 14 cm, 24 x 15 cm and 25 x 15 cm
On the two central panels, respectively: *pinxit / Symon*
Sir Florent van Ertborn Bequest 1841
Inv. 257-260

These four small scenes originally formed two panels, which at an unknown time were sawn through crosswise. *Mary* was on the reverse side of *Calvary*, and *Gabriel* was represented on the verso side of the *Deposition*. If one places the *Calvary* next to the *Deposition*, one has a diptych on the reverse with a representation of the Annunciation. In this arrangement, there is a direct connection between Mary, who is startled by the angel, and the message he brings her, namely that she shall bear the son of God.

On the left side of the scene depicting the crucifixion, the Roman soldier Longinus pierces Christ's side with a lance. In this way, the blind and unbelieving soldier wishes to prove that Christ has already died. Drops of blood flowing from this wound land in his eyes, by which means he is able to see again and recognizes Christ as the son of the true God. The Roman centurion to the right, who indicates the crucified Christ with the words "Truly, this was the Son of God" (Matthew 27:54), acquires a similar insight. The contrite Mary Magdalen embraces the foot of the cross. She bears witness to the consciousness that her sins were at the origin of the suffering of the Savior. Striking for these panels is the outspoken expression of emotions. Through it, the emphasis lies on physical and visible suffering rather than on spiritual pain. This is emphatically expressed in the *Calvary*, where two women bend anxiously over Mary, who has swooned, and in the *Deposition*, where the many onlookers express their compassion. This almost bodily *compassio* was recommended for strengthening the experience of faith.

Together with the *Bearing of the cross* in Paris (Louvre) and the *Entombment* in Berlin (Staatliche Museen), these panels formed a folding construction. Given its small dimensions, the four-panel painting was probably intended as a portable altar for private devotion. The donor is depicted kneeling in prayer before the *Deposition*. Probably, he is cardinal Napoleone Orsini (died 1342), for whom Simone Martini also painted other works, including a portrait. The diamond-shaped coat of arms on the reverse of the *Bearing of the cross* in Paris refers to a female member of the Italian Orsini family. It was probably applied later, after the transfer of the art work by inheritance.

Until the end of the eighteenth century, the text "HOC OPUS" could be read on the frame of the *Bearing of the cross* in the Louvre. Together with the inscriptions on the panels presented here, one can make out the signature of the painter: "HOC OPUS PINXIT SYMON" (Simon painted this work).

Sandra Janssens

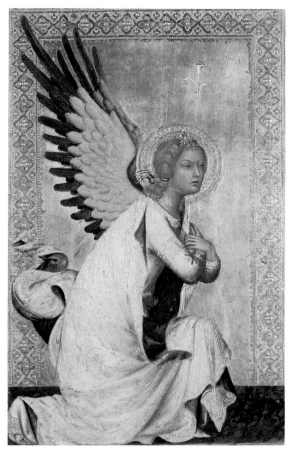
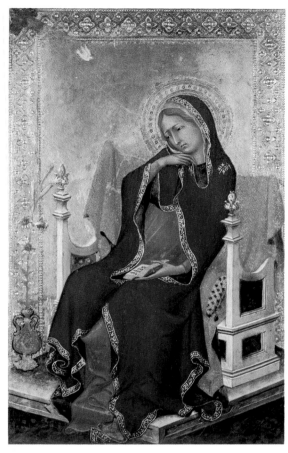
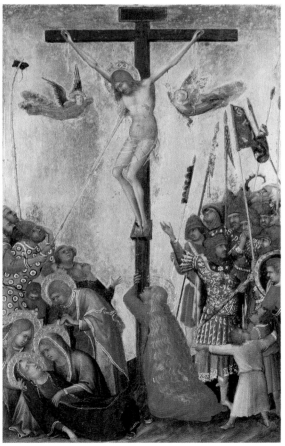
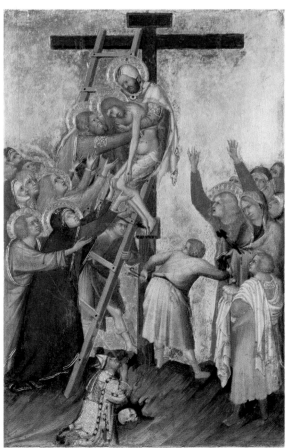

Anonymous master

Northern France (?) (ca. 1363)

Calvary of Hendrik van Rijn
Panel, 133 x 130 cm
Below:
Anno domini : M° : CCC° : LXIII° : in cius. Obiit dominus henricus de chidiaconus. istivs que altaris
Sir Florent van Ertborn Bequest 1841
Inv. 519

crastino sancti bonifacii et socio(rum) reno · hui(us) eccl(es)ie prepositus et ar fundator. Orate pro eo :

Under the protection of John the Evangelist, Hendrik van Rijn, archdeacon of the Sint-Janskerk in Utrecht, kneels next to the cross. He directs his gaze toward Mary and asks her in prayer for intercession. With her hand, she indicates the ultimate recipient of the supplication: the cruci-fied Christ. The inscription makes clear that this scene is intended as a memorial or epitaph: "In the year of Our Lord 1363, on the day for (the feast of) St Boniface and his companions, Mr Hendrik van Rijn, provost and archdeacon of this church, and donor of this altar, died. Pray for him". Van Rijn's devotion for a holy image was supposed to serve as an example to the viewer and incite him to piety. With the sentence *Pray for him*, the viewer is at the same time asked to include the deceased donor in his prayers. Concern for bringing about the salvation of the soul after death and delivery from purgatory through the agency of the saints and their images is characteristic of the Christian experience during the Middle Ages.

The background of the scene consists of applied gilt relief, a form of decoration that was wide-spread in the fourteenth century. The rampant lion on the guilt tiles and on the cope of the donor refer to the coat of arms of the Van Rijn family. Hendrik van Rijn and his brothers were closely allied with the count of Holland, residing in The Hague. In the conflict between the count and the city of Utrecht, the Van Rijn family took the side of the former. In 1345, they swore fealty to him. In exchange, they got back their land as vassalage and the guarantee of protection in time of need. This alliance with the count of Holland is mirrored in the coat of arms of the Van Rijn family. The coat of arms of the count has four rampant lions, that of Hendrik van Rijn has three.

The donor is depicted at a smaller scale than the saints. In the Middle Ages, saints were seen as spiritually elevated and more majestic and therefore also represented as physically larger than mere mortals.

The stylised sun and moon in the upper corners evoke the cosmic character of the event of sal-vation. A nine-lobed, scalloped wheel is imbedded in the zodiac. This is a very old motif in folk art throughout the whole world, which symbolizes the sun.

This pre-Eyckian Calvary shows the influence of northern German and northern French painting. It is most probable that it is the work of a travelling artist. The name of its maker has not yet been discovered.

Sandra Janssens

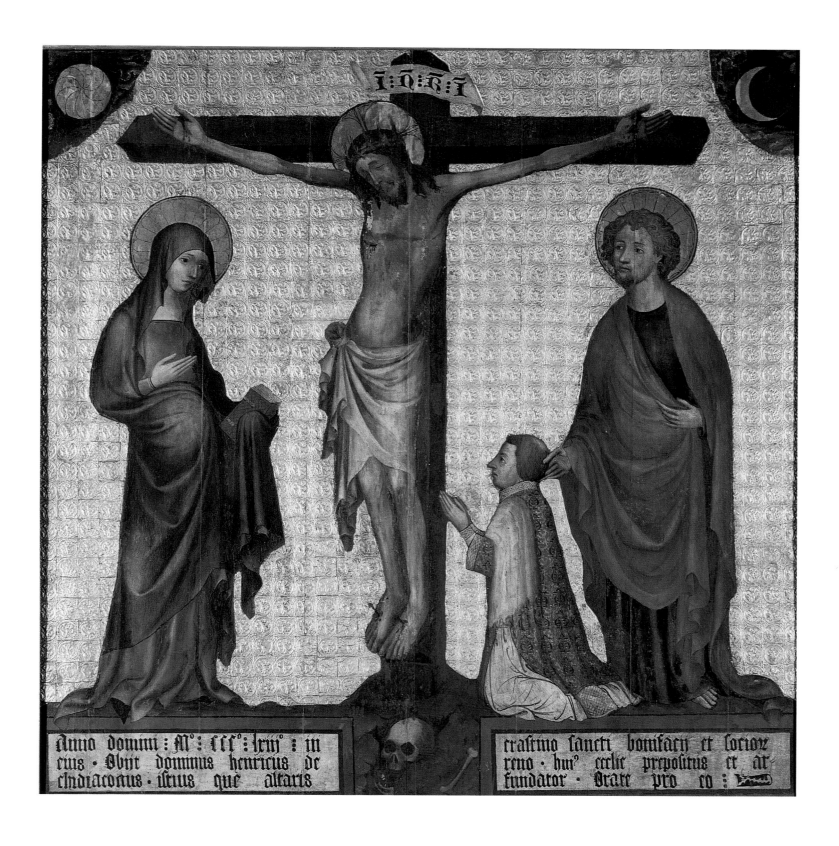

Jan van Eyck

Maaseik ca. 1390 - Bruges 1441

Saint Barbara
Panel, 31 x 18 cm
On the original frame: *IOH[ANN]ES DE EYCK ME FECIT 1437*
Sir Florent van Ertborn Bequest 1841
Inv. 410

"His underpainting was much more exactly and precisely done than the finished works of other masters ever could be. I well remember seeing a small portrait by him of a woman with a landscape behind which was merely underpainted but nevertheless most excellently neat and smooth; it was at the house of my master Lucas de Heere in Ghent", so wrote Karel van Mander in his famous *Schilderboeck*.

This text relates to Van Eyck's famous panel in the Koninklijk Museum. The girl in the painting is Barbara. She was the only daughter of a Syrian nobleman who kept her in a fortified tower so that no one could see her. There, she led a life of luxury. When her father wanted to marry her off, she resisted. To bring her around, she was allowed to leave the tower now and then. To her father's rage, however, Barbara converted to Christianity. In his absence she had three window openings made in the tower in honour of the Holy Trinity. Stubbornly, she refused to renounce her new faith. For this reason, her father delivered her over to the governor, who had her flogged. In the dead of night she was visited by a glimmering light. Her wounds healed miraculously. The same occurred when she was submitted to still worse tortures for a second time. Finally, Barbara's father asked for permission to behead his daughter personally. After this fatal deed, the earth began to shake and the man was struck by lightning.

In the painting, Barbara leafs through a prayer book. In her left hand, she holds a palm branch. The pious martyr is clad in a dress, of which the numerous folds fan out in all directions. Even more monumental is the gothic church tower that rises from the landscape behind her. The building is still in scaffolding. Numerous small figures work cranes and carry various loads. The artist has used the life story of the saint to depict a contemporary building site.

Some authors view this work as a grisaille, or as one of the earliest autonomous drawings. In Van Mander's text, the painting is defined with the term *doodverf*, or dead-colouring, which means underpainting. That Van Eyck's dead-colouring is unusually fine is beyond dispute. The artist probably began painting the frame and reverse of the panel in imitation marble. On the surface of the picture he painted in some of the sky and then stopped working afterward for one reason or another. *Saint Barbara* is the oldest unfinished panel in Netherlandish art. It is a wonderful specimen of drawing that has pleased generations of art lovers.

Nico Van Hout

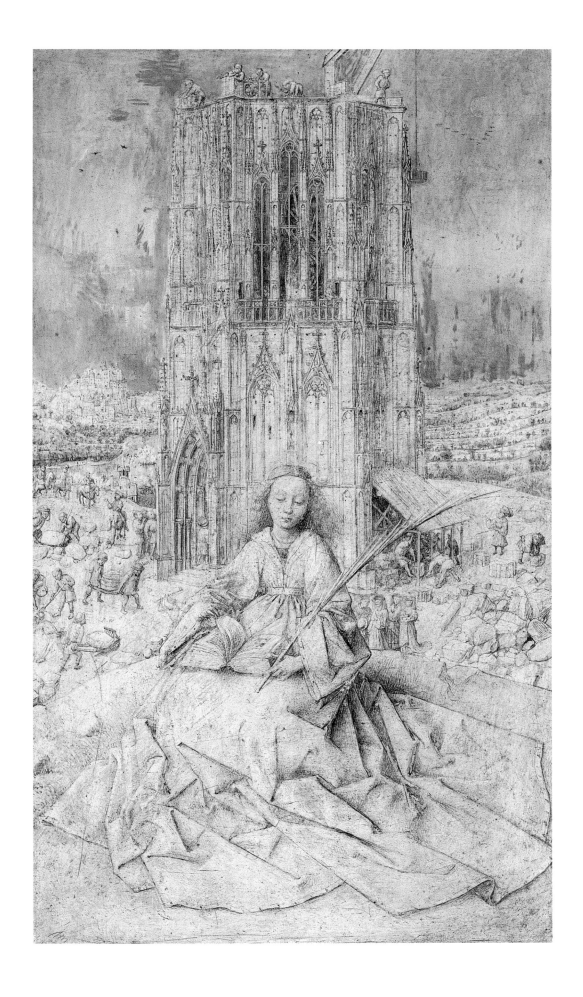

Jan van Eyck

Maaseik ca. 1390 · Bruges 1441

Madonna at the fountain
Panel, 24.9 x 18.2 cm
On the frame: *AAC (IXH) XAN and JOHES DE EYCK ME FECIT + PLEVIT ANO 1439*
Sir Florent van Ertborn Bequest 1841
Inv. 411

This precious object of only a few square centimetres in size is cherished in the museum as an icon of tenderness. Standing erect in a blue garment, Mary looks lovingly at the infant Jesus, whom she holds in her arms and tenderly presses against herself. Behind her, a cloth of honour is held aloft by two angels with many-coloured wings. It is a fabric in gold brocade with floral and animal motifs. In the left foreground, we notice a bronze fountain crowned by a small statue of a lion. Four streams of water escape from a sphere and fall into a basin. The event occurs in a garden in which rose bushes bloom in front of a low wall. A multitude of flowers, including irises, violets, forget-me-nots and lilies-of-the-valley make of the whole a real gem.

For the fifteenth-century believer this scene served as a religious icon of compassion, solace and mystery. This type of representation was created as early as the twelfth century in Byzantine art. In the late Middle Ages, it was a favourite theme in the art of the Flemish Primitives. The 'Enclosed Garden' in which the Madonna stands is a metaphor recalling an enclosed paradise – in this case Mary herself. Nevertheless, there is some uncertainty here as to whether we are really concerned with an enclosed garden, since this one is not completely closed off. The dress in dark blue, from time immemorial the colour of Mary, refers to royalty and at the same time served in the Middle Ages as the colour of faithfulness and loyalty. Since the fourteenth century, the rose as been the emblem par excellence of Mary, but at the same time that of court- ly love. The other flowers also express beauty, refinement and purity. The fountain is also the symbol of the Mother of God as life-giving source. In medieval literature numerous references to Marian symbolism can be found.

This small work still has its original, finely marbled frame with a clear reference to its self-con- fident maker: '(As good) as I can. Joh(ann)es van Eyck made and completed me in the year 1439'. The small format suggests that the painting was made for the private devotion of an undoubt- edly well-to-do person.

The astonishing technique and detailed execution show the absolute mastery of the artist, whose fame was already spread throughout Europe in the fifteenth century. His art is the epit- ome of the refined art of miniature and book illumination practiced in the great cultural centres of Europe. Jan van Eyck was also active in this branch of the arts. The *Madonna at the fountain* is one of the few works that can be attributed to him with certainty. It is a veritable pearl that will continue to speak to the imagination of connoisseurs worldwide.

Wim Decoodt

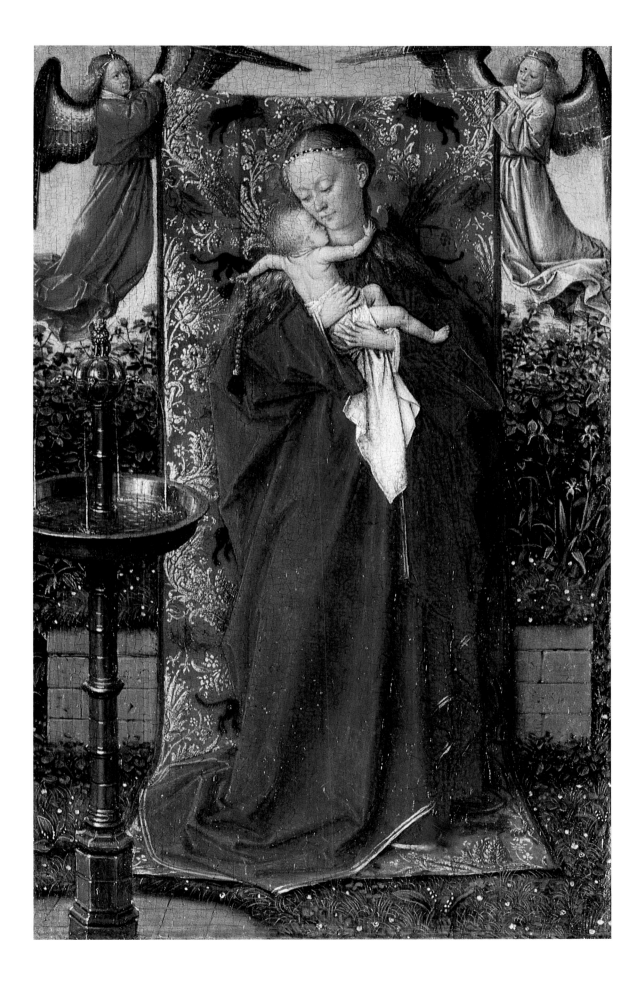

Rogier van der Weyden

Tournai ca. 1399 - Brussels 1464

Portrait of Philippe de Croÿ
Panel, 49 x 30 cm
Sir Florent van Ertborn Bequest 1841
Inv. 254

There are no known signed and dated works by Rogier van der Weyden, one of the most important painters in the Southern Netherlands in the fifteenth century. His entire oeuvre has been reconstructed by art historians. This painting is one of the key works in his oeuvre; its authenticity has never been disputed. Van der Weyden was a student of Robert Campin, but also studied the work of Jan van Eyck. Both were representatives of a different painting tradition.

In his portraits Rogier van der Weyden approaches his models in a human manner, in imitation of Jan van Eyck: he portrays them as they are. Nevertheless, he emphasizes the personal character of his models less, in contrast to Van Eyck; he is less able to penetrate their individuality, but above all he is a stylist with his own refined manner of drawing.

In this portrait he shows a young man in a position of prayer in three-quarter profile before a dark green background. He holds a rosary ending in a crucifix between his folded hands. On the little finger of his left hand he wears a fine gold ring with a ruby. Below, at his side, the handle of a sword or dagger is just visible. Around his neck is a necklace consisting of countless fine gold chains. By means of the sober composition, soft colouring and dark background, all attention is drawn to the face and hands. The serene expression of his face is intensely studied and is modelled by the light, as it were. The portrait exudes a quiet emotionality that allows us to surmise that the sitter was a cultured and pious aristocrat.

On the basis of two inscriptions and a blazon on the reverse, the sitter has been identified as Philippe de Croÿ (1434-1482), son of Jean de Croÿ and Marie de Lalaing, lady of Quiévrain. This man of noble blood was known as one of the most cultivated nobles in the circle of Philip the Good. From 1456 to 1465 he was the high-bailiff of Henegouwen, and after the death of his father he was count of Chimay. Starting from the same date, he was also a knight of the Golden Fleece. He gave his title as seigneur of Sempy to his brother when he inherited the title of seigneur of Quiévrain after the death of his mother in 1461. The reference on the reverse of this painting to his title as seigneur of Sempy suggests that the portrait dates from before 1461. Dendrochronological research has shown that the tree from which the panel is made was felled around 1455. Taking the drying time of the wood into account, the portrait could have been painted around 1460.

In the upper left corner of the back-cloth is a monogram embroidered in gold. It has been read in different ways, but probably contains the first and last letters of his first name, possibly even all of the letters of the first name and family name of the sitter.

This small painting is a splendid example of the way in which Rogier van der Weyden was able to explore the aesthetic and psychological possibilities of the devotional portrait. Originally, it was part of a diptych that may have shown a Madonna on the left wing. It is often suggested that it was the Madonna in the Henry E. Huntington Library and Art Gallery (San Marino, California).

Yolande Deckers

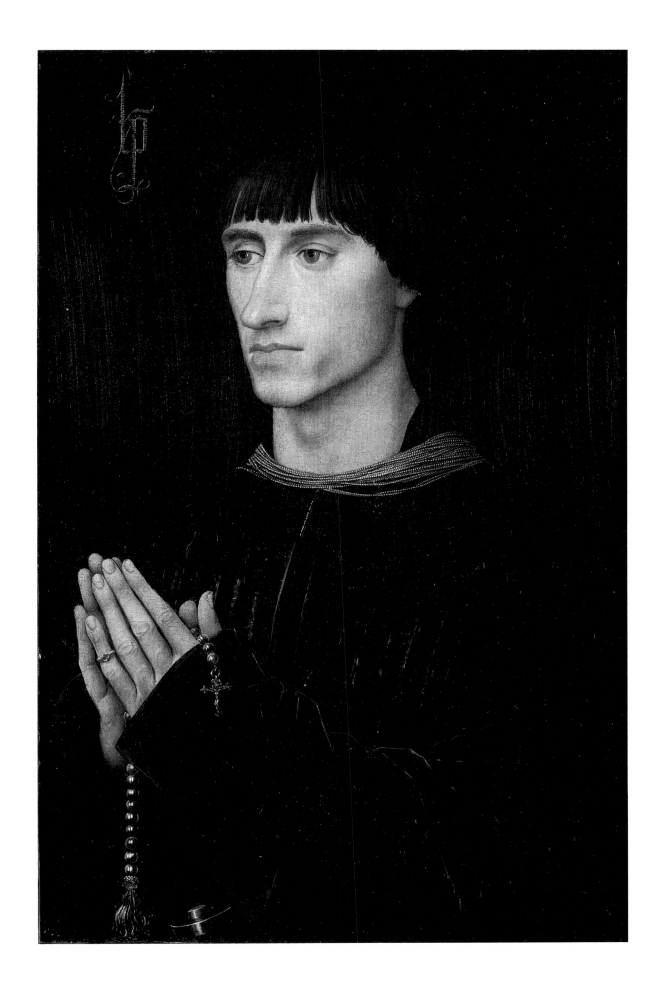

Rogier van der Weyden and assistants

Tournai ca. 1399 - Brussels 1464

Triptych of the Seven Sacraments
Panel, central panel: 220 x 97 cm; wings: 119 x 63 cm
Sir Florent van Ertborn Bequest 1841
Inv. 393-395

In this sacrament altar, Rogier van der Weyden situates the death of Christ in the central aisle of a high, gothic church. The seven sacraments are depicted around the crucifixion, which rises high above its surroundings. Above the visualization of each sacrament hovers an angel in liturgically coloured garments, each with a text banderole in its hands. The sacrifice of Christ is repeated in the action of the priest, who holds the host aloft during the consecration. The other sacraments are situated in side chapels to the left and right. To the left, a newborn is held up for baptism, a bishop confirms a boy and a priest takes the confession of a believer. The cycle of life continues further to the right, where a novice is consecrated as a priest, a marriage is blessed and a priest administers the last rites to a dying man. It is striking that the figures in the central aisle are a good deal larger – and thus more important and of another order – than those in the side aisles. In this select company we experience the two beggars between the columns as a contrast.

The death of Christ arouses strong emotions in those present around the cross, which is a typical characteristic of Van der Weyden's style. The figures, which are the real eye-catchers in this large space, testify to considerable powers of expression. Their colorful garments draw attention to the central event at the foot of the cross.

The coats of arms in the upper corners of the three panels, painted in the arched tracery of the imitation gold frame, are those of the city of Tournai (right) and of Jean Chevrot, bishop of Tournai. Thanks to this blazon, the bishop administering the sacrament of confirmation can be identified as Jean Chevrot. It is more than probable that he was also the commissioner of this altarpiece. The location for which it was destined has not yet been discovered; that it was painted for a church or chapel is beyond doubt. In this connection the Chevrot chapel of the Church of St Hippolyte in Poligny is often mentioned. The painting is dated to around 1440-1445 on stylistic grounds.

Rogier van der Weyden was, along with Jan van Eyck, the most famous artist of the fifteenth century. Before he became a master in Tournai in 1432, he was there for a few years as a pupil of Robert Campin. When he was the city painter of Brussels, he assumed the Dutch version of his name, 'de le Pasture', which then became Van der Weyden. He received numerous commissions from the great men of his time, so that he was able to build up an atelier with many assistants. His trip to Italy in 1450 – a pilgrimage to Rome – allowed him to become acquainted with the Italian art that undoubtedly influenced his oeuvre. On the other hand, his work also left an impression on the peninsula that is not to be underestimated.

Els Maréchal

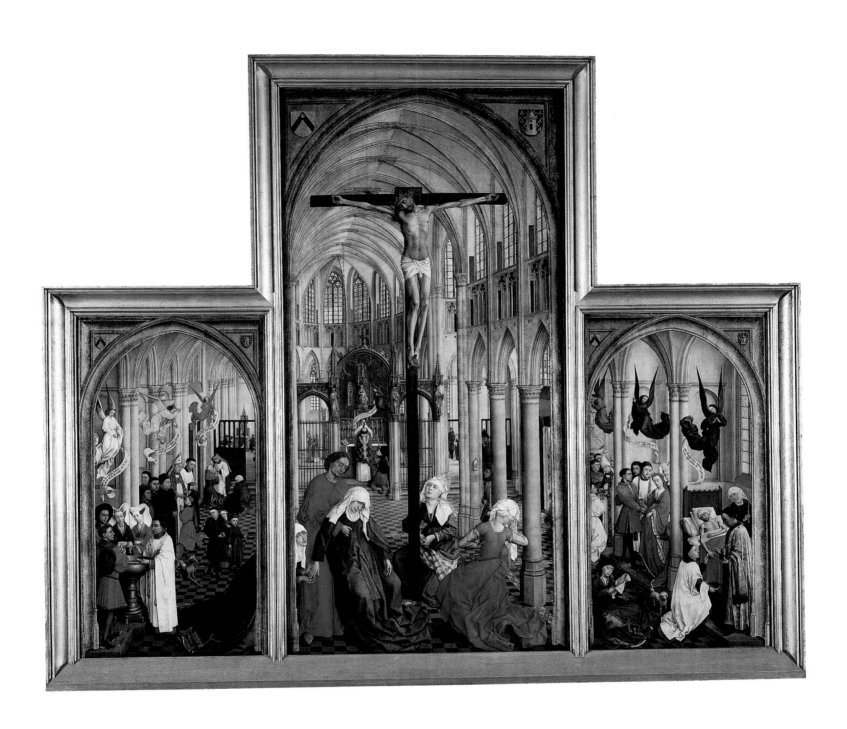

Jean Fouquet

Tours 1415/1420 - Tours 1480

Madonna surrounded by seraphim and cherubim
Panel, 94.5 x 85.5 cm
Sir Florent van Ertborn Bequest 1841
Inv. 132

The *Madonna surrounded by seraphim and cherubim* can be viewed as *the* masterpiece of the Koninklijk Museum voor Schone Kunsten. The work, by the hand of the French court painter Jean Fouquet, was created around 1450 and shows the Virgin Mary as Queen of Heaven with the infant Jesus on her lap. Mother and child sit on a richly decorated throne that is supported by cherubim and seraphim.

Here, Jean Fouquet has probably portrayed Agnes Sorel, the beloved of Charles VII. In any case, it is a pleasing woman dressed according to the then-current fashion. Her high, shaved hairline and ermine mantle illustrate her social prominence. The tightly laced waistline emphasizes the slightly undone lapel, by which means her entire breast is revealed and the scene acquires a lightly erotic tint. The whole produces an irreal effect: the milk-white skin of the Virgin and child contrast sharply with the red and blue of the angels.

The *Madonna surrounded by seraphim and cherubim* hung for a long time above the tomb of Catherine Budé, in Notre-Dame de Melun. It is the right wing of the so-called *Melun diptych* that Jean Fouquet made on the orders of Etienne Chevalier, treasurer of the French king and husband of Catherine Budé.

The patron had himself portrayed on the left wing, which is currently in the Gemäldegalerie in Berlin. Chevalier and his patron saint, Saint Stephen, are realistically portrayed in an interior that refers to the Italian Renaissance. He sits in an attitude of prayer and faces Mary in order to implore her intercession on behalf of his deceased wife. With the *Melun diptych* Fouquet reaches a synthesis between his capabilities as a book illuminator and his knowledge of the Italian Renaissance.

Jean Fouquet received his training as a book illuminator in Paris. His stay in Italy, where he painted the portrait of pope Eugenius VI before 1447, brought him into contact with the Italian Renaissance. Under the influence of this artistic current he began to apply perspective in a different way and introduced classical architecture in his work. After his return to France he worked for members of the French court and was subsequently court painter to the French king.

Jean Fouquet lived in a period in which a historical and artistic revolution took place in France. At his birth, around 1420, the Hundred Years War was raging between France and England. France was politically divided and had various local artistic styles. Upon his death, in 1480, the Hundred Years War had been over for some time and the Bourbon dynasty had begun to set its stamp on French politics. A centralized politics expressed itself by means of a leading court culture: beginning in 1475, Jean Fouquet fulfilled the function of 'Peintre du Roy'.

Anneleen Decraene

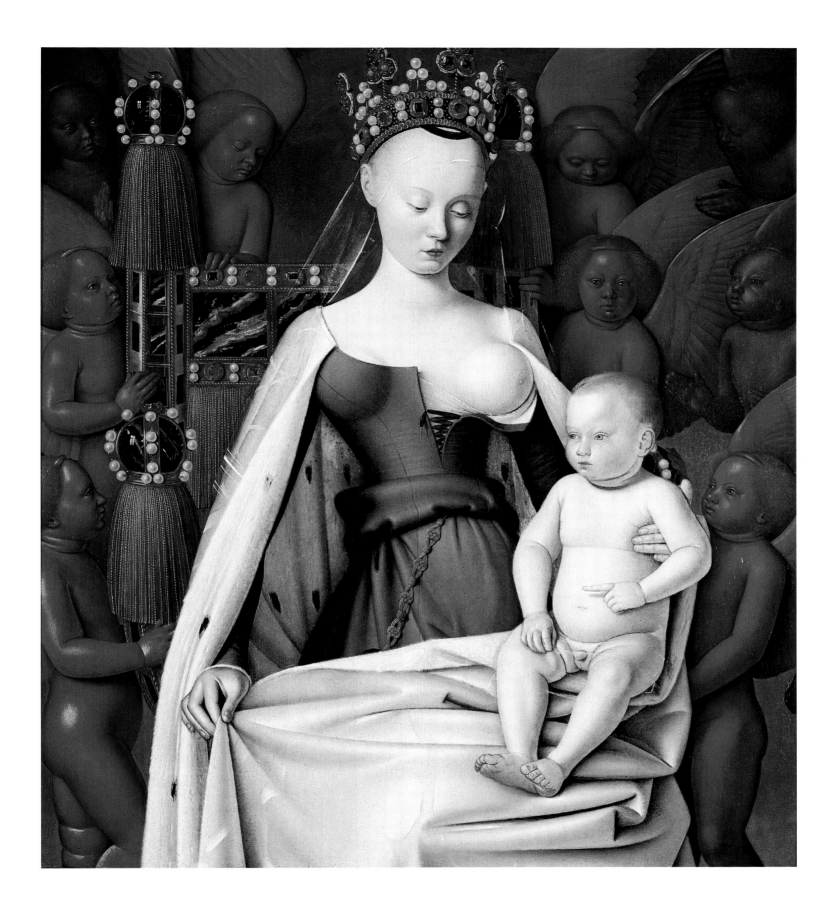

Antonello da Messina

Messina ca. 1430 - Messina 1479

Calvary
Panel, 52.5 x 4.5 cm
Below left: *1475. Antonellus messaneus me pinxit*
Sir Florent van Ertborn Bequest 1841
Inv. 4

The Scicilian painter Antonello da Messina assimilates in this scene a number of notable aspects from the passion of Christ. The two thieves, who flank Christ on the cross, are tied to truncated trees. The bodies of the three men condemned to death are realistically and graphically worked out. This was possible because the study of the human body, using anatomical research and dissection, formed an important part of the drawing skills of the Italian renaissance artist.

On the ground, strewn with skulls and bones, Mary mourns and John, the favourite apostle of Christ, kneels. The presence of a skull near the crucified Christ is not unusual. Since the tenth century, it was believed that Adam was buried on Golgotha. This information, however, has a deeper meaning. Because of the misstep of Adam and Eve, who could not resist the temptation of the demonic snake, man was overtaken by sin. The Fall was nullified by the sacrifice of Christ. Golgotha is thus the place where the source of original sin and victory over it come together.

The themes of death and salvation are strongly present here in a symbolic way. The owl refers to the Jews, or more generally to the sinners who turn away from virtue and the true faith, just as the nocturnal bird avoids daylight. The snakes that slither through the skulls, according to Christian symbolism, are emblems of death and the devil. From a tree-stump behind the cross sprouts a new branch. The combination of dead stump and green twig represents the contrast between the Old and the New Covenant of God with humanity. In the New Covenant, man finds salvation thanks to the crucifixion of Christ.

The work of Antonello da Messina shows the distinct influence of the Flemish Primitives. This is expressed above all in the detailed execution of the plants and animals and in the atmospheric depiction of the landscape. The painter also takes over the technique of oil painting from the Flemish Primitives. By this means, the reproduction of colour has become richer and livelier than with the earlier technique using tempera, a binding agent made from egg and lime. The artist probably became acquainted with the new technique via the presence of paintings by the Flemish Primitives in Naples and southern Italy.

The small piece of paper in the foreground nailed to a piece of wood bears the signature of the artist: '1475. Antonello of Messina painted me'.

Sandra Janssens

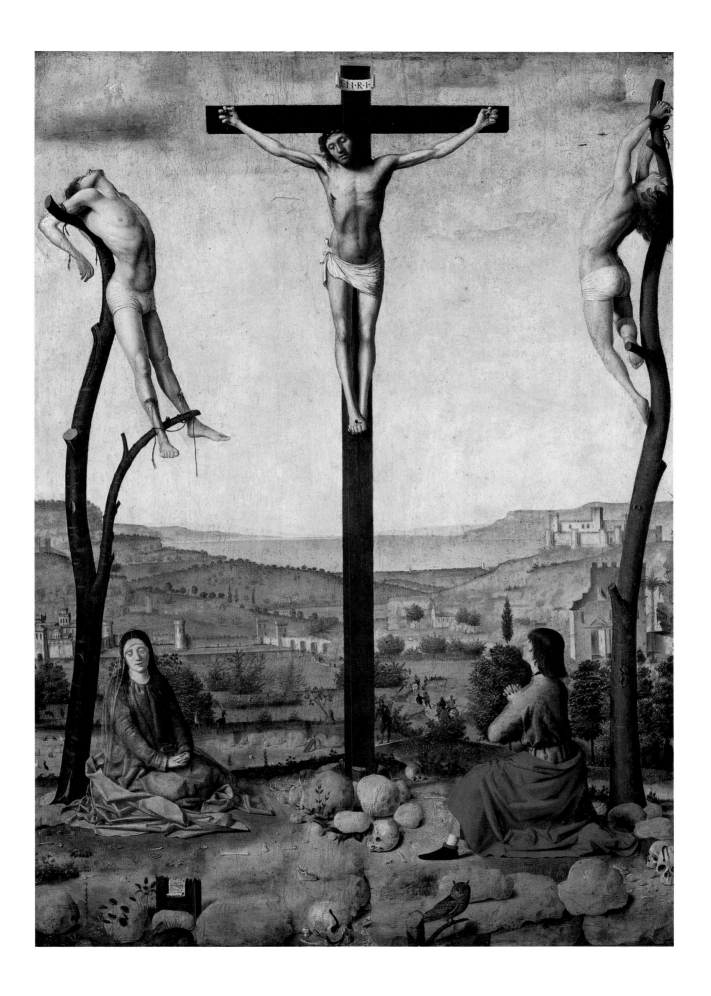

Hans Memling

Seligenstadt before 1440 - Bruges 1494

Man with a Roman coin
Panel (oak) 31.8 x 23.2 cm
Sir Florent van Ertborn Bequest 1841
Inv. 5

Memling, by whom the museum also possesses the monumental panels *Christ with singing and music-making angels* in addition to this portrait, worked for a diverse public. He received commissions from religious institutions and wealthy Bruges and foreign citizens. Bruges, the city where he worked, was at that time an international trade centre where many foreign merchants and traders lived. As a portraitist he must have been quite beloved given the large number of portraits by his hand that have been preserved.

Here is a middle-aged man portrayed in three-quarter profile facing right. He is dressed in a black garment that is pulled tight around the neck with a stay-lace. Such costumes were in fashion in Italy in the late fifteenth century. Memling's portrait sitters usually stare straight out in front. There are only two known portraits, the present work included, in which the sitter appears to look at the viewer. Nevertheless, there is no question of a real confrontation here. The gaze of this man is dreamy, introspective and without contact with the outside world. In his hand he holds a sestertius, a coin from Roman antiquity struck during the reign of emperor Nero. At the very bottom, in the centre, two laurel leaves can be seen.

In spite of the fact that the figure takes up a great deal of the surface area, a whole landscape is still worked out in the background, with swans, a rider and even an exotic palm tree on the right side. Memling is the first artist north of the Alps who placed an individual portrait against a landscape background. In this he was probably influenced by Italian art. The cropping of the picture and the placement high above the horizon of the landscape gives the portrait a monumental effect and elevates the contrast between near and far.

Various attempts to identify the sitter have been undertaken, whereby the prominently displayed coin in particular has served as a point of departure. Was the man a caster of medallions or coins, or a collector? Although one presumes that he is of Italian origin, his true identity remains a matter of speculation. Most probably, the answer lies locked within the painting itself, and the Roman coin, the palm tree and the laurel leaves have something to do with his name or emblems.

As was customary with the technique of the Flemish Primitives, the portrait was painted on an oak panel, which in this case consists of a single plank. To this was applied a white ground layer. The panel and the original frame, as was customary at the time, were primed and painted together so that they formed a single whole. Alas, the original frame of the painting has vanished. For the rest, the panel is in very good condition, which is fairly extraordinary for a painting of this age. The unsigned panel was probably created around 1480. In 2001 it was restored. Through the thinning of the highly darkened and degraded layers of varnish, the quality of the portrait came into its own once again. Some details were more clearly visible as well. Thus, whoever looks at the work from nearby can detect a stork in the sky on the left, and a flock of birds on the right.

Lizet Klaassen

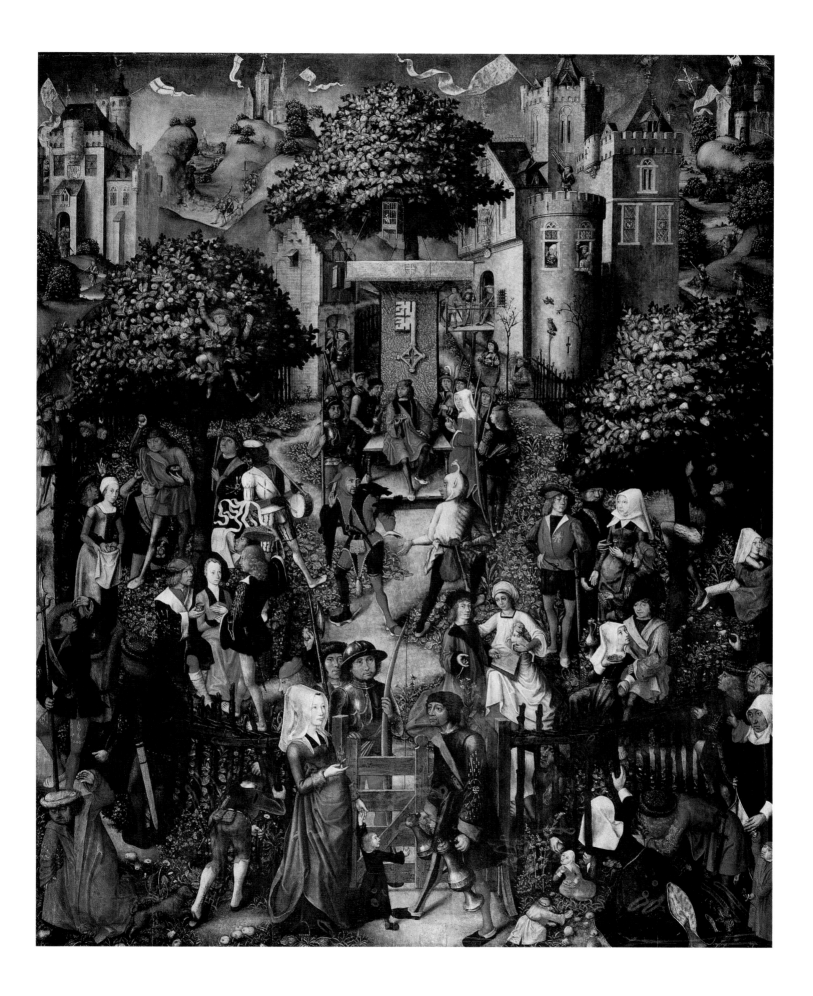

Master of Frankfurt

1460 - 1533 (?)

The painter and his wife
Panel, 38 x 26 cm
On the frame: *36. 1496. 27.*
Purchase 1974
Inv. 5096

It is generally assumed that this double portrait is a self-portrait of the Master of Frankfurt in the company of his wife. The couple is portrayed at half-length, and husband and wife have turned their faces toward each other in three-quarter profile. They pose before an evenly-lit background behind a table carefully laid with everyday objects, including a dish with cherries and a vase of violets. On the original frame, the year *1496* is applied in decorative letters, as are the ages of the man and woman, *36* and *27*, respectively.

In accordance with the habit of reserving the place of honour for the husband, the woman sits on the left side of her spouse. The painter has placed his arm lovingly around her waist. He looks straight out of the painting and in this way seems to seek direct contact with the viewer. The woman's gaze, full of respect and devotion, is directed toward her husband. She prudently holds up a violet, the flower we also encounter in the vase and gilt foliage on the upper part of the painting, where the escutcheon of the Antwerp guild of St Luke, the painters' guild, is visible. On the banderole is the device of 'De Violieren', the rhetoricians division of the guild of St Luke, *Wt Ionsten versaemt* (united by friendship).

This painting is in many respects a surprising occurrence for Netherlandish art around 1500. It is not only one of the earliest double portraits within a single frame, but also one of the earliest portraits of an artist and, if we do in fact assume that it is a self-portrait, one of the oldest surviving self-portraits. Through the direct and merciless manner in which the artist has portrayed himself, with wide-set eyes that look directly at the viewer, a pronounced nose and a rounded, somewhat forward-jutting chin, this portrait speaks less of pride than of a high degree of self-confidence. The artist's self-image north of the Alps would, under the influence of humanism and the Renaissance, change with extraordinary rapidity in the first decades of the sixteenth century. This new self-confidence manifested itself for the first time in the numerous self-portraits of Albrecht Dürer.

In this intriguing portrait, it seems as if the painter wanted to portray himself both as craftsman and husband. One might therefore ask whether the portrait might not be an early illustration of the idea that love leads to creativity?

Ben Van Beneden

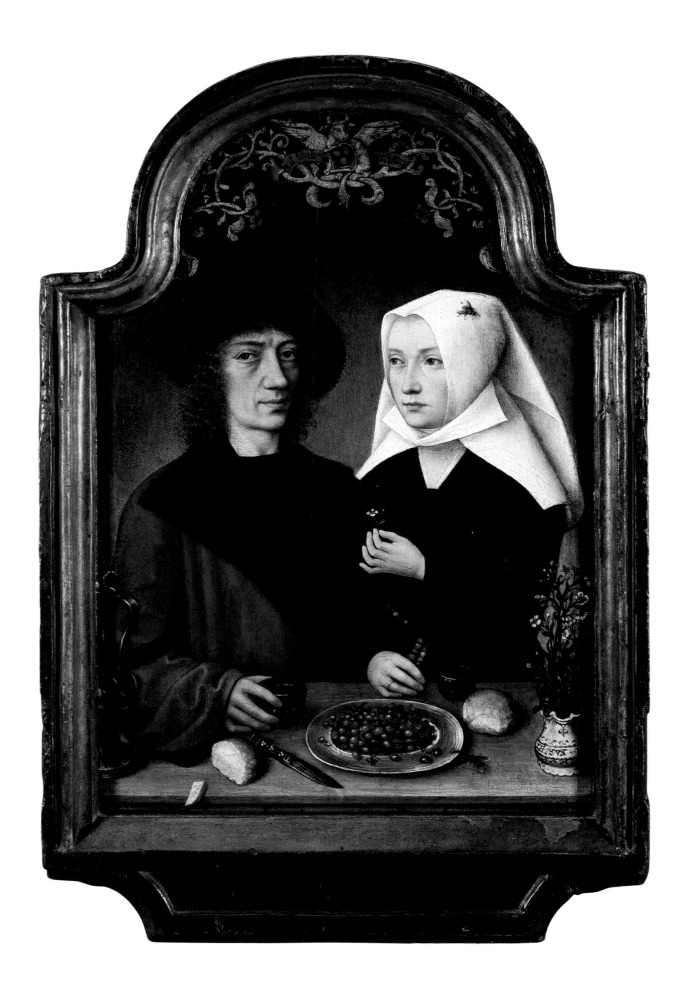

Gerard David

Oudewater ? - Bruges 1523

Rest on the flight into Egypt
Panel, 81 x 99 cm
Sir Florent van Ertborn Bequest 1841
Inv. 47

In 1484 Gerard David established himself in Bruges, a city where the legacy of Jan van Eyck was still strongly present and Hans Memling was a prominent painter. He built a successful career there and after the death of Memling in 1494 became the most important painter in the city. David, however, was no mere follower of these great models. He evolved with the times and adapted to working conditions in Bruges and Flanders, which in the meantime had become less than favorable. He sought out new clients, and along with traditional commissions for institutions and private patrons he also sold paintings on the open market. In 1515 Gerard David became a member of the Antwerp guild of St Luke and thereby acquired a second point of sale for his work without actually having to move there. Gerard David tried to meet the desires of a public that wielded great purchasing power, and among other things painted numerous Madonnas in handy formats. These works were intended for every house: they had a meaningful religious content, were of high quality and moreover were agreeable and inspiring to look at. This mode of production demanded a different approach. This is attested to by the many drawings and sketches of hands, figures and positions by David which have been preserved, and which served as models for paintings intended for the market. Gradually painters began to specialize in particular themes. Gerard David therefore developed the *Rest on the flight into Egypt*, a subject that did well on the market.

In a rocky landscape on the edge of a forest, Mary sits with the child. Somewhat further off Joseph lies resting and even further off the ass grazes in the meadow. David is one of the first painters to depict the forest in a fairly realistic way. A dense forest is a metaphor for the rule of God over all living creatures. The landscape here is approached in a completely different manner than the panoramic landscapes that arose in the beginning of the sixteenth century. The great wide world as reproduced in the panoramic landscapes is here reduced and condensed. It has become a place in which to enclose oneself, to separate oneself, to meditate, not in order to discover the world, but in order to enter into contact with God. In works like the *Rest on the flight into Egypt*, devotion and reflection are more important than narration. Everyone is a traveller, a pilgrim on the way to the heavenly Jerusalem. The forest, which here acquires such an important role, is a place where hermits dwell, where cloistered communities retreat; in short, it is a northern version of the biblical desert.

Mary sits on a rock and makes of her mantle, which corresponds to the structure of boulder and landscape, a part of the natural surroundings, as it were. Joseph literally folds himself into the landscape. The row of plants, demonstratively and 'unnaturally' arranged in the foreground, consists of Marian flowers and refers to Paradise. At the same time, this scene offers an intimate image of family life. The basket with children's things near Mary and the act of feeding itself are entirely commonplace, which explains why such images were so popular. The idea that even Jesus was raised on mother's milk shows his human side. The fact that he is depicted naked, so that everyone can see that he is a ordinary little boy, is a help to every traveller in the footsteps of Christ.

Nanny Schrijvers

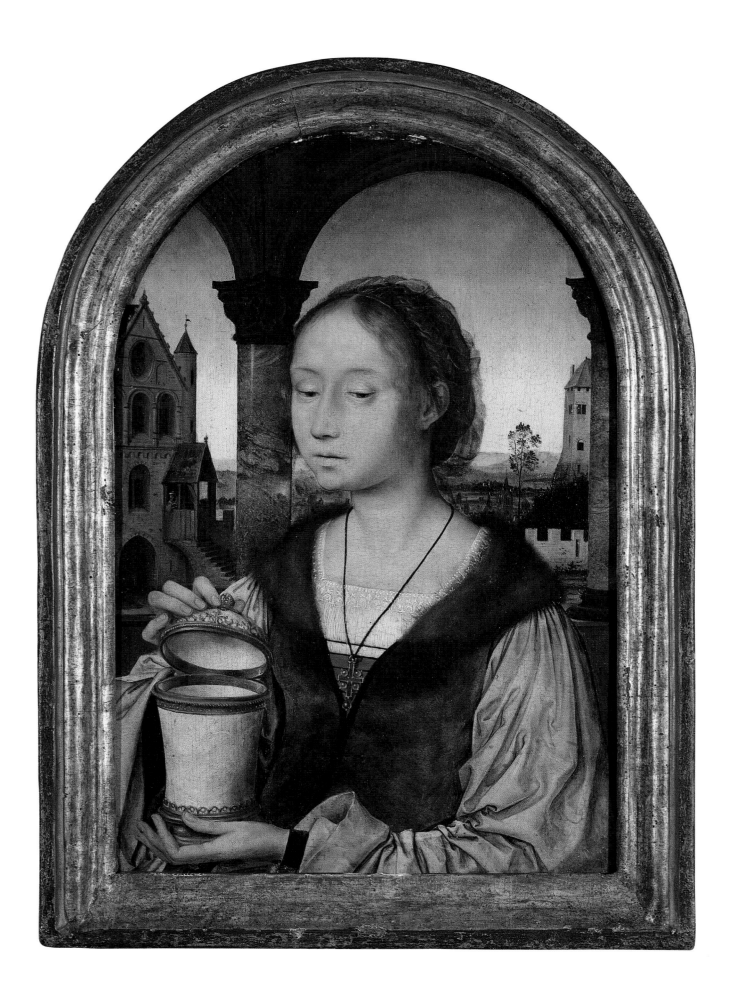

Quinten Massijs I

Leuven ca. 1460 - Antwerp 1530

Joiners' triptych
Panel, central panel: 260 x 263 cm;
wings: 260 x 120 cm
Original collection
Inv. 245-249

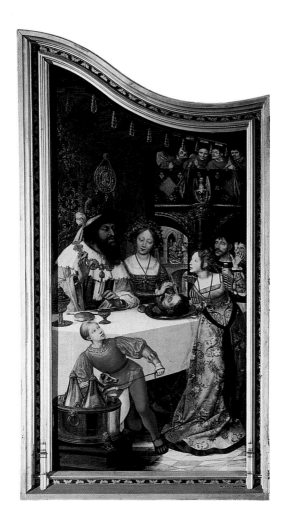

The Antwerp joiners, originally united in the same guild with the coopers, established their own professional association in 1479. The new guild ordered an altarpiece for their chapel in which, just as in the previous altarpiece, a Lamentation of Christ was to be represented. They had their patron saints, John the Baptist and John the Evangelist, represented on the wings; by this means they distinguished themselves from the coopers, whose patron saint was Matthew. The joiners initially chose a sculpted retable, probably because they themselves could make the cabinets in which the sculptures would be arranged, and gave the commission to two sculptors from Leuven. Because results were not forthcoming, they transferred the commission to an Antwerp sculptor in 1503 without, however, achieving any results, and thereafter the commission was awarded to Quinten Massijs. Perhaps for this reason the wings, which depict the martyrdom of John the Baptist on the left and that of John the Evangelist on the right, are closely related to sculpted retables. Both scenes are overpopulated, as it were, and the heathens in costly, exotic clothing recall expressive figures in carved wood. The heads of the executioners on the right panel are inspired by Leonardo da Vinci, while the wine steward on the left panel is borrowed from Albrecht Dürer.

On the right, John the Evangelist is being cooked in a kettle of boiling oil, which does not seem to harm him, while the emperor Domitian looks on with his senators and their retinue. The representation of the 'bad' as ugly and strange belongs to traditional pictorial language. It is therefore not exceptional that the Romans are given a rather caricaturial eastern appearance here. John, the emperor and his company form a screen, as it were, that closes off our view of the background. There, the Roman Porta Latina is depicted, which is all too obviously inspired by *het Steen* in Antwerp, with the fluttering imperial eagle of the Holy Roman Empire clearly visible. In this heavily populated scene, the executioner's assistants stoking the fire are seen from a different point of view than the rest of the figures and the background.

On the left panel, Salome dancingly serves a dish with the head of John the Baptist to her uncle and stepfather, Herodes, and her mother, Herodias. The beheading itself is depicted in the background. The banquet shows similarities to the feasts of the upper classes around 1500, at which dishes alternated with song and dance and all manner of – preferably spectacular – performances. Salome provides a blood-curdling *entremets*. In spite of the pomp and splendour, there is little on the table. The most beautiful tableware, like chalices or salt-cellars, were placed before the most important guests so that it was clear who possessed the highest status. The wine was kept in coolers near the table. A page stood ready to fill the cups.

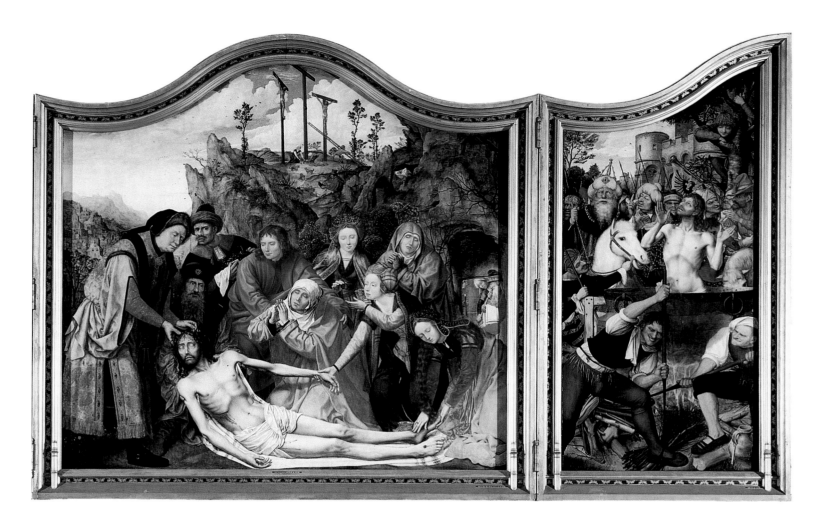

The scene on the central panel, the lamentation of the dead Christ, was supposed to encourage reflection and prayer, more so even than the images on the wings. Hence, the dead body lies directly in front, quite close to the viewer. Moreover, all of the figures in the foreground are connected to each other through the body of Christ. St John, Mary and Christ form the psychological centre of the scene. The red, blue and white of their garments recall earlier lamentations.

In the background of the central panel a splendid landscape is depicted, with an open tomb, Golgotha with its three crosses, Jerusalem and mountains so far off that they – entirely in the style of Italian atmospheric perspective – are depicted as vague and light. The cliff with three crosses repeats the vertical accent of John, who protects Mary. The arch-shaped tomb answers to the forward-bending Mary Magdalene, and the bowed back of Joseph of Arimathea, who supports Christ's head, is a counterweight to the hilly slope on which the city of Jerusalem is built.

The altarpiece has a definite function: it presents and re-presents the guild to the external world. It is supposed to bear a message, and this message must be legible. For this reason Massijs sought connections to successful sixteenth-century models. However, the balanced construction, measured distribution of light, and degree of monumentality of the figures are new. Reality is idealized as a harmonious whole. The tempered, soft use of colour differs from that of the Flemish Primitives, who tended to place intense colors next to each other. Massijs, by contrast, softens his colours and allows them to influence each other.

Nanny Schrijvers

Joachim Patinir

Bouvignes ca. 1474 - Antwerp 1524

Landscape with the flight into Egypt
Panel, 17 x 21 cm
Lower left: *Opus. Joachim D. Patinir*
Sir Florent van Ertborn Bequest 1841
Inv. 64

Upon a first glance at this small painting, one is immediately struck by the splendid landscape with steep cliffs, the lovely village and the blue sea bordered by distant mountains. Only afterwards does it become apparent that dramatic events are taking place in this landscape. In the centre, but depicted on a small scale, Joseph guides the ass on which Mary sits with the new-born Jesus. They are fleeing to Egypt after Herod commanded that all boys under two years of age be murdered. In the village, the soldiers of Herod attack like savages and kill innocent children. At the extreme left, one notices a pedestal on a rock, from which a statue has fallen. This is an element taken from legend, which among other things reports that a heathen idol fell from its socle when Jesus passed by. Here, it is clear that Patinir chose to depict nature rather than the biblical event.

Patinir depicts this landscape from a very high vantage point. The composition is built by means of three spatial planes. The foreground with its steep cliffs extends from the lower right to the upper left, and fills half of the panel. A path runs in the direction of the village, situated below on the right side of the panel, which dominates the middle ground. In the third plane the sea extends far out into the distance. A delicately nuanced cloudy sky is mirrored in the pond with two decorative swans near the houses of the village. The mountains in the distance grow vague in the air and light. The colours also evolve with the various spatial divisions. We call this aerial perspective because the colours grow increasingly vague as the landscape elements are located further away, by which means the impression of depth is created.

The whole of creation, nature in all its diversity, is depicted with a religious subject in its midst. However detailed and panoramic the painting may be, the religious scene has not yet been pushed aside. Although the landscape seems realistic, it does not depict a specific region and certainly not a landscape that can be found between Bethlehem and Egypt. Nevertheless, in the early sixteenth century, when this work was painted, it was novel to specialize entirely in the painting of landscapes.

Joachim Patinir came from the region around Dinant. He probably received his training in Bruges, in the atelier of Gerard David. Afterwards, he became a member of the Antwerp guild of St Luke. In the sixteenth century many painters began to specialize in specific genres. Patinir was the first real landscape painter in the Netherlands. Albrecht Dürer mentions a work by Patinir in the account of his trip through the Netherlands.

The *Landscape with the flight into Egypt* is probably an early work by Patinir. This can be deduced from the analytic construction of the landscape. It seems as if Patinir made direct observations from nature, probably in sketches of various natural features which he later combined. We recognize the cliffs from the region around Dinant where he was born; the village was taken from hilly Brabant and the sea recalls Italy.

Els Maréchal

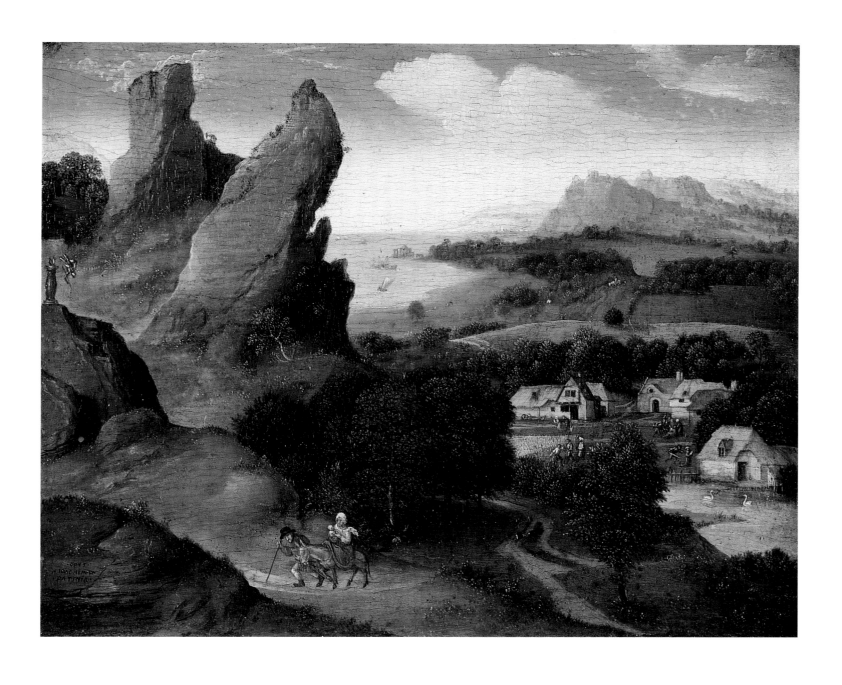

Master of the Antwerp Adoration

Active around 1520

Adoration of the magi
Panel, central panel: 29 x 22 cm; wings: 29 x 8.5 cm
Sir Florent van Ertborn Bequest 1841
Inv. 208 - 210 bis

The Master of the Antwerp Adoration is one of the masters with a provisional name who worked in Antwerp between 1500 and 1530 and adhered to a specific, mannerist, artificial style described by art historians as Antwerp mannerism. The production of these painters or ateliers was considerable and rather commercial. Certain themes, like the Crucifixion and the Adoration of the magi, were taken up time and again and were often executed in a stereotypical fashion. The quality of such paintings is often quite divergent.

This small-format triptych, one of the most beautiful examples of its sort, is particularly well-executed. It was probably painted around 1519, when Antwerp mannerism was at its peak. On the central panel, the Adoration of the magi is depicted. Mary sits on the ground with the child on her lap and St Joseph stands behind her. To the left and right, the three kings are represented: on the left, the Moorish king Balthazar with a cup filled with myrrh in his hand, and the old king Melchior, who offers the child gold; on the right, king Gaspar with frankincense. The scene takes place before the ruins of the palace of king David. The architecture forms a vertical accent and causes all attention to be drawn to the central group of figures. In the background, the city of Bethlehem is suggested by a few houses and a city gate. Three groups of riders and soldiers, the escorts of the kings, gather in the marketplace. On the wings, we see St George on the left with the dragon and St Margaret of Antioch on the right, together with the kneeling donor. In various places on the painting, the underdrawing is visible to the naked eye.

This small triptych is closely related to a larger triptych with the same scene on the central panel preserved in the Musées royaux des Beaux-Arts de Belgique, Brussels (inv. 577). Both paintings must have been created around the same time and are attributed to the same master. In the past, there have been several attempts to identify the artist. Recently it has been suggested that he can be identified as the Antwerp master Adriaen van Overbeke.

Yolande Deckers

Bernard van Orley

Brussels 1491/92 - Brussels 1542

Last Judgement and the Seven Works of Mercy
Panel, central panel: 248 x 218 cm; wings: 248 x 94 cm
Lower left: *HIC JACET SEP(U)LT(U)S VENERA-BILIS.VIR.IN...(CUIS) (ANIMA) (?) VIVAT IN.PACE*
On loan from the Openbaar Centrum voor Maatschappelijk Welzijn, Antwerp
Inv. 741-745

In the centre of this apocalyptic event, Christ sits on a rainbow, image of the covenant between God and humankind. He passes judgement on the people on the basis of their actions. In this, he is accompanied by the archangel Michael, below him, who weighs souls with a scale. The merciful, those who have shown compassion to their poor fellow men, are taken up into paradise on the left. On the right, the others are damned as punishment for their negligence and sent to hell. In the centre, the seventh work of mercy is represented, namely the burial of the dead. The remaining six works are distributed across the wings. In them, the physical lack of those in need is empha-sized in a highly realistic manner. To the left, almoners give drink to the thirsty. A man is received on a step with open arms, a refer-ence to extending hospitality to strangers. In the background, people distribute food to the hungry. In the foreground of the right wing, poor beggars are provided with clothing. Behind them, support and consolation are offered to a sick man. Further on, the visiting of prisoners is depicted. At the very top of the wings, Mary sits on the left and John on the right, each accompanied by six apostles. As mediators they praise the good works of humanity to Christ, in order to persuade the Judge to greater lenience in his judgement. The saints Stephen, Mark, Lawrence and Elizabeth of Hungary, who are depicted on the exterior side of the wings, act as paragons of mercy by giving money and clothing to the poor.

In 1518-1519 the Antwerp Almshouse commissioned this painting from Bernard van Orley, court painter to Margaret of Austria. The triptych was delivered six years later and placed on the altar of the Almshouse in the cathedral of Antwerp. The *Aalmoezenhuis der Huysarmmeesters*, or

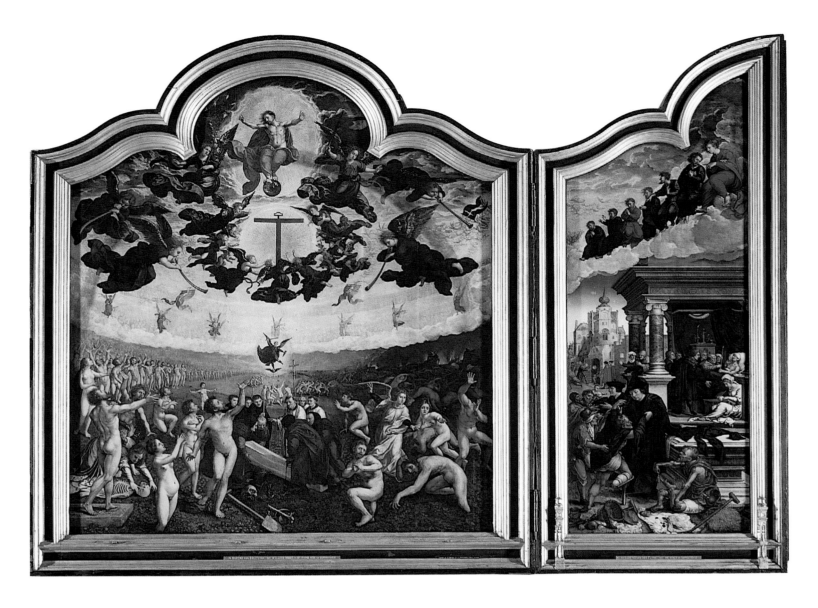

Almshouse of the Poor Householders, grew out of a private undertaking that provided assistance to the poor of the entire city. The scenes on the triptych illustrate their charitable activities, which they exercised in the service of God. It was Christ who said: "Truly, I tell you, just as you did it to the least of these who are members of my family, you did it to me." (Matthew 25:40). The representation of the Last Judgement likewise contains an exhortation, because the almoners will also be judged for their mercy at the end of time. The theme of the painting was also politically current, given the Ieper reforms (1525-1530), which marked a turning point for the better and more centralized planning of assistance systems in the Netherlands.

Sandra Janssens

Jean Clouet

? - Paris 1540 or 1541

The dauphin François, son of François I
Above left and right: *Francoi Dauphin*
Panel, 16 x 13 cm
Sir Florent van Ertborn Bequest 1841
Inv. 33

This little painting has long been viewed as the portrait of the young François II, son of the French king Henry II. Uncertainty has governed with respect to the identity of the artist; initially, Hans Holbein II was proposed, and afterward the painters François Clouet, son of Jean Clouet, and Corneille de Lyon. In 1901, however, the art critic J. Moreau-Nélaton attributed the portrait to Jean Clouet. In doing so he referred to the chalk drawing by Jean Clouet preserved in the Musée Condé at Chantilly. This drawing precedes the painted portrait, and bears the inscription: *Monsr. le daulfin filz du Roy francois.*

Moreau-Nélaton also demonstrated that the royal child portrayed is the son of king François I, and not of Henry II. Jean Clouet, who is only known as a portrait painter, was in fact in the service of François I between 1516 and 1536. Between 1518 and 1537 he received personal compensation from the French king for "portraicts et effigies au vif".

The dauphin François was born in 1518. Because of his early death, in 1536, he did not play a significant role; as a consequence there is little information about him to be found. Judging by the portrait, which depicts a child of four or five years at the most, Clouet probably painted the dauphin at the beginning of the 1520s. The clothing – a low-cut doublet with white slits – also points to the same period. We also encounter the black hat with a broad band adorned with swan feathers in other portraits by Jean Clouet from around the same time, among other places in the *Portrait of François I* (Musée du Louvre, Paris; preliminary drawing, Musée Condé, Chantilly) and the *Portrait of Claude de Guise* (Palazzo Pitti, Florence).

The delicacy and refinement of the small child's portrait are striking. Here, too, there are more points of comparison with other portraits by Jean Clouet, like the bright, diffuse light that is evenly distributed across the face, the extremely fine draughtsmanship of the blond hair, and the white, comma-shaped strokes with which the feathers on the hat are depicted. The even green background heightens the intensity of the yellow-gold and warm red of the clothing, and focuses attention on the child's pale face.

Clouet certainly had an eye for the detailed depiction of splendid clothing and the dignified posture that emphatically point to the high status of the sitter. However, he also effectively captures the expression of the dauphin's face, which speaks of child-like innocence as well as an awareness of royal dignity. In this way, the portrait of the young prince, which belongs to the idealizing art of the court, acquires a particularly lively and sensitive character.

Dorine Cardyn

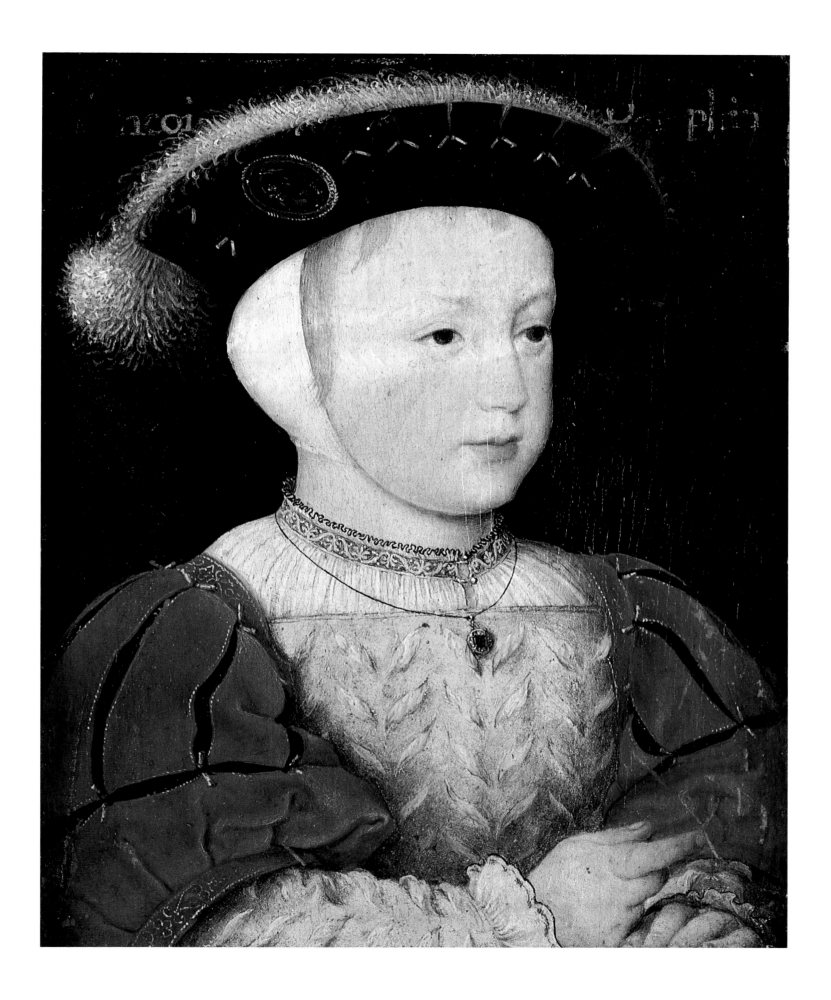

Anonymous Master

Southern Netherlands, beginning of the sixteenth century

Enclosed Garden
Box, 89 x 53 x 16 cm; with open wings, 106 cm
Purchase 1971
Inv. 5094

The 'Enclosed Garden' or *hortus conclusus* has various meanings. There are many known 'Gardens' in which the figures depicted are engaged in profane or religious activities. As art, they are of a completely separate order. Generally, they consist of a shallow box that stands upright on one end, with the opening facing the viewer. The box is adorned with all manner of ornaments – mostly floral – in *passementerie*, which serve as a background for free-standing polychrome sculptures; as an ensemble the latter can encompass many different levels of meaning. The box is usually closed by means of painted wings depicting a saint or religious scene. It may sound somewhat grandiloquent, but such boxes belong to the most rare works of art in the world: they are not only a Flemish specialty, but are more specifically a Mechelen occurrence, the real centre of which was the local Onze-Lieve-Vrouwhospitaal. Chronologically, they can be situated roughly in the period between ca. 1510 and 1560. The hybrid and complicated transition from Flemish gothic to the Renaissance is clearly reflected in these works of art. Enclosed Gardens were probably made exclusively in convents. The role of the nuns in the creation of such works probably consisted chiefly in the making of *passementerie*. For the rest, the gardens are clearly a form of assemblage: 'boxmakers', painters, sculptors, and 'decorators' each had their own share in the process. As far as anyone knows, only one single example of an Enclosed Garden has ever been found in a private collection. When the museum purchased it in 1971, it constituted a truly unique acquisition.

Below, one notes that the Antwerp Garden has a wicker enclosure in which there is a small gate. It refers to the most important symbolic meaning of most such Gardens, the 'Enclosed Garden' of the Song of Songs in which only the King of Kings is granted access. Together with the 'Sealed Fountain', which appears in Van Eyck's *Madonna at the fountain* (see page 22), the 'Enclosed Garden' forms one of the most important symbolic references to Mary's virginity, a theme that was not without importance in convents. The most important element in the Antwerp Enclosed Garden is therefore the central Madonna in the aureole, "fair as the moon, and bright as the sun" (Song of Songs 6:10). In the lower zone there are numerous other figures and elements that often have symbolic meanings or are directly related to the central theme of virginity. Striking in this respect are the figures representing the *Expulsion of Adam and Eve from Paradise*.

On the wings, the *Assumption* and the *Harrowing of Hell* are depicted on the left, and the *Miracle of Pentecost* and *'Noli me tangere'* (Christ appears to Mary Magdalene as a gardener) on the right. Because of the gilt backgrounds, or because of the iconography of Assumption, in which only Christ's feet and their imprint on a rock can be seen, these small scenes exhibit a distinctly archaising character. In contrast to the actual 'Garden', the wings are of German origin and are at least a half century older than the sculptures, which can be dated to around 1500.

Eric Vandamme

Marinus van Reymerswale

Reimerswaal 1490/1495 · Goes 1546/1556

City treasurer
Panel, 65 x 52 cm
Sir Florent van Ertborn Bequest 1841
Inv. 244

Marinus van Reymerswale made various paintings of city treasurers, some of which are signed and dated. A number of these works are actually portraits; others seem to be based on portraits but worked out in a more general sense, so that the figure is staged more as a type or even a caricature. The text that the man on the left side of the painting writes in a book appeared in an earlier portrait of the city treasurer of Reimerswaal. The identity of the man has been deduced from the text he has before him. It concerns the collection of duties on beer, wine, fish ... From the mention of the Visbrug, a toponym that certainly does not occur in every city, one may conclude that it indeed concerns the city of Reimerswaal. It was the city treasurer who collected and recorded the duties. Titles like 'money-changers', 'tax collectors' or 'bankers' ... which are often given to this work and others like it, are therefore not correct.

Van Reymerswale probably reused the design of the portrait of the city treasurer of Reimerswaal, but without the individual features of the man in question and with clothing that does not immediately call to mind a recognizable time or place. The clothing creates distance, for contemporaries of the painter as well as for us: the man on the left of this painting wears a *kovel*, a sort of cap or hood which is not attached to the collar, and which has a long point formed by loose threads and strings of fabric wound around it. It is a strikingly pompous head covering that can seem comical or even ridiculous. Is this intended satirically, or does red simply give more weight to the painting?

Van Reymerswale could sell these not-individualized exemplars on the open market to city treasurers who could not afford a portrait or to other interested parties. This image appears to have been especially popular, just as were comparable subjects like the 'banker and his wife', 'lawyers' or 'money-changers'. Many of these themes go back to originals by Quinten Massijs, the present city treasurer included. Van Reymerswale had an outspoken preference for such financial subjects, and there was apparently a public for them – after all, everyone is involved with money in the end.

The city treasurer shown here counts and writes in a cramped workspace. The man next to him, who guarantees the flow of business, sits before an open door where there is hardly room to pass by. The viewer is directly confronted with the painting and is shown what is essential by the stern man. Is it a warning or an exhortation? Is it about honour or deceit? About miserliness or thrift? Sin or virtue?

On the shelf above, next to a box full of bank notes and loose documents, pushed back in the corner, there stands a stump of a candle. Does this motif have a symbolic meaning? The candle is out, is almost used up. Does this pertain to wealth, to the earthly possessions shown here? Probably not. Although the difficult and ambivalent relationship to earthly wealth is often the subject of paintings, here, on the contrary, a man is represented in terms of his function; thus, the image can only be about the way in which he fulfils this responsibility as a model for all city treasurers: "Do not use dishonest standards when measuring length, weight or quantity. Use honest scales and honest weights, an honest ephah, and an honest hin. I am the Lord your God..." (Leviticus 19:35-37)

Nanny Schrijvers

Jan Massijs

Antwerp ca. 1509 - Antwerp 1573

Judith
Panel, 115 x 80 cm
On the edge of the sword: *Ioannes Massiis Ping.*
Mrs. Huybrechts-Delstanche Bequest 1957
Inv. 5076

In her left hand, the biblical Judith holds the head of Holofernes, general of the Assyrian king Nebuchadnezzar. She turns her eyes discreetly away from her cruel trophy. The sword in her right hand allows us to surmise what she has just done. After she had intoxicated and seduced Holofernes, an enemy of her people, she cut off his head. The Jewish people were thereby saved from destruction. In the distance, on the left side of the panel, we notice the panic that the event has brought about in the camp of the occupier.

Judith, adorned with decorative jewels and a transparent veil, succeeded in seducing Holofernes with her bodily charms. She has become a profane, sensual heroine who exudes distinction. An inward rest has returned after the violent strain of her dynamic action. Her subdued expression is painted with refinement in a conventionalized style. Judith here stands as a symbol of belief in the person who takes matters into their own hands.

The Judith theme, which is borrowed from the Old Testament, was especially beloved in Western European painting and literature. Numerous renaissance artists depicted the story, but Rubens would also try his hand at the theme later. Jan Massijs painted it several times. The panel in the Koninklijk Museum can be placed in the last mature period of his oeuvre on stylistic grounds, more specifically, in the 1560s. Here, Massijs brings together a synthesis of Flemish realism and outside influences. In addition to religious subjects, he also painted genre scenes and landscapes.

Little is known about the life and work of the Antwerp artist Jan Massijs. He was a son from the second marriage of the famous painter Quinten Massijs. Like his brother Cornelis, he worked in the atelier of his father. Both had the chance to make the acquaintance of the cultural, intellectual and religious climate and the humanism-influenced circle of acquaintances in which their father lived. Jan initially worked in the style of his father. He was inscribed as a master in the guild of St Luke only after Quinten's death. Because he had ties with a heretical group, he was persecuted for Lutheranism and in 1544 was banished. In 1558 he returned to Antwerp and was left in peace. His later work shows the influence of the school of Fontainebleau and Northern Italian painting. It is presumed that as an exile he made his way to Italy via France, and lived for a time in Genoa.

Els Maréchal

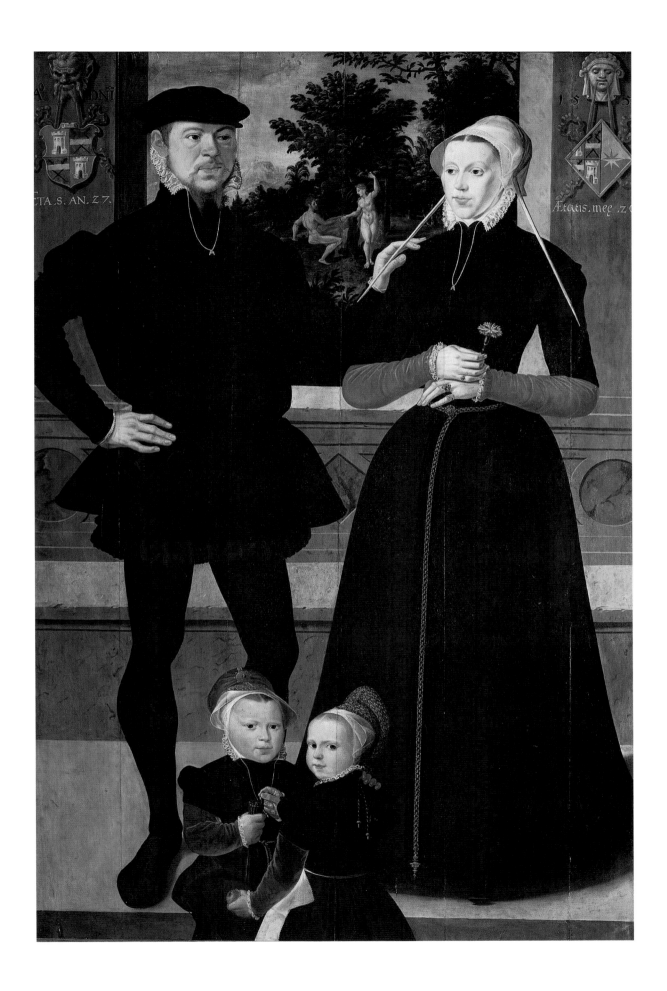

Joachim Beuckelaer

Antwerp ca. 1530 - Antwerp ca. 1574

Vegetable market
Panel, 149 x 215 cm
On the awning of the wooden gate in the background: *JOCH BEUCKELAER 18 NOV.BRIS 1567*
Gift of Artibus Patriae 1950
Inv. 5045

The artist Pieter Aertsen, originally from Amsterdam, created a new genre in Antwerp around the middle of the sixteenth century: market scenes with an overwhelming quantity of fruits and vegetables which sometimes form attractively composed still lifes around peddlers, market gardeners and peasant women. In this genre, his nephew and pupil Joachim Beuckelaer was likewise a virtuoso protagonist. Thanks to him, the genre remained successful until the seventeenth century.

In the *Vegetable market* three merchants, a boy and an old woman, in the centre, and a young poultry-seller, on the left, have displayed their wares around them in wicker baskets and earthenware dishes. We see endive and pumpkins, gooseberries and blackberries, various cabbage sorts, parsnips and gherkins, turnips, cherries and artichokes, woodcocks, titmice and teals, grapes and medlars, apples, pears, peaches, plums, hazelnuts and walnuts.

Such market scenes are related to genres like the kitchen piece and the still life. They are traditionally viewed as an expression of the spirit of the Renaissance and humanism, precisely because they give expression to a renewed sense of reality, nature and everyday life. In addition, the discovery of new continents in the sixteenth century meant the introduction of new plants in Europe which were gladly put on display in such paintings.

Nevertheless, the reality evoked in this painting is in a certain sense an illusion. The sorts of vegetables and fruits shown here could never have been harvested or offered for sale at the same time. From this, one may conclude that the painter did not intend to depict an actual situation, but that he wanted to refer to an underlying allegorical meaning. In treatises on natural science, botanical guides and the writings of moralizing rhetoricians from the Middle Ages, many of the products of nature represented here were seen as sensual stimulants. On account of their taste or shape, they were also used in the vernacular to speak metaphorically of love, pleasure, eroticism and sexuality. Thus the sweet taste of fruit has been compared from time immemorial with the sweetness of romance.

By extension this painting can easily be read as the depiction of an amorous situation: the young fruit-seller will be coupled with the bird-seller by her older companion. His merchandise does not lie: the poultry he offers for sale marks him as a 'vogelaar' or 'fowler', a popular name for a womaniser.

In recent art historical contributions certain authors have warned against such interpretations, whereby too much emphasis is placed on the underlying symbolic meaning. The excess that characterizes such images has not only a symbolic meaning but should also be interpreted as the conscious display of luxury. Thus, this *Vegetable market* could be an example of a painting in which the artist has incorporated a message that can be read on different levels: the natural, the metaphorical and the moral.

Yolande Deckers

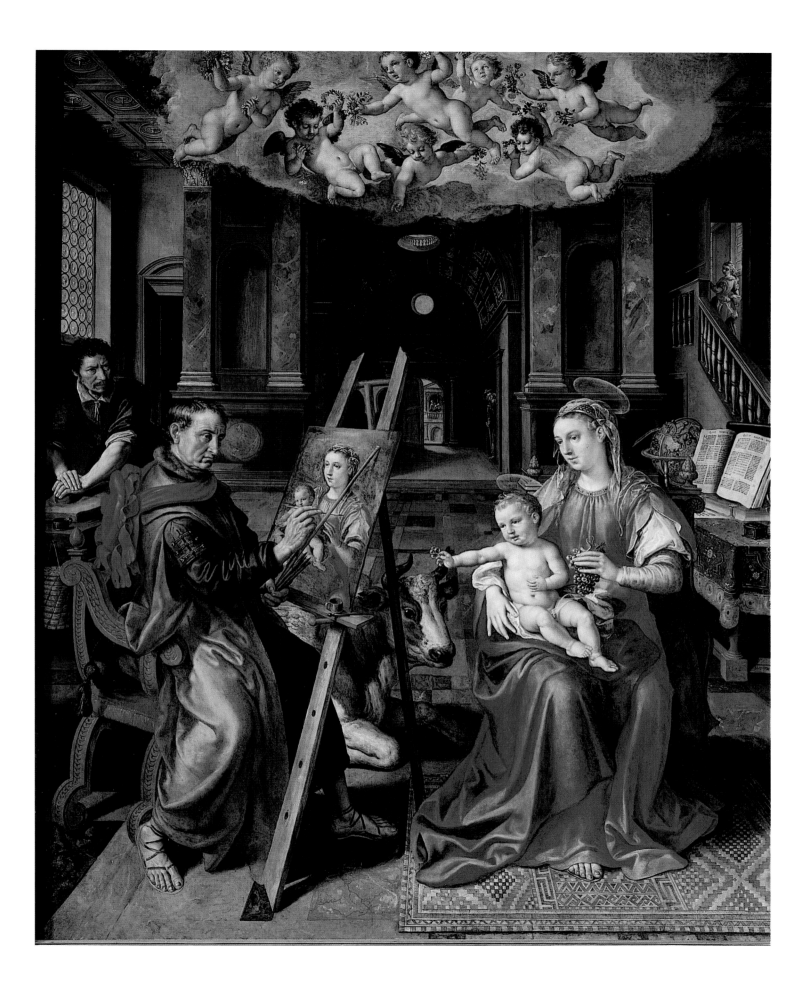

Jan Brueghel I

Brussels 1568 - Antwerp 1625

Flowers in a vase
Panel, 101 x 76 cm
Purchase 1880
Inv. 643

A vertically balanced bouquet of flowers in a ceramic vase fills the entire panel. Two slender branches, on one side the poisonous crown imperial, leaning somewhat to the left, and on the other the white lily, inclined to the right, almost reach the upper edge of the panel. Below them is arranged an abundance of flower sorts in various stages of bloom and growth. With a bit of detective work, it is possible to recognize forget-me-nots, tulips, carnations, roses, narcissus, primula, anemones, cuckoo flower, iris, cornflowers, and peonies. All of the flowers have been painted with equal attention, just like the insects below.

The vase likewise attracts attention, with representations of Amphitrite (left) and Ceres (right), who symbolize water and earth, respectively. Fire and air were probably represented on the back side of the vase, personified by Vulcan and Apollo. Are we here concerned with a symbolic depiction of the four elements, or the brevity of human existence?

This compact mass of flowers does not really form a natural bouquet. There are almost no areas of overlap, so that one can see all of the flowers in their entirety in an almost encyclopaedic manner. Klaus Ertz reports that while the flowers were in bloom, Brueghel painted directly on the wood or copper panels in oil, without preparatory drawings. Brueghel shows himself to be a virtuoso in the domain of flower painting through his technical perfection, his sense of harmony and his feeling for composition. Ertz believes that two different hands, each with their own particular qualities, can be discerned in this bouquet. He sees the painting as an example of collaboration between father Jan I and son Jan II. Previously, the bouquet was attributed successively to father and son. Jan Brueghel I only began painting flower pieces at the age of 38. According to Ertz, his contacts with the court of archduke Albert in Brussels gave him the dreamed-of chance to study rare and expensive flowers, shells and strange, costly objects.

Jan, son of the legendary Pieter Bruegel, was a devout Catholic and moved in the highest circles. He was highly esteemed by contemporaries. He was friends with Rubens and his most important patrons were archdukes, emperors, kings or cardinals. This work does credit to his name as a flower painter, although this appellation is much too limited for this many-sided artist. He was the first important painter to raise the flower still life to an independent genre. In addition to colourful flower pieces, he produced rich miniature landscapes and hell scenes. He also depicted village life and mythology in a highly personal manner.

Els Maréchal

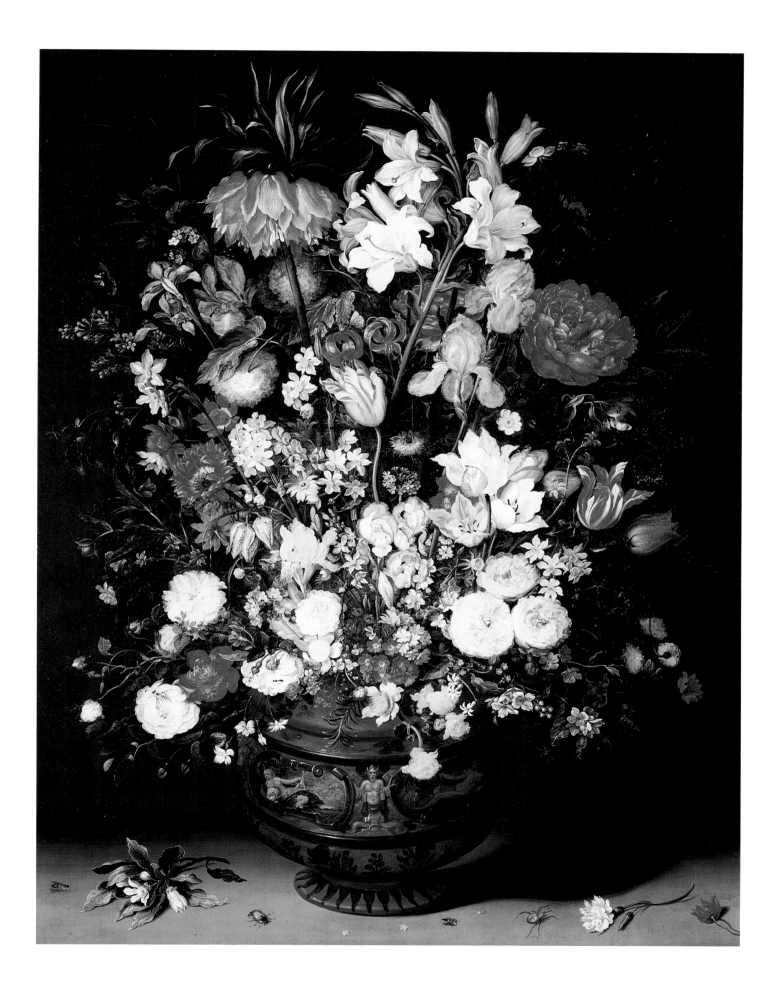

Jan Brueghel I

Brussels 1568 - Antwerp 1625

Visiting the farm
Panel, 30.5 x 46.5 cm
Purchase 1885
Inv. 645

A couple in middle-class attire, accompanied by a maid, pays a visit to a farm. There is a fairly large company in the room. A small child hopes to receive money from the wealthy guests. The guest has given his host a sugar-loaf. A newborn is kept warm close to the fire, while a dog sleeps in his cradle. A third child sits on a chair and drinks from a pitcher. In the centre, the slop for the pigs steams in a large open kettle over the fire. Further interesting details can be discerned here and there. Colored prints have been fastened to the back of the bench, including a Calvary. Deep in the background hangs a cage containing a magpie. Under it, a dog looks longingly at a man eating porridge. A pair churns butter. You can almost hear the different noises that the various occupations bring forth in the interior.

Earlier, it was suggested that the scene depicted here shows the visit of a wealthy foster father to his newborn god-child. More probably, what is depicted here is the visit of a landlord to his tenant, who has just had a new baby. The family does not really appear to be poor, given the sober setting of the table, the churn, the furniture, the earthenware and the other household goods present. The scene probably formed the pendant to a peasant wedding. For a wedding, the landlord provided the beer, while for a birth or lying-in visit, a sugar-loaf was offered. In this way, Pieter Bruegel I recorded the daily life of the peasant folk. He is rightly viewed as a critical chronicler of his times.

This panel is a copy after an original by Pieter Bruegel I, the father of Jan. It was initially believed that the original was lost, but now scholars have presumed that it is the grisaille preserved in the Fondation Custodia in Paris. The Koninklijk Museum also possesses a copy of the same subject in colour, but by Pieter Brueghel II, the brother of Jan I. In addition, numerous other copies are known, in colour as well as in grisaille, including an exemplar in colour by Jan I now in Vienna. The large number of copies indicates that the subject was quite popular in its time. Within the oeuvre of Bruegel it is not unusual that so many copies of a given composition are made by the sons. For some paintings, there are as many as fifty known exemplars.

After his formative years in Antwerp, Jan Brueghel stayed in Naples, Rome and Milan. From 1592 until 1594 he lived in Rome, where he sold many works to the cardinal Colonna. The *Visiting the farm* or *Visiting the tenants* is dated 1597, just after his return from Italy. Jan Brueghel's father certainly served as an example to him, which does not take away from the fact that he simultaneously succeeded in forging a worthy and highly personal path of his own. As an innovator, he moreover gives evidence of a particlarly artistic quality.

Els Maréchal

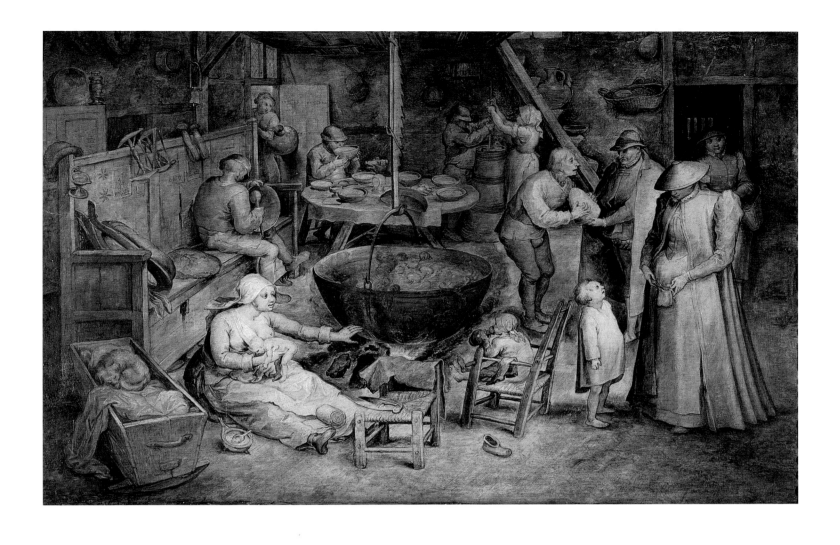

Abraham Janssens

Antwerp 1575 - Antwerp 1632

Scaldis and Antverpia
Panel, 174 x 308 cm
Original collection
Inv. 212

Scaldis, the old river god, lies on the ground. He leans on a large amphora, out of which flow the waters of the Scheldt. He offers Antverpia, the personification of Antwerp, a horn of plenty. This representation was commissioned from Abraham Janssens by the city magistracy in1608 to adorn the chimney of the Chamber of State of the Antwerp city hall. In that chamber, peace negotiations between the United Provinces and the Spanish Netherlands were to be carried out. Diplomatic consideration would eventually lead to the Twelve Years' Truce between the Northern and Southern Netherlands (April 9, 1609). Through this painting, the city leadership wanted to encourage the negotiators to open the Scheldt to shipping traffic once again. Free passage was indeed an indispensable condition for Antwerp's prosperity. At that time Janssens belonged to the most important painters of the harbour city. It is therefore not surprising that the prestigious commission was entrusted to him. Janssens was to receive the considerable sum of 750 guilders for the painting. The composition of Janssens' *Scaldis and Antverpia* is based on Michelangelo's famous *Creation of Adam* (Janssens actually borrowed compositional schemes from other artists more frequently). The figures are massive, robust. The light is sharp and casts dark shadows, as in the masterpieces of Caravaggio. The scale is frankly impressive, even overwhelming. The fruits and vegetables that fall from the cornucopia take the form of a face, a visual joke that reminds the viewer of Arcimboldo.

Opposite this work hung another masterpiece, namely the colossal *Adoration of the magi* by Janssens' rival, Peter Paul Rubens, who had just returned from Italy. Rubens received 1800 guilders for this painting, more than double what the city had ever before spent on a painting. In 1612 the painting was given by the city government to Don Rodrigo Calderon, member of the Privy Council and ambassador of the Spanish king, in the idle hope that this gesture would win him in favour of Antwerp's affairs. Later, the work was purchased by Philip IV. Via the royal collection it eventually ended up in the Prado in Madrid. The confrontation between two artistic masterpieces in the Chamber of State has always been seen as a duel between the two painters. The alleged rivalry was also put into words by Arnold Houbraken in his *Groote Schouburgh* (1718-1721). In it, the author sketches a picture of Janssens' character that is diametrically opposed to that of the industrious Rubens. Janssens "went daily for a walk with his new wife, and nourished idleness, which ate away at him like a moth, whereby his household was in a bad state, finally fell into poverty, while he wandered about drunkenly, consoled himself in the taverns, and washed away the difficulties with drink." If there was indeed any question of artistic competition between two 'rivals', then it was highly uneven: although it is true that *Scaldis and Antverpia* forms the high point of Janssens' oeuvre, the *Adoration of the magi* was merely Rubens' starting point in a career that would have a previously unheard-of impact on the artistic life of the city on the Scheldt.

Nico Van Hout

Peter Paul Rubens

Siegen 1577 - Antwerp 1640

Venus Frigida
Panel, 142 x 184 cm
On the stone: *P.P. Rubens F. 1.6.1.4.*
Purchase 1888
Inv. 709

"Sine Cerere et Libero [Baccho] friget Venus". Without Ceres and Bacchus, Venus will freeze. Without bread and wine, there is no love. Rubens let himself be inspired by these winged words while painting his frozen Venus, *Venus Frigida*. The saying comes from a comedy by the Roman playwright Terence (185-159 B.C.), which was cited by writers and depicted by painters many times since the Renaissance. The moralists of the time also turned the meaning around thusly: whoever would live a life without voluptuousness must eat and drink in moderation.

The cold-benumbed goddess sits in the foreground with her back to us. Her gaze betrays dejection and apathy. Even Amor, who usually inflames many a heart with his arrows, shivers from the cold and tries to protect himself with a piece of Venus' loincloth. His quiver lies on the ground. In the background creeps a satyr who wants to startle the chilled pair and arouse them from their sleep. He bears a horn of plenty filled with ears of grain, grapes and other fruits intended to reawaken their lust for life.

Rubens did not paint the goddess from life. Drawing from nude models was not yet self-evident. Like other artists, he copied many poses from ancient and renaissance statues which he conveniently incorporated into his own compositions. In this case, he was inspired by the back side of a marble statue that he had admired in the Palazzo Farnese during his stay in Rome. Before Rubens, Maarten van Heemskerck had also shown interest in this work and had made a pen sketch of it. Nevertheless, *Venus Frigida* is not in the least made of stone. With a broad brush the artist has blended transparent and opaque fleshtones into each other to form a smoothly amalgamated surface. In the body of the paint we discover a highly nuanced mingling of tints – red, orange, yellow and blue – which reproduces the qualities of shivering skin.

The panel belongs to a small group of paintings that Rubens signed and dated 1614. The figures originally took up nearly the entire surface of the painting. The picture-filling composition was afterward (possibly in the eighteenth century) enlarged to its present dimensions on the left and right sides, as well as along the upper edge. In this way the image acquired more breathing room, as it were. The piece added to the left side is considerably larger and depicts a darkened landscape.

Nico Van Hout

Peter Paul Rubens

Siegen 1577 - Antwerp 1640

The prodigal son
Panel, 107 x 155 cm
Purchase 1894
Inv. 781

In the parable of the prodigal son, Luke (15:11-32) tells of how the youngest of two sons asks his well-to-do father for his inheritance, travels to a distant country and there squanders his money. A famine breaks out and the young man turns to tending pigs in order to survive. Even the slop which is fed to the pigs is denied him. The young man repents and returns home, where his father receives him with open arms and offers him forgiveness.

On this panel the prodigal son is depicted at the lower right. He looks pleadingly at the stable-lass in hopes of getting some of the food intended for the pigs. A stable-boy, hidden behind a supporting beam, observes everything with the requisite suspicion. The title of the work refers to only part of the scene, but this small group attracts attention by means of lighting. A play of horizontals, verticals and diagonals ensures that the eye of the viewer scans the entire surface of the panel. The gaze is drawn in via the diagonal wooden beam at the lower left and is detained by the horses and their groom, the figures with candles, the cows, the hungry pigs and piglets that press up to the trough where the maid and the prodigal son are also portrayed.

The *Prodigal son* is painted on a human scale, and not only because of the format used, which appears quite suitable for a room in a house. A relaxed atmosphere reigns throughout. The religious theme is not dramatically presented as it would be in a baroque altarpiece. There is a natural transition from interior to exterior via a more open part of the stable and a landscape in which dusky red colours the sky. The horses are brought to their watering-place before night sets in. The dark interior is lit by a few candles. All sorts of farming implements are strewn about nonchalantly.

Rubens experienced visible pleasure in painting this scene. Most of his landscapes were created during the last decade of his life. This work, which should certainly be dated earlier, always remained in his own collection, as is reported in the inventory of his estate. However great the appearance of reality may be, this is not an actual stable from Rubens' time. He recorded many of the motifs in the stable – the farming implements, the animals and the activities of the farmers – in sketches made in the countryside. Numerous sketches have been preserved of country women, tools, trees and carts. These drawings were kept in the atelier and were sometimes reused in other compositions and paintings. Rubens had already used the drawing of the farmer's cart, for example, in another painting. Here, the Antwerp master displays his talent and does so in an incredibly exact way, because he observed and drew all of the parts of the painting separately. The work is not dated but can be situated around 1618.

Els Maréchal

Peter Paul Rubens

Siegen 1577 - Antwerp 1640

The adoration of the magi
Panel, 447 x 336 cm
Original collection
Inv. 298

After his return to Antwerp, Rubens became one of the most celebrated and sought-after artists of his time. In the twenties, he received commissions for major series and important altarpieces. During this decade, he was enormously prolific and was moreover charged with various diplomatic missions.

A colorful procession enters a vaguely-defined space where a child is shown to the surprised onlookers. However spontaneous and confidently painted this panel may appear, Rubens realizes a complex iconographical program here. Mary shows her newborn child to the three kings, who come in bearing gifts. They are accompanied by a lively retinue of servants, soldiers and visitors of various skin-colours. They come on foot, on horseback and even mounted on the backs of two camels. Gaspar kneels and offers incense. Arrayed in a red mantle, the old king Melchior offers gold, and behind him stands the Moorish king Balthazar in a turban and green robe. He brings myrrh for the newborn. The three kings symbolize all of the countries and peoples that have been informed of the birth of Jesus, who is the Messiah. With their gifts they honour him as God, as king and as a human being. The event does not take place in a traditional stable but in the ruins of an ancient building. This ruin refers to the palace of king David, from whose lineage the Messiah would be born, according to the Bible. The ox depicted in the foreground serves as a metaphor for the faith of the kings, in contrast to the unbelief of the Jews, which is symbolized by the ass. Even the spider in her web at the right between the crossbeams is an allusion to the evil that will be defeated by Jesus the saviour.

Although Mary and Jesus are not depicted centrally in this scene, they nevertheless receive a great deal of attention. In the group of kings and their followers, a movement delineates itself that proceeds directly in the direction of Mary; moreover, all of the figures direct their gazes at the Christ-child. Joseph fulfils only a modest role and is cut off by the framing of the picture. This terribly dynamic painting from the period of the high baroque shows great spontaneity. Details are not finished and the loose brushstrokes give it a decorative flourish. The eminent Rubens scholar Frans Baudouin noted that in this instance Rubens has applied a technique usually associated with his oil sketches on a large scale. The colouring, in all its clarity, gives the painting great expressiveness.

Today, the altarpiece hangs in a museum, but it was originally intended for the high altar of the abbey of St Michael in Antwerp. It was commissioned in 1624 by Matthias Yrsselius, abbot of the Norbertine abbey, and was completed by Rubens in 1626. During the French occupation this work, along with many other altarpieces, was taken to Paris. In 1815 it was returned to Antwerp. Because the abbey had been abolished in the meantime, it was entrusted to what was then the museum.

Els Maréchal

Peter Paul Rubens

Siegen 1577 - Antwerp 1640

Jan Gaspar Gevartius
Panel, 119 x 98 cm
Sir Philippe Arnold Louis Joseph Gillès van 's-Gravenwezel Bequest
Inv. 706

The secretary of the city of Antwerp, Jan Gaspar Gevartius or Gevaerts (1593-1666) is represented here in three-quarter length, sitting in an armchair at a writing-table. On the table stands a bust of Marcus Aurelius. The presence of the bust of Marcus Aurelius says something about the place Gevartius occupied in society. The ideals of the times were inspired by the culture and literature of Antiquity. It so happens that Gevartius also wrote an unpublished work on Marcus Aurelius, who was not only emperor of Rome but also a philosopher.

Gevartius and Rubens were close friends. When Rubens stayed abroad for long periods of time on account of his diplomatic missions, as he often did, he entrusted the humanist Gevartius with the education of his eldest son, Albert. As secretary of the city, Gevartius was responsible for the organization of official festivities in Antwerp; as an eminent humanist, he was likewise answerable for the Latin inscriptions that went along with them. In this context it should be mentioned that he collaborated with Rubens on the occasion of the Joyous Entry of the cardinal-infante Ferdinand in 1635.

The conventional pose of the portrait is disrupted and enlivened by the fact that the sitter looks at the viewer. He writes in a manuscript with a quill pen and has just interrupted his work. He wears a black tabbard with which the starched white pleated collar contrasts. His hands are decoratively set off by fine white cuffs. The learnedness of the man is coupled with distinction. It is a sober portrait of a man comparable to that of Ludovicus Nonnius, another humanist who belonged to the circle of Gevartius, Rockox and Moretus. In the limited space, a few books are visible, from which one can make out the profession or interests of the sitter.

In all probability this work was commissioned by Gevartius. There is a portrait of the father of Gevartius attributed to Cornelis de Vos which very closely resembles the present one by Rubens. Both portraits undoubtedly belong together. The real question, then, is which work was painted first. Did Cornelis de Vos make a pendant for Rubens' work, or did Rubens take on the archaic style of De Vos in order to end up with a well-matched pair of portraits? According to the Rubens scholar Hans Vlieghe, the undated, unsigned portrait can be dated to 1628 at the earliest. That was at any rate the year in which Gevartius was working on his study of Marcus Aurelius.

During the period of great cycles and colourful altarpieces, Rubens painted this beautiful portrait of his friend. For the most part, the museum possesses religious paintings by Rubens. The portrait of Gevartius and the *Venus Frigida* form a happy exception to this rule.

Els Maréchal

Cornelis de Vos

Hulst 1584/85 - Antwerp 1651

Abraham Grapheus
Panel, 120 x 102 cm
Below left: *C. DE Vos, F. Anno 1620*
Original collection
Inv. 104

Cornelis de Vos was a renowned portraitist. This half-length portrait of Abraham Grapheus is one of his first great realizations. Grapheus, or De Graef, was admitted to the guild of St Luke as a painter in 1572. It quickly became apparent that his qualities lay elsewhere. He made himself useful as the 'knaep' or factotum of the guild and in this capacity enjoyed the esteem of Rubens, Jordaens, Van Noort and Jan Brueghel. In this very particular portrait the older man is depicted with a few attributes that evoke the seventeenth-century atmosphere of the Antwerp guild of St Luke. He is hung with the 'breuken' of the painters guild, a series of silver plates fastened on an ornamental chain, which were normally worn by the 'head man' of the guild. The head of an ox, symbol of Saint Luke, patron of the guild, is visible on one of the silver plates. Underneath it the arms of the guild are represented. The chalice in Grapheus' hand, on which the portraits of the legendary role models for the master painter – Apelles, Zeuxis, Raphael and Albrecht Dürer – are depicted, can probably to be identified as a cup given to the guild in 1549 by several prominent Antwerp families. The knob of the lid is also shaped like the head of an ox. The chalice on the table to the right is crowned by *Pictura*, the personification of the art of painting. This cup, which was made from a design by Sebastiaan Vrancx (1612), was paid for by various Antwerp notables, including Cornelis van der Geest, a prominent merchant and patron of the arts. In contrast to the portrait, the precious silverwork of the wealthy guild was not returned to Antwerp by the French in 1815. De Vos probably gave this portrait to the guild on the occasion of his election as dean in 1619.

Abraham Grapheus and his attributes were undoubtedly painted from life. De Vos was able to model the head of the aged man, with his staring gaze, deep wrinkles and curling gray hair, in a plastic way using broad strokes. According to Katlijne Van der Stighelen, Grapheus' averted gaze, atypical for De Vos, can be associated with earlier portrait studies of Grapheus. The factotum of the Antwerp guild of St Luke, with his characteristic head, was a popular model for Van Dyck and Jordaens, among others.

De Vos not only painted portraits and history paintings, but also genre scenes. In addition to being an artist, he was also active as an art dealer, which is confirmed by various documents.

Sofie Van Loo

Frans Francken II

Antwerp 1581 - Antwerp 1642

The cabinet of Sebastiaan Leerse
Panel, 77 x 114 cm
Lower right: *F. FRANCK IN. et F.*
Gift of Artibus Patriae 1878
Inv. 669

In prosperous Antwerp, the middle classes began to collect art starting around the middle of the sixteenth century. Wealthy merchants and members of the city magistracy imitated the lifestyle of the aristocracy, in which an interest in the arts played a part. Around 1610, the collecting of art led to the creation of a new genre in Antwerp painting, the so-called collector's cabinet.

Frans Francken II played an important role in the development of this subject. He evolved from painting still lifes consisting of works of art and other costly items arranged on tables to the depiction of art collections exhibited in an interior. For the furnishing of his art galleries, he chose actual as well as fictitious collections.

A well-to-do family poses confidently in the most prominent room of their house. By means of a family portrait by Anthony van Dyck (Gemäldegalerie, Kassel), the family can be identified as that of the Antwerp merchant Sebastiaan Leerse, with his second wife and their son, Jan Baptist. The likeness between the people in both paintings, however, is not entirely convincing. Moreover, there is no contemporary inventory of the collection of Sebastian Leerse that could confirm that the paintings here belonged to him.

The art collection represented answers in every respect to the taste of the Antwerp *sinjoor* (as Antwerp citizens were called) from the beginning of the seventeenth century. Small, finely executed works by contemporary South-Netherlandish masters enjoy pride of place. The subjects of the paintings were diverse: biblical and mythological scenes, landscapes, city- and seascapes, still lifes, architecture pieces and genre scenes alternate with one another.

Frans Francken II himself was a productive painter of cabinet pieces. He is also represented in this collection of paintings. In the centre, above the buffet, there is a biblical scene depicting the adoration of the magi that strongly recalls his work. And a painting has been placed against the chair that bears his signature. It depicts Apelles and Campaspe. A popular subject since the Renaissance, it shows the Greek painter Apelles as he portrays the beautiful Campaspe, mistress of Alexander the Great, in the guise of the love goddess Aphrodite. The theme is borrowed from the *Naturalis Historia* by the Roman writer Pliny, who says that Apelles fell deeply in love with Campaspe while he was painting her portrait, which prompted his princely patron to the generous gesture of giving him his mistress as a gift. This antique legend of the honour shown by a king to a painter lent itself well to extolling the status of artists generally. By placing this myth in the cabinet as a painting, Frans Francken II at once pays homage to art, artist and art collector.

Siska Beele

Theodoor Rombouts

Antwerp 1597 - Antwerp 1637

Card players
Canvas, 152 x 206 cm
Van den Bosch - Van Camp Bequest 1847
Inv. 358

In a loosely elaborated interior, two soldiers play a game of cards. The money on the table shows that this is no innocent pastime, but that they are gambling. Blaise Pascal (1623-1662), the French scientist and philosopher, rightly noted that it is not financial gain that counts in such games. If one gives a player the money he can win on the condition that he doesn't play, he is unhappy. If one lets him play, but not for money, he is bored to death.

For centuries, playing cards for money was seen in a bad light by religious institutions and middle-class moralists. The negative consequences of gambling are twofold. On the one hand, one plays away the time that one should be devoting to study, going to church and working. On the other hand, the game is often paired with cursing, fighting, deceit, theft and loss of money and goods. Intensified by tobacco and drunkenness, a catastrophic combination results. It seems as if the older woman on the right is attempting to warn the third soldier of these consequences. In addition, such games of chance were chiefly practiced by barflies and soldiers, who already enjoyed a bad reputation themselves. It is therefore not to be wondered at that playing cards symbolized laziness, greed and strife. A painting with such a theme, then, also has a moralizing function. However, the large format of this painting indicates that it was meant for a well-to-do citizen, for whom aesthetics were probably more important than moralizing content.

Theodoor Rombouts is known as the most important representative of Flemish Caravaggism on account of his reinterpretations of genre scenes with musicians and card-players in imitation of the Italian painter Michelangelo Merisi da Caravaggio (1573-1610). Typical for Caravaggist works are the representation of figures at half-length and strong light effects. The characters move freely in the vaguely described space and often overstep the boundaries of the painting. The card players are portrayed as folkish types, which is a typical characteristic of figures in works by Caravaggio and his followers. The clothing of the soldiers in this painting is borrowed from the costumes of contemporary theatrical performances.

Rombouts' oeuvre consists chiefly of monumental paintings in horizontal format with characters that are developed in an expressive, realistic manner. These paintings, usually with profane themes, were for the most part intended for private individuals and the open market.

Sandra Janssens

Adriaen Brouwer

Oudenaarde (?) 1605/6 - Antwerp (?) 1638

Card players
Panel, 25 x 39 cm
Purchase, Courtebourne sale 1880
Inv. 642

Adriaen Brouwer was probably born in Oudenaarde. In 1626 he was registered in Amsterdam and Haarlem. In the latter city, he is supposed to have been a pupil of Frans Hals. According to the documents, he was a master in the Antwerp guild of St Luke in 1631/32. He remained in the city on the Scheldt until his death. Only around sixty paintings by Brouwer are known, of which only a few bear his signature and none a date. This small oeuvre, however, forms one of the high points in the genre painting of the Low Countries and exercised a great influence on generations of artists north and south.

Shortly after his death, the image of Brouwer as a bohemian, as an artist on the margins of society, had already been created. He "was himself not able, if he had money, to restrain himself from drinking, swilling and foolishness," wrote the artist biographer Arnold Houbraken in his *Groote Schouburgh*, published some eighty years after the death of the artist. It is indeed known that Brouwer was in debt to a number of creditors. Because he couldn't pay his debts in a timely manner, he ended up imprisoned for a while in the Antwerp citadel (the place where the Koninklijk Museum would later be erected!). However, it is not excluded that Houbraken fattened up his biography with a few juicy anecdotes in order to enhance its amusement value. That the subjects of Brouwer's paintings mirror the way of life and milieu of the painter, as Houbraken maintains, overlooks the fact that art and reality do not always coincide. Moreover, there had long been an interested public for images of uncontrolled behaviour like the agression that stems from addiction.

During his Haarlem period, Brouwer still seems to have sought connections with the caricaturial representations and colorful palette of the many Bruegel followers. The panel depicting the *Card players* in the collection of the Koninklijk Museum also draws from these earlier examples. At the same time, the work shows the naturalness and intimacy that would characterize his later paintings. In these later scenes, attention is only attracted by a single red hat, a blue shirt or a green jacket that detaches itself from the surrounding subdued tones. Because he strips his representations of all that is accidental, Brouwer succeeds in immediately fixing the viewer's gaze on what is essential in his painting: a specific facial expression resulting from pleasure, joy, rage or pain.

Nico Van Hout

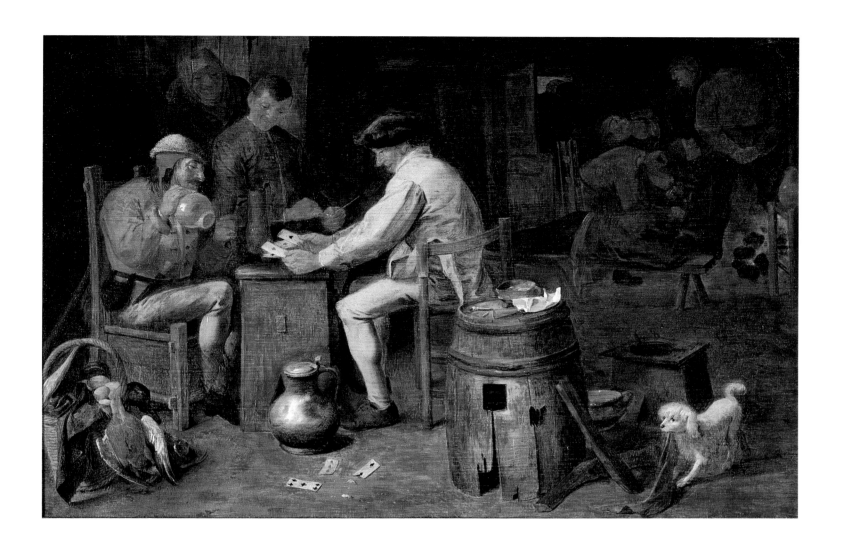

Jacob Jordaens I

Antwerp 1593 - Antwerp 1678

Meleager and Atalanta
Canvas, 152 x 120 cm
Purchase 1905
Inv. 844

The subject of this painting is borrowed from the *Metamorphoses* of Ovid (VIII 260-546). Caledonia was plagued by an enormous wild boar that was sent by the angry goddess Diana, because the king of Caledonia had neglected to bring her offerings. The hunt was initiated by a group of strong and courageous men, among whom was Meleager, son of king Oeneus of Caledonia. Nevertheless, it was the combative huntress Atalanta who first seriously wounded the animal, to the displeasure of Meleager's uncles, who also took part in the hunt. But it was Meleager who finally succeeded in delivering the death-blow to the savage swine. He gave the head of the giant boar to his beloved Atalanta, but his jealous uncles attempted to rob her of this hunting trophy. For this, Meleager drew his sword to kill them. The further events of the story are not portrayed here: Meleager killed his two uncles, thereby provoking his mother's rage. Because of the curse she placed on him, he died a gruesome death.

Jordaens chose the critical moment in which the hunters offer resistance, Meleager draws his sword and Atalanta looks at him with both hope and fear. The deadly stroke is still to come but the tension is already visible. The dramatic weight of the whole event is plastically portrayed by the painter. The characters are seen from below and stand in the foreground, whereby they form a screen in front of the viewer. People and animals are cropped by the framing of the picture. By this means, the artist gets the chance, as if effortlessly, to draw attention to what is essential. By means of very intense lighting, Jordaens succeeds in accentuating and above all giving shape to the two main characters.

This painting is situated around 1617-1618 on stylistic grounds and is based on a composition by Rubens, preserved in the Metropolitan Museum in New York. An oil sketch by Jordaens from the collection of the prince of Liechtenstein is viewed as a preliminary study for the Antwerp painting. In the first half of the 1620s, Jordaens painted the same theme again, but in addition chose to represent the continuance of the story. This painting, preserved in the Prado in Madrid, was later enlarged by him.

Jacob Jordaens lived and worked in Antwerp his entire life. Although he did not make the customary trip to Italy, he was able to admire the work of Italian masters in Antwerp. After the death of Rubens (1640) and Anthony van Dyck (1641), he became the most important artist in the Southern Netherlands.

Els Maréchal

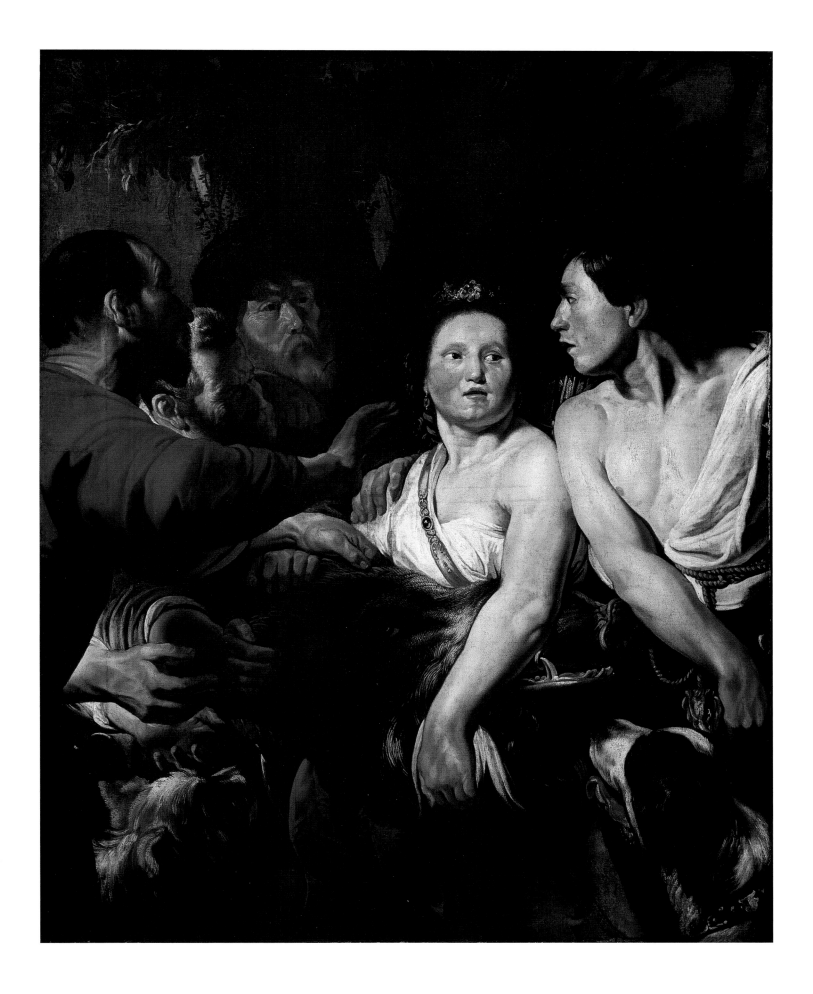

Jacob Jordaens I

Antwerp 1593 - Antwerp 1678

As the old sing, so the young pipe
Canvas, 128 x 192 cm
Above, in the center: *J. JORDE. FECIT 1638*
Purchase 1883
Inv. 677

Around the central and almost radiant female figure, a domestic scene plays itself out. To the right, grandmother puts on her glasses in order to be able to sing along with the text of the song. The grandfather, in an armchair on the left side, sings along with gusto, songbook in hand. The father squeezes a bagpipe under his arm and blows on the instrument with all his might. Encouraged by their elders, the little ones also make their contribution. On the mother's lap sits a rosy baby blowing on the whistle of its rattle, while big brother, leaning on grandpa, plays a recorder with great concentration. Even the dog pricks his ears and is absorbed by the music. The life-like characterization of the figures is further enhanced by the attractively laid table.

At the top of the work is a proverb in a cartouche: "As the old sing, so the young pipe". The proverb depicted appears in Jacob Cats' *Spiegel van de oude en de nieuwe tijd (...)*, published in 1632. The meaning of this genre scene is fairly clear: children imitate their parents. The painting, signed by Jacob Jordaens and dated 1638, is the earliest known version of this popular theme par excellence, which was drawn and painted by the painter several times.

Did Jordaens depict acquaintances from his surroundings on this canvas? In the old man, we recognize Adam van Noort, master and father-in-law of Jordaens. Van Noort was drawn from life in various studies by Jordaens, so that it is not difficult to identify him here. There is less certainty with respect to the other figures. It has been suggested that the bagpipe player is Jordaens himself, but his self-portraits reveal a different physiognomy. But there are study drawings of various other figures, including the bagpipe player.

This lovely family concert shows us Jordaens at his best. It is an attractive work in terms of its use of colour because of the refined nuances of hue and light. The hard forms and strong contrasts between light and dark of his earlier paintings are softened here and show the hand of an experienced painter. All of the figures, portrayed at half-length in a shallow room, form a distinct whole.

According to Roger d'Hulst, the eminent Jordaens specialist, this work testifies to the exuberant lust for life and middle-class wisdom of Jordaens, who with such subjects answered to the tastes of prosperous citizens who preferred such folkish scenes.

Jordaens left behind a sizable oeuvre after a long and productive career. Among other things, he worked with Rubens and had an extensive workshop. He worked for the middle classes but also for the church and the civil government, and received large commissions from royal and aristocratic circles, through which he acquired international renown.

Els Maréchal

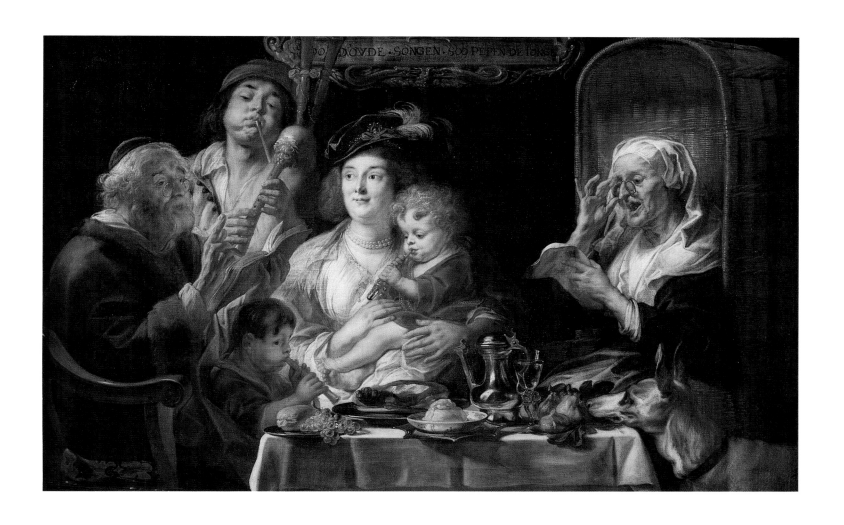

Clara Peeters

Antwerp ca.1590/1594? - Antwerp ca. 1640/1657?

Still life with fish
Panel (oak), 34.8 x 50 cm
Lower left: *Clara P.*
Purchase 1905
Inv. 834

Clara Peeters can be looked at as one of the founders of the genre of still life. On the basis of her earliest signed works (1607-1611), she is viewed as the first painter of bird and fish still lifes. The art historian Henri Hymans wrote: "Clara is an artist of the highest level, whose works were not surpassed by other representatives of the genre that she practiced".

Clara Peeters appears to have known considerable success as a painter of still lifes among the buying public of the time. This is evident for the most part from the numerous copies and forgeries of her work, rather than from the data concerning her life. Clara Peeters is not recorded in the registry of members of the guild of St Luke, and her birth and death dates are the subject of dispute. The baptismal and marriage registries of the Antwerp church of St Walburgis record a Clara Peeters, daughter of Jan Peeters and Elisabeth Vleuterinck (?), who was baptized on May 15, 1594, and married to Henricus Joosten on May 31, 1639. However, it is not certain that this Clara Peeters is the painter, because the name Clara Peeters appears frequently in Antwerp records. If this is in fact the case, then she would have painted her first still lifes (signed and dated 1607 or 1609) at a very tender age. Her life remains the subject of speculations, hypotheses and uncertainties. Her death is not recorded in a single document.

After the restoration of *Still life with fish* in 1999, it appeared all the more that Clara Peeters was a virtuoso painter. In this fish still life, her favourite theme, various painting techniques can be distinguished. The carp in the bowl, for example, is smooth, depicted with very thin layers of paint. The langoustines, by contrast, are painted with thick, pastose layers of paint. Through a combination of techniques, Peeters achieved a notable three-dimensional effect in the depiction of space and depth.

By looking closely, it is possible to discern two signatures on the painting. Above the present signature on the lower left, a second one is visible. After she had applied the original signature, Peeters lowered the level of the table, whereby it was largely covered by the new layer of paint. The *National Museum of Women in the Arts* in Washington possesses a painting by Peeters with a similar composition. In that painting, too, there is a terracotta colander with a carp and a pike, and smoked fish, shrimp and oysters depicted on the table. Both works can be dated to around 1620, given that they exhibit stylistic and compositional similarities to other works from the same period. These works are monochromatic and have a lower horizon in comparison to the bird's-eye-view prevalent in her early works.

Sofie Van Loo

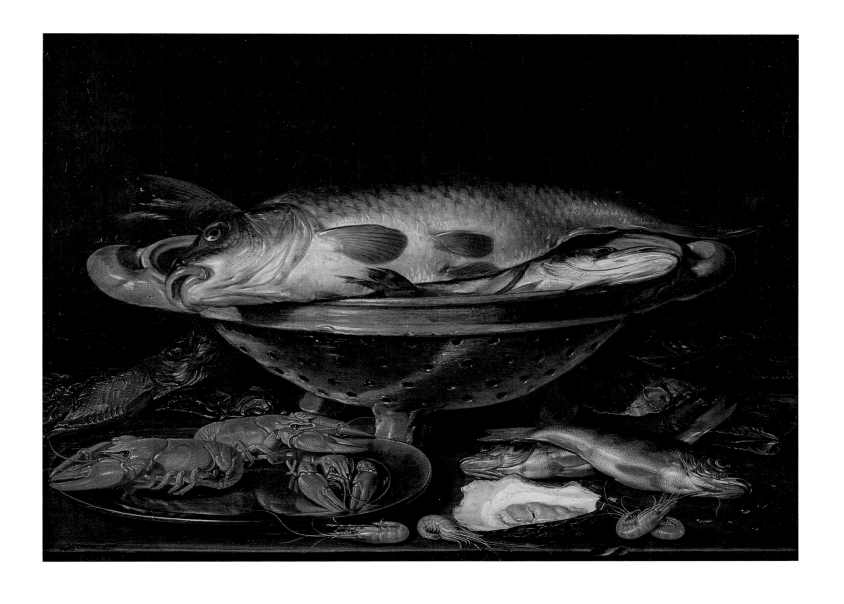

Anthony van Dyck

Antwerp 1599 - London 1641

The Lamentation
Canvas, 115 x 208 cm
Original collection
Inv. 404

The body of the dead Christ lies almost fully extended, his head resting on Mary's knees. She spreads her arms in a hopeless gesture. Carefully, John lifts the hand of Jesus. He draws the attention of the two angels to the wounds caused by the nails with which Christ was hammered to the cross. Everything takes place close to the viewer. The five figures fill nearly the entire surface of the painting, so that there is hardly room for either the rocky outcropping or the dramatically clouded sky. The boulders behind Mary are symmetrically repeated in the forms of the angels' gray wings. The body of Christ is fully adapted to suit the wide, narrow format of the canvas. The work was probably altered over the course of its history. Prints after the painting show that there were originally broad borders above and below.

The entire event is baroque in spirit, but preserves a high degree of intimacy by means of the limited number of figures and by its sober location. The painting comes across as cold and sombre. Together with its cool colouring, this suits the sorrowful event perfectly. The blue tone of the cloth on which Christ's body lies is repeated in the clouds. For Mary's head covering, John's garments and those of the angel, Van Dyck has used warmer tones with subtle differences of light and dark.

This canvas was commissioned by the Italian abbot Cesare Alessandro Scaglia, count of Verrua. Scaglia carried out various diplomatic missions but was also a businessman and art dealer. During his ambassadorship in London, he served the interests of the Spanish king Philip IV. In 1639, the gravely ill Scaglia came to Antwerp. Because he wanted to spend his last years in the cloister of the Franciscan friars there, he had an altar erected. Anthony van Dyck received the commission to paint a lamentation of Christ that was to hang above his grave in the chapel of Our Lady of the Seven Sorrows. Scaglia was a patron of Van Dyck and gave him several commissions. The abbot possessed seven paintings by the artist and had his portrait painted by him several times.

Anthony van Dyck is, along with Rubens and Jordaens, the third great master of Flemish painting in the seventeenth century. The personal pictorial language and innovative manner of Rubens spoke to him quite compellingly. Rubens, for his part, saw him as his best pupil. They worked closely together on a number of important commissions. Van Dyck was chiefly active in the Southern Netherlands, Italy and England. He travelled to England in 1620, where he received commissions from the king and the nobility. Throughout Europe he enjoyed enormous fame as a portraitist.

Els Maréchal

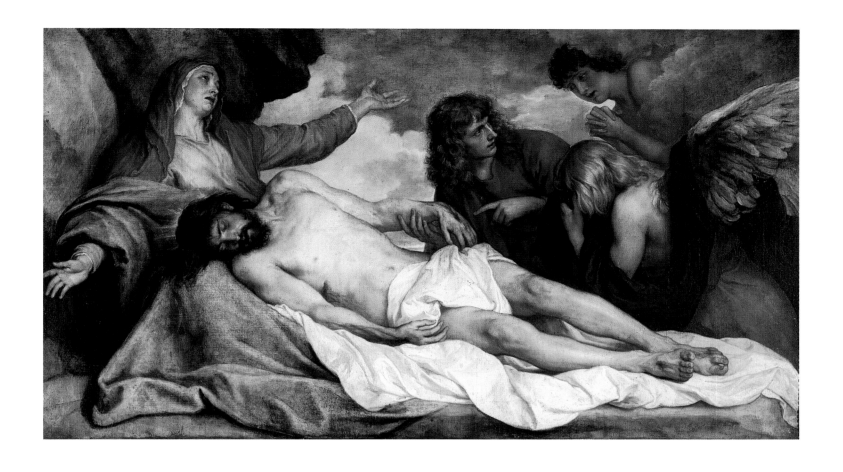

Frans Snijders

Antwerp 1579 - Antwerp 1657

Flowers and fruit
Canvas, 117 x 194 cm
Gift of baron Ph. A. de Pret de Terveken 1819
Inv. 893

A rich store of fruit, vegetables and fresh provisions, then customary on the menu in better-situated circles, is piled on the table and the ground in decorative bowls and simple wicker baskets. The table with the still life is placed parallel with a greenish-grey wall on which two rectangles can be seen. Nuanced reds, ochres and greens make for warm, full colouring. This narrative representation, which depicts the pleasures of the table, exhibits a clear composition. The scene is enlivened by what is happening, so that it becomes more than a 'still life' alone. Three animals, distributed evenly across the canvas, attract the viewer's attention. There are no people in the room, but this is richly compensated by the animals. A dog, a monkey and a parrot with a colorful tail have thrown the storeroom into considerable confusion. Small monkeys, like squirrels, were beloved house pets of the well-to-do. Possession of a parrot was also associated with high social status.

Snijders often reused motifs that he had already applied successfully in other works. We recognize the small monkey, seen here holding fast to his loot, from other paintings, just like the vase with roses or the wicker basket. Notably, the fruit is not mingled together but is represented separately, by sort, which causes the painting to come across as less baroque. For the patron, such a storeroom constituted an exterior sign of the old, noble wealth associated with the possession of an estate, as Susan Koslow notes in her monograph on Frans Snijders. Fruit cultivated in the orchards of the rich symbolized an idealized country life. Vegetables, with the exception of asparagus and artichokes, were more common and belonged rather to the farmer's meal. The apricots, peaches, quince, strawberries, medlars and grapes are all represented here as just having been harvested. It is therefore impossible that this scene depicts an actual still life, because these fruits do not grow and ripen in the same season.

The subject of the storeroom continued to interest Snijders for a long time. The compositional scheme was fixed from around 1618 and was applied repeatedly. The changes that would later be carried out – the addition of new elements and the enlarging of the foreground space – do not change anything essential. Koslow situates this storeroom in Snijders' later period (1640-1657). This period is characterized by simplified compositional schemes and a pictorial way of working using clearly discernible brushstrokes.

Frans Snijders was one of the most important representatives of animal painting and the baroque still life in the Southern Netherlands. He associated with other prominent painters. In addition to being friends with Jan Brueghel the Elder, he was the brother-in-law of Cornelis de Vos and regularly worked with Rubens. He had an extraordinarily successful career as a painter and was quite prolific.

Els Maréchal

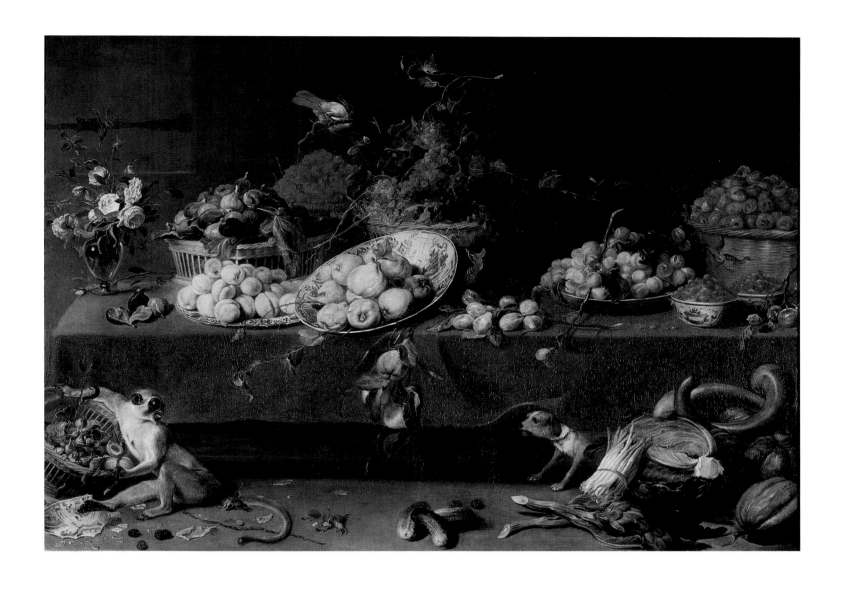

Frans Hals

Antwerp 1582/83 - Haarlem 1666

Stephanus Geraerdts, Haarlem alderman
Canvas, 115 x 87 cm
Purchase 1886
Inv. 674

The Flemish textile worker Franchoys Hals probably predicted the fall of Antwerp, because even before 1585 he had already moved to Haarlem with his family. This Dutch city received political refugees and capable tradesmen with open arms. The Hals family produced two important artists: Dirk (Haarlem 1591 - Haarlem 1656) a genre painter of note, and Frans, who would grow to be one of the most trend-setting portrait painters of his time.

Stephanus Geraerdts belongs to the most beautiful works of Frans Hals and is undoubtedly the most important North-Netherlandish painting in the collection of the museum. It is presumed that Hals painted this work around 1650-52. Geraerdts can be identified by means of the coat of arms in the background. He fulfilled the functions of alderman and councillor in Haarlem and moved into a fine house on the Keizersgracht in Amsterdam. Hals portrayed the dignitary in a highly relaxed manner. Dutch regents usually had themselves immortalized in much stiffer poses and generally cast a serious glance at the viewer. Geraerdts' smile was recorded in a moment. The painter probably sketched the facial features of his model with a brush, painting directly on the canvas. At any rate, no preliminary studies by Hals are known.

"They say, that he had the habit of laying in his portraits thickly, and meltingly, and afterwards applying the brushstrokes to them, saying: *Now what is recognizably of the master has to go in It*", so wrote Arnold Houbraken in his *Groote Schouburgh*. Geraerdts' sleeve and hand belong in every respect to the most virtuosic passages in baroque painting. With swift, straight brushstrokes the artist was able to create the illusion of a deep-black coat with gold embroidery.

Geraerdts is not laughing here for no reason. The painting originally formed the left half of a portrait pair, which was separated in 1886. The right portrait ended up in a private collection. That painting portrays Stephanus' wife Isabella Coymans, who looks over at her husband archly and offers him a rose. Unfortunately, this moment of tenderness can only be recalled today by means of reproductions.

Nico Van Hout

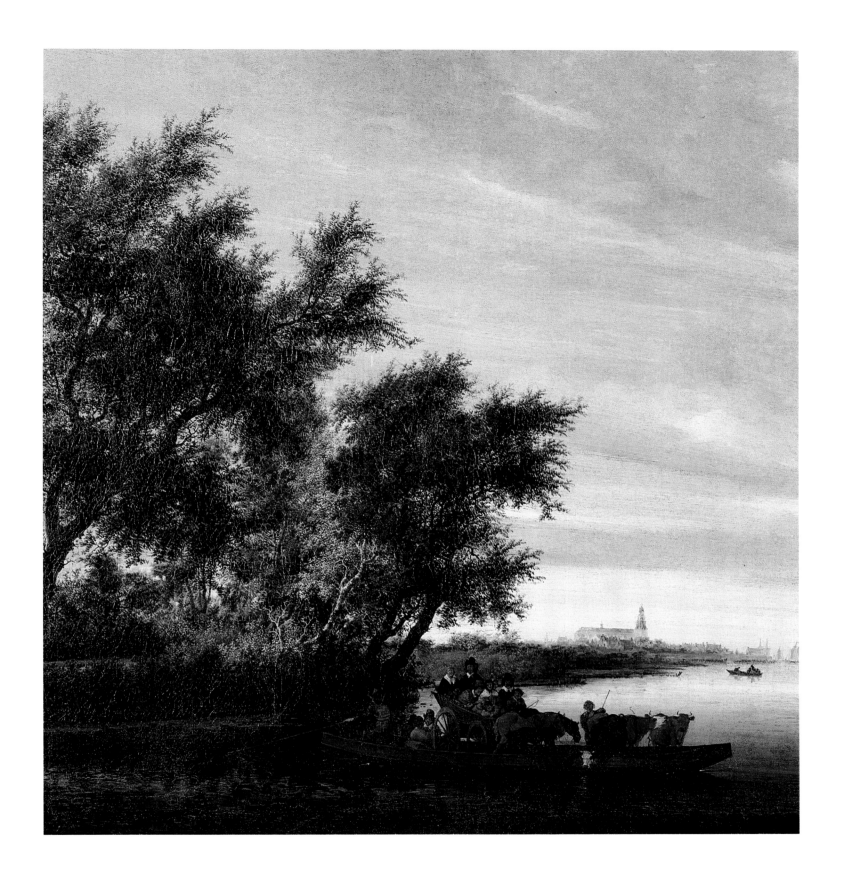

Floris van Schooten

Haarlem ca. 1585/90 - Haarlem 1656

Dutch breakfast
Panel, 50 x 82 cm
On the blade of the knife: *FVS*
Purchase 1905
Inv. 836

In the beginning of the seventeenth century, the first full-fledged generation of still-life painters appeared in the Netherlands. Haarlem was an important centre for this activity, and Floris van Schooten was active there. More than a hundred paintings by him have survived.

The stylistic development of Van Schooten runs parallel to the development of Netherlandish still-life painting in the first half of the seventeenth century: market and kitchen pieces, still lifes with kitchen utensils, 'set tables', monochrome 'breakfasts' and 'banquets' with a subdued palette, simple fruit still lifes. This work shows characteristics of this evolution: the point of view is lower than in earlier works, the color is less exuberant, the number of objects is reduced and the composition has been made more sober. Van Schooten's still lifes often have approximately the same dimensions, with an outspoken preference for panels with a wide format.

In the centre stands a plate with a blackberry tart. Around it, the other objects are arranged in a circle. However, it is more a display of foodstuffs than the depiction of an actual meal. The wooden table runs parallel to the lower edge of the painting. The starched white table linen with the embroidered edge could have been made in Haarlem.

The light falls diagonally across the table from the front left side of the picture. The carefully worked-out play of reflections and shadows strengthens the illusion of depth. The projecting plates, the handle of the knife, the bunched folds of the tablecloth and the apples on the wooden tabletop all cast very distinct shadows, which further strengthens the impression of depth. The surface of the smoked ham on the left and the skins of the fruit are shining. The green glass of the glass of white wine and the metal of the salt-cellar show innumerable small reflections of light. This enlivens the composition. Observe, too, the convincing reflection of the bread in the base and edges of the tin plate, and the painstaking reproduction of the colour gradations, curves and bruises on the apples. The background is left vague.

The white porcelain plate holding pats of butter, which has a border decorated with blue peacock feathers and swimming swans, also appears in other works by Van Schooten. The cylindrical salt-cellar with engraved decorations rests on three feet in the form of reclining lions, of which two are visible. The salt is not the fine-grained variety we know today, but is rougher, flakier. On the blade of the knife, the artist has painted his monogram: FVS.

Cheese was a popular theme in the first half of the seventeenth century. The large, yellow cheese is probably from Gouda. The smaller, darker, riper cheese on top of it appears to be from Edam. The cuts made by a knife are skilfully portrayed, just like the cracks resulting from age on the uppermost cheese. Van Schooten liked to display stacks of cheese. Here, the cheese dominates the entire right side of the image.

Cheese and salt together could refer to the recommendation, well-known at the time, that salt served as a means of opening the stomach and cheese as a means of closing it. Cheese and butter together indicate intemperance. Eating these two foods together was condemned as excess ('Zuivel op zuivel, is 't werk van den duivel': or, 'Dairy with dairy is the devil's work').

Peter Rogiest

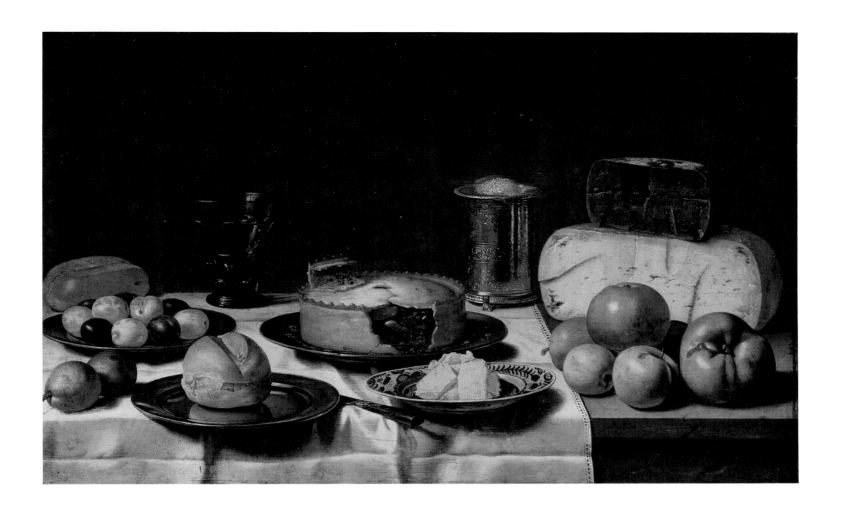

Erasmus Quellinus II

Antwerp 1607 - Antwerp 1678

Jan Fijt

Antwerp 1611 - Antwerp 1661

Portrait of a young boy
Panel, 136 x 103 cm
Baroness Adelaïde Van den Hecke-Baut de Rasmon Bequest 1859
Inv. 407

The title is indeed correct. Here, it is not a girl who has been portrayed but a boy, although to our modern eyes it seems unusual for a boy to be running around in a blue damask dress. The dress is, moreover, depicted with great care. For this reason the picture is also a source for the history of children's clothing. In earlier times, boys wore long dresses until they were six or even seven years old. But there was a difference in the clothing styles for girls and boys. The kind of soft, flat white collar with two tassels like the one worn by our young hunter was worn by boys, as were the large ribbon bows at the waist and the diagonally placed cap with an ostrich feather. The two hunting dogs, a spaniel and a greyhound, are also male attributes. The female sex had other occupations and would have been portrayed with a lap dog instead.

The city silhouette that can be discerned in the distance may be identified as Antwerp. The boy probably lived in Antwerp, where the artist also lived and worked, but precisely which child has been depicted is not known. Since hunting with falcons was previously the privilege of the nobility, one could conclude that we have a noble boy before us here. But that does not help us further with the identification because customs change, and the bourgeoisie often sought to imitate the nobility by taking on their habits. The author Van Luttervelt saw the small boy, adorned with a falcon with a red hood and a falconer's bag on his hip, as above all the portrait of a little bourgeois gentleman. The motive for commissioning such a portrait was probably the parents' pride in their son. Sons were portrayed somewhat more frequently than daughters.

The painting was given to the museum in 1859 and belonged to the Van den Hecke-Baut de Rasmon Bequest. Should we seek the sitter's identity there? The panel was not signed or dated. On the basis of costume history, the work can be situated around 1655. Quellinus often collaborated with contemporaries, whereby each could excel in his own specialty. On this panel, he had the animals painted by the renowned animal painter Jan Fijt, who is known as the creator of the Flemish open-air hunt still life. Collaboration between artists had been customary in Antwerp since the sixteenth century. The phenomenon also occurred in the seventeenth century, often among the greatest artists of the time. Indeed, a well-known example is the successful collaboration between Peter Paul Rubens and his friend Jan Brueghel I.

Several portraits by Quellinus II are known, but along with mythological and historical themes, religious subjects are predominant in his oeuvre.

Els Maréchal

Franciscus Gijsbrechts

Active 1672 - 1677

Vanitas
Canvas, 115 x 134 cm
On the table-leg: *F. Gysbrechts*
Purchase 1984
Inv. 5102

Not much is known about Franciscus Gijsbrechts. He was probably related to trompe-l'oeil painter Cornelis Norbertus Gijsbrechts and he – like the latter – worked at the Danish royal court in Copenhagen in the 1670s. Their painting style is closely related, although Franciscus has a more fluid brush-style. The few known works by him are primarily vanitas pieces, such as this one, and a few trompe-l'oeils.

A vanitas is a still life in which a moralizing exhortation is held up to the viewer via the objects portrayed; more specifically, it refers to the uselessness of earthly goods in light of the finality of death. Under the guise of a virtuous message, the painter demonstrates his skill in the depiction of various materials. The viewer can invoke its moral value in order to enjoy the deceptive realism of the image without inhibition. Transitory objects are transformed into timeless art.

In this *Vanitas* the skull is the central element. Its upper jaw rests on a closed book. The mandible and some of the upper teeth are missing. This *memento mori* reminds us of the fact that life is short and death inescapable. The incompleteness of the skull further emphasizes its meaning as a symbol of death and decay. A near-empty hourglass and an almost burned-out candle, its flame guttering, refer to the continual passing of time. The drifting soap-bubbles recall the brevity and fragility of human life. The grievously battered marble table-top is cracked here and there. In light of eternity even the hardest stone is transitory. The remaining objects are associated with all sorts of human activities. The pipe, the paper with tobacco, the musical score and musical instruments (lute, violin, recorder, trumpet) can refer to the pleasures and enjoyments of human life. These are just as fleeting as smoke, and die away just as swiftly as music. Book and reading glasses can refer to the relativity of knowledge and wisdom. The well-thumbed, open folio behind the skull is dog-eared and has torn edges where the pages have been cut. The royal decree with seal and globe may stand for worldly might and riches. Even those who hold power cannot escape from death.

The table is covered with a dark-blue cloth with long fringe around the edges. A pale-red fabric is partially draped over the display. The tones used in the fabrics (and the lute) reappear in the veins of the marble. In the background on the right we discern a bar of red sealing-wax, an ink pot, a quill pen and a candlestick with a nearly exhausted candle. Not only the writing implements but also the books, reading glasses, candle, skull and globe on the table are objects that one typically finds in a study. One might also encounter the skull, lute, globe and books in an artist's workshop. This may signal an additional meaning alongside the vanitas idea. Emphasis has also been placed on the judicious use of one's allotted time.

In Ripa's *Iconologia*, the hourglass is an attribute of 'studio', the practice of the arts. The emphasis on the limited time available can be an encouragement to study and work with devotion and perseverance. This virtue is rewarded: through and in his work the artist will survive and achieve immortal fame. The skull crowned with ears of grain not only contains a reference to the Christian belief in the Resurrection and Eternal Life, but also to the saying 'Ars longa, vita brevis'. The work of the artist thus signals a victory over time and death.

John Michael Rijsbrack

Antwerp 1694 - London 1770

Self-Portrait
Terracotta, 60.5 x 50 x 26 cm
Reverse: (original?) *Mich. Rysbrack / Fecit*
On loan from the Koning Boudewijnstichting 2000

Fortunately there exist engraved and painted portraits of the artist Michael Rijsbrack. By means of comparison with these portraits, this sculpture can be identified as a self-portrait. In a painted portrait by John Vanderbank, preserved in the National Portrait Gallery in London, the artist even wears the same domestic head covering. This terracotta is a good likeness, depicted in a natural style. The artist has portrayed himself as a man who is withdrawn and at the same time relaxed. The portrait's lively character is increased by the slightly opened mouth and the play of light and shadow. The realism of it is so thoroughgoing that one even finds an iris and a pupil in the eye. One notices a sense of precise detail in the depiction of the brushy eyebrows and the clothing, on which even the buttons and buttonholes are distinctly visible. The artist wears a shirt, a jacket, and a cape draped nonchalantly over his shoulder. His arms are minimally indicated and the socle is hidden beneath a cascade of folds. In all its simplicity, it is nevertheless possible to speak of a refined finish, which testifies to the knowledge and mastery of the sculptor.

Sculptors often sketch out a preliminary drawing first and afterwards make a modello in order to have a precise idea of the definitive portrait or monument in mind. For this purpose, malleable materials like clay and wax were generally used. They allow the artist to shape the material entirely in accordance with his wishes. Is the terracotta portrait of Rijsbrack a sculpture in its own right, or is it a design intended for carving out in a more lasting material like marble? Although there is no trace of a marble version, the sculpture seems to have been executed as an independent work of art. It was probably intended to be placed against a wall, because the back is left open.

Michael Rijsbrack belonged to an Antwerp family of artists. He probably received his education between 1706 and 1712 with the well-known Antwerp sculptor Michiel van der Vorst. With his brother, Pieter Andreas, he left for England in 1720. He enjoyed considerable fame there and is moreover viewed as one of the great masters of English sculpture in the eighteenth century. He made numerous reliefs after antique portraits with an unconstrained demeanour, received commissions for funerary monuments and realized many portrait busts. After 1745 his sculptures were less in demand in England, although this in no sense reflects on their quality. This *Self-portrait* is one of the few works by him still in Belgium.

Els Maréchal

Henri Leys

Antwerp 1815 - Antwerp 1869

Albrecht Dürer visiting Antwerp in 1520
Panel, 90 x 160 cm
Lower right: *H. Leys f. 1855*
Purchase with the support of Artibus Patriae 1931
Inv. 2198

On Sunday, August 19, 1520, the great procession of Our Lady went out into the city. The famous German artist Albrecht Dürer (1471-1528) followed the nearly two-hour pageant with great interest. In his travel journal, he noted everything in detail: the masses of people, the festive atmosphere, the splendid costumes, the musicians and their instruments, the accompanying torches, the parade of trade associations, guilds and brotherhoods, the worldly and spiritual authorities and the decorated wagons with scenes borrowed from the Bible and the lives of the saints. "I have seen more than I can tell in one book," he concluded.

It was this diary fragment that inspired Henri Leys in 1855 to make a painting dedicated to the artist he so much admired. Under the awning of the inn 'Engelenborch' on Wolstraat, Dürer observes the church procession. With his costly mantle and long, curly hair, he is a distinguished presence. It is the moment in which the crossbowmen's guild passes by, respectable and reserved. Quinten Massijs, the most important painter in Antwerp, explains the spectacle to Dürer while the philosopher Desiderius Erasmus indicates something to Agnes Frey, Dürer's wife. Susanna, the servant who accompanied the couple on their journey, seen from behind, is shown in the middle holding a child.

In a review of the Triennial Exhibition in Antwerp in 1855, where Leys introduced his painting to the public, the reporter for the periodical *De Vlaamsche School* praised the qualities of the painting in exuberant terms. He admired the detailed depiction of architecture and clothing, the realism of the postures and facial expressions, the painstaking drawing style and the brilliant colours. Leys' archaising style was particularly appreciated. In his striving for authenticity the artist even imitated the technique of the old masters and painted on a wooden panel.

A real antiquarian, Leys reconstructed a day in Dürer's sojourn in Antwerp. For the necessary historical information he consulted a publication by Frederic Verachter, the city archivist of Antwerp. In 1840 this historian assembled all of the information concerning Dürer's stay in the Low Countries and translated his travel diary. Some parts of the picture, however, are fictitious and even incorrect. The presence of Quinten Massijs and Erasmus at the procession is an invention of the artist. The portrait of Massijs is imaginary, and Erasmus has been given the facial features of Peter Gillis, the Antwerp city secretary whose portrait was painted by Massijs. Leys' painting thus seems historically responsible but is in fact a nostalgic look back at the rich intellectual and artistic life of the city on the Scheldt at the dawn of its Golden Age.

Siska Beele

Gustave Wappers

Antwerp 1803 - Paris 1874

Young artist daydreaming
Canvas, 79 x 63 cm
Lower right: *Gustaf Wappers 1857*
Constant van Ouwenhuyzen Bequest 1890
Inv. 1187

As a young artist, Gustave Wappers rebelled against the cool, rationalized neoclassicism of Jacques Louis David that was then the leading artistic direction in Belgium. Wappers was not an enthusiastic follower of the ideals of antique art. He chose subjects from his own national history and imitated the style of the masters of the sixteenth and seventeenth centuries. With such monumental canvases as *The self-sacrifice of burgomaster Van der Werff* (1829, Centraal Museum Utrecht) and *The September days of 1830, on the Grand Place in Brussels* (1835, Musées royaux des Beaux-Arts de Belgique, Brussels) he caused a commotion and confirmed the triumph of the Belgian romantic school.

Wappers' artistic career flourished. His history paintings traveled throughout Europe. He made the first official portrait of king Leopold I. His paintings were highly sought-after by collectors, both at home and abroad. In 1832 he was a teacher at the Antwerp academy, and in 1840 he was named director of the institution. Under Wappers' direction, the program of instruction was expanded and the building enlarged. The number of students rose spectacularly: from 443 in 1840 to 1,365 in 1848. Foreign students from as far away as America and Java also followed courses there. After a dispute with the minister of Interior Affairs, Charles Rogier, Wappers resigned as director in 1853. He left for Paris, where he successfully continued his career as a painter.

In 1857 he painted the sentimental scene *Young artist daydreaming*. The event takes place in the eighteenth century. At first glance, it seems to be a gallant, charming scene. The light palette of white, light blue and pink recalls airy rococo scenes. On closer inspection, we notice the sombre, brooding gaze of the artist. She has interrupted her painting and stares straight ahead. On the unfinished canvas, three winged little boys are depicted as they tumble through the air. One of them, however, wears a death's-head mask and is about to pierce one of his playmates with an arrow. Winged little boys, armed with bow and arrow, are Erotes or love gods. One of these is Eros, son of Aphrodite and god of love. He causes people to fall in love by shooting his arrows into their hearts. The second figure is Eros' half-brother Anteros, emblem of reciprocal love. But Anteros can also be a symbol of vindictive, scornful love. This is depicted here by the third boy, the one wearing the death's-head mask. The young daydreaming artist thus cherishes an unrequited love and expresses her love pangs in the painting. And what role does the man in the background play? Is he merely her teacher, disconcerted by the discovery of what she has just painted? Or is he himself the object of her love, who only just now comprehends what she feels for him and what he has unwittingly done to her?

Siska Beele

Alfred Stevens

Brussels 1823 - Paris 1906

The Paris sphinx
Canvas, 72 x 53 cm
Above left: *A. Stevens*
Purchase 1902
Inv. 1373

1867, the year in which the Paris sphinx was painted, was a successful year for Alfred Stevens. The forty-four-year-old Stevens received a separate room for his eighteen paintings at the world exhibition in Paris, and he received the Légion d'Honneur from emperor Napoleon III. Stevens was a rich and admired man who counted Manet, Whistler and Zola among his friends. In addition to Alfred, there were two other Stevens brothers active in Paris. Jozef was a celebrated animal painter and as a critic, Arthur provided the best possible advertisement for his brothers. Alfred owed his fame to the modernity of his genre scenes and his refined realism. A few years after he debuted in Paris with socially stirring themes (1844), around 1855, he crossed over to themes from the life of contemporary middle-class ladies. Stevens became the chronicler *par excellence* of the *demi-mondaines*. His work offered a slow-motion film of the life of the woman who really had nothing to do, "qui vit pour soi-même": the arranging of the toilette, the homecoming, the reading of a book, the visit, but above all participation in the little dramas that played themselves out in the dark salons. A letter, an exotic statuette, a dried flower or a mirror could give occasion to such paintngs as *Waiting*, *Cruel certainty*, *Bad news*, *Dreams* or *Memories*.

Besides the version in the Antwerp museum, at least two other Paris sphinxes are known: one in an American private collection (ca. 1870) and another in the Clark Art Institute, Williamstown (Mass. USA, ca. 1880). The three 'Paris sphinxes' differ from the women Stevens usually depicts. All three are frontally portrayed and half-length, stare directly at the viewer, rest their heads on their arms, have no attributes and fill, against a neutral background, the entire surface of the image. Moreover, the sphinx in Williamstown appears to be a winter version of the Antwerp summer sphinx.

These women are secretive, a quality to which the mysterious title contributes. Why are they called sphinxes, and what hidden riddles do they entertain? The viewer remains uncertain, but the inscrutability of these women must have seen a great deal of success. By analogy with the *Comédie humaine* of Balzac, Stevens was called the painter of the *Comédie féminine*.

Later, after 1870, Stevens' popularity dwindled, and in Baudelaire's *Pauvre Belgique* we read: "Le grand malheur de ce peintre minutieux, c'est que la lettre, le bouquet, la chaise, la bague, la guipure, etc. deviennent l'objet important, l'objet qui crève les yeux. [A.S.] est un peintre parfaitement flamand, en tant qu'il ait de la perfection dans le néant, ou dans l'imitation de la nature, ce qui est la même chose."

Leen de Jong

Hippolyte Boulenger

Tournai 1837 - Brussels 1874

Valley of the Josaphat in Schaarbeek
Panel, 110 x 85 cm
Lower left: *Hip. Boulenger*
Purchase 1925
Inv. 1988

The history of modern art is closely intertwined with the phenomenon of the public exhibitions that were systematically organized beginning in the eighteenth century. You were only recognized as a real artist once you had shown your work at an exhibition. Since then there have been almost no artists who never (even posthumously) took part in an exhibition. The catalogues of exhibitions like the nineteenth-century 'salons' are for modern art a source of information comparable to the lists of members of the guild of St Luke for the art of the Ancien Régime.

In 1866 Hippolyte Boulenger took part in the Salon of Brussels, and in the exhibition catalogue he called himself a 'student of the school of Tervuren'. Young, unknown artists often referred, by way of recommending themselves, to a famous teacher. In Tervuren, however, there was no art school. In a manner somewhat provocative, Boulenger wanted to point out to the public that, like the earlier French landscape painters from the so-called Ecole de Barbizon, he recognized no other teacher than nature itself. In Tervuren, moreover, artists like Edouard Huberti, Joseph-Théodore Coosemans and Alphonse Asselbergs began painting out in the open in the 1860s.

Boulenger is the most important representative of *plein-airisme* or realism in nineteenth-century landscape painting in Belgium. In contrast to traditional landscape painters, *plein-airistes* like Boulenger did not believe that it was possible to represent an objective and universal image of nature. On the contrary, they found that the attempt to be rational, objective and universal only led to an idealized, conventional and untruthful sort of painting. In order to be truthful, the artist thus had to go in search of the particular in nature – an unpretentious brook in the vicinity of Brussels – and he must, in immediate confrontation with the motif, attempt to give an unconventional, personal view of it. In this way artists from Constable to Cézanne discovered the 'autonomous' possibilities of form, colour, light or brushstroke. In this evolution, Belgian artists did not play a leading role. Boulenger himself, though, had a personal sense of monumentality. The fragile silhouettes of the trees inscribe themselves powerfully against the blue spring sky. The capricious play of dark branches is complemented by the fluffy white clouds. The visible pleasure with which the painting was made likewise testifies to the great talent of the artist. Scarcely covered areas are succeeded by carefully calculated tonal effects in diverse layers. Heavily painted phenomena alternate with sketchy strokes, scribbles and traces of dried paint.

Herwig Todts

Henri De Braekeleer

Antwerp 1840 – Antwerp 1888

The man in the chair
Canvas, 79 x 63 cm
Lower right: *Henri De Braekeleer*
Gift of G. Caroly 1921
Inv. 1845

In 1921 baron Gustave Caroly purchased *The man in the chair* for the then fabulous price of 165,000 Belgian franks from the estate of the Brussels collector Eugène Marlier. Baron Caroly promptly gave the work to the museum. From the last decades of the nineteenth century until well into the twentieth, Henri De Braekeleer enjoyed – in limited circles, it is true – what was in fact an almost legendary fame. Former chief curator Walther Vanbeselaere did not hesitate to compare him to Vermeer or Van Eyck.

De Braekeleer first exhibited the painting in 1876 with the title *Hall in the Brouwershuis*. The Water-house or Brewer's House, where water distribution to the surrounding breweries was regulated via an ingenious system, was built in the sixteenth century under the impetus of Gilbert van Schoonbeke. In the nineteenth century, the council hall of the brewer's nation in particular enjoyed a great deal of interest. In the interior, the original so-called Cordovan (in fact Mechelen) leather wall-covering had been preserved. At least eight pictures of the interior are known by De Braekeleer alone. It is possible that De Braekeleer's uncle and teacher Henri Leys first showed him around this noteworthy interior. Leys used such historical monuments in scenes in which he depicted events from the sixteenth century. Cultural patrimony was brought to life again by the use of historical characters, as it were. De Braekeleer, however, had no interest in historical reconstructions; the Brouwershuis appears here as a contemporary antiquarian curiosity. The old man (a chance visitor?) emphasizes the forlornness and vanished glory of the place. In this way the painting seems like a traditional genre scene: the representation of an anonymous person in an everyday situation. According to the unwritten rules of this sort of image, the banality of the scene must be penetrated by its entertaining or stirring character. Perhaps De Braekeleer deliberately staged a partly heart-warming, partly droll character. And why do his feet rest on a cushion? Is he sitting under the statue of St Arnoldus and the luxurious seventeenth-century mythological painting by chance? For De Braekeleer it was probably more about poetry: the divergent guises of the light, colour, diverse materials and the tireless concentration and subtle sensitivity of the artist who saw and painted all of it.

Herwig Todts

Henri De Braekeleer

Antwerp 1840 - Antwerp 1888

The meal
Canvas, 69 x 94 cm
Lower right: *Henri de Braekeleer*
Purchase 1955
Inv. 2820

Henri De Braekeleer had concluded a contract with the Brussels art dealer Gustave Coûteaux in 1869. Up until 1876 he delivered thirty-nine works to Coûteaux, including his most ambitious and characteristic realizations. In those years De Braekeleer would also gradually receive recognition. In 1876 the agreement with the widow Coûteaux expired. During the last twelve years of his life the artist was obviously struggling with professional, physical and perhaps also psychiatric problems. Around 1879-1880 he worked very little or not at all for months on end, and his family and friends were clearly worried.

In the past, the distance between his mature work from the seventies and his last realizations has been overemphasized. In fact, there is no question of a real break either on the level of iconography or on the level of artistic conception. De Braekeleer remained a painter who as a *pleinairist* or realist wanted to reveal the poetry of the everyday. And his preference continued to go to interiors with figures.

Nevertheless, a painting like *The meal* or *The dessert*, as it was originally called, bears witness to a turning point in his oeuvre. The sunny tone of the painting is striking in comparison to *The man in the chair* and other works from the seventies. A number of white motifs add to the clarity of the composition. De Braekeleer clearly strives for a melding together of light and colour – in particular, observe the brilliant floral still life on the table to the left – but nowhere does this lead to the informal, sketch-like design characteristic of French impressionism or the *tachisme* of Guillaume Vogels and the young Ensor. The objects are detailed and highly tangible. De Braekeleer is interested in the effect of light, but for him a painting remains more than just the registration of an optical experience.

Paul Buschmann Junior called the work "spontaneously pointillated, not according to the sterile recipe of later divisionists, but naturally, according to the spirit of Vermeer of Delft. A splendid work in his style is the painter's dining room, (...) an orgy for the eye." The orgy of which he spoke is moreover not only caused by the feast of light and color but also by the diverse objects that populate this overstuffed composition. In particular the succession of furniture and all manner of objects seems improbably overloaded.

The writer Maurice Gilliams called the main figure "a lady of the newly arriving, prosperous middle class, still full of tasteless desires and of low origins not yet spiritually overcome. In her new social affluence she has no other destiny than that of a senselessly pretty and tarted-up, glittering uselessness." The lady in question is Elisabeth, Henri's youngest sister. In the interior we encounter furniture, paintings by De Braekeleer himself, and objects that belong to the appurtenances of his parents' home.

Herwig Todts

Jan Van Beers

Lier 1852 - Fay-aux-Loges (France) 1927

The Emperor Charles V as a child
Canvas, 139 x 149 cm
Center below: *Jan Van Beers, Paris 1879*
Gift of Mrs F. Reinemund 1937
Inv. 2336

When the *Emperor Charles V as a child* was first shown at the Brussels Salon of 1880, the press was especially enthusiastic about the painting. Both the subject and the style of the canvas were completely in line with the romantic history painting that had been shaped in the middle of the nineteenth century by artists like Henri Leys (1815-1869).

That it was actually the conservative press that found themselves charmed by this painting hardly comes as a surprise. Scenes that valorised national history and portraits of figures who had played an important political role in the past were always beloved subjects. The style of the work drew praise from many a connoisseur. Van Beers had convincingly set down the princely allure and apparent nonchalance of the future emperor in paint. The manner in which he had reproduced the material details of textile and fur with extremely economic means and great virtuosity aroused intense admiration. Journalists were full of admiration for this Lier artist who had emigrated to Paris. Van Beers was immediately compared to already consecrated history painters and everything seemed to indicate that his career in the French capital would take flight. Nevertheless, he has gone down in history as a somewhat neurotic figure who did not shrink from scandal and was all too fond of seeing his name in the press. Already in 1881, a lawsuit took place because the artist was suspected of using photographic aids in the creation of his work. Shortly thereafter a new scandal arose, with another lawsuit as its consequence, because he had paintings made assembly-line fashion by a studio.

The initial enthusiasm for his oeuvre of a number of connoisseurs cooled fairly quickly. This had a lot to do with abrupt changes in the subjects of his work. Although Jan Van Beers still made a number of paintings with historical content after 1879, the better part of his production consisted of more or less trivial genre scenes. Fashionably dressed portraits of 'demi-mondaines' were among his favourite subjects, as were landscapes and marine paintings. These easy to understand and hence also highly marketable paintings made the painter a prosperous man. Although he was beloved of the well-to-do Parisian bourgeoisie, his lack of 'seriousness' as much as the practice of painting on the 'assembly line' were quickly imputed to him by a number of art critics.

Nevertheless, Jan Van Beers was above all a talented portraitist. The extremely realistic portraits of the French publicist Henri Rochefort (1831-1913) and of Peter Benoit (1834-1901), both in the museum's collection, are among his most well-known works in this genre. These small character-filled portraits, executed with precise draughtsmanship and a fine touch, are particularly revealing of his talent in this area.

Nathalie Monteyne

Jean Pierre François Lamorinière

Antwerp 1828 - Antwerp 1911

Forest of fir trees in Putte
Canvas, 114 x 126 cm
Lower right: *F. Lamorinière XX 1883*
Purchase 1899
Inv. 1589

In 1883 the Antwerp landscape painter Lamorinière painted this forest of fir trees in the Campines region. Although he had already used the motif of a forest of fir trees earlier, this painting is one of the masterpieces in his oeuvre in terms of technical and artistic ability. This is in part to be explained by the soft tonality of the green. For this Lamorinière used what was then a newly developed sort of paint that did not darken quickly. He attached great importance to the material and technical finish of his work. With this kind of paint he tried to preserve the authenticity of the colours.

In nineteenth-century Belgian landscape painting Lamorinière is a transitional figure between the romantic and realism. He painted his landscapes after nature, on the basis of sketches and drawings made in the open air. Direct observation may therefore be very important, but the compositions still have a definite romantic component. They were meant to correspond to the ideal, spiritual image that the artist had of nature. For this reason the strict composition, analysis of detail, emphasis on the static, the smooth, minute style of painting. All of these elements can be found here. The vista-like effect, the play of lines of the stately, rising tree-trunks and the perspectival effect of their shadows give this work a strongly spatial feel. It bears a hint of grandeur. It seems almost a natural cathedral.

Lamorinière often populated his works with animals (human beings are frequently absent). Perhaps the influence of the animal painter Emmanuel Noterman (1808-1863), one of his teachers at the Antwerp Academy, is at work here. But his obssessional drive toward completeness, toward the painstaking inclusion of every detail in the composition, could also have played a role.

Lamorinière liked trees. He passionately recorded every detail of their anatomy. Characteristic of this predilection is what Henry Lavachery reports in his study of the artist. A few weeks before his death, already blind for many years, Lamorinière felt the need to sketch a tree just one more time. "J'ai vu ce croquis, léger comme la fumée d'un songe. Et c'est un arbre encore pourtant dans sa masse essentielle. Ainsi le dernier geste de création de Lamorinière aura été l'image d'un arbre, l'objet de la création que son oeil et sa main avaient le mieux aimé."

Peter Rogiest

Alexandre Cabanel

Montpellier 1823 - Paris 1889

Cleopatra having poison tested on prisoners condemned to death
Canvas, 165 x 290 cm
Lower left: *Alex. Cabanel 1887*
Collection of the museum of the academicians (1887)
Inv. 1505

Cleopatra has always spoken to the imagination of the western world. She ruled over Egypt, one of the most powerful kingdoms of the ancient world. Her relationship with Marc Anthony and her suicide after the Battle of Actium (33 B.C.) created an image of Cleopatra as a femme fatale. Shakespeare wrote his dramatic *Anthony and Cleopatra*. Artists from the seventeenth and eighteenth centuries were inspired by the woman who had grown into a myth. In 1743, Tiepolo filled his *Anthony received by Cleopatra* (National Gallery of Victoria, Melbourne) with figures in rich eighteenth-century clothing moving amidst a splendid decor with a few Egyptianizing elements. Cleopatra also continued to fascinate writers and artists in the nineteenth century. Interest in the art of ancient Egypt, moreover, reached an unheard-of peak at that time. Archeological discoveries, studies and travel led to genuine Egyptomania in the nineteenth century.

Cabanel combines the image of Cleopatra as the personification of passion and death with his familiarity with the art of ancient Egypt in a spectacular scene. Fantasy, sentiment and historical details melt together to form a theatrical and clearly legible narrative, characteristics also central to later historical films. The painting is divided into two distinct scenes. On the left, the dying prisoners on whom the poison is being tested are depicted. This scene, which takes place in the background, is given shape by means of small figures in colourless, almost hazy surroundings. On the right, Cleopatra watches, full of boredom, sitting in luxurious surroundings while a servant waves a cooling fan in her direction. This scene is emphatically situated in the foreground and is worked out with great precision and refinement, with numerous colorful details.

Cabanel relied on images that he knew from books about Egypt. The building on the left is inspired by the temples of Philae and Edfu. The headdress of Cleopatra is decorated with a vulture, a royal symbol that represented the feminine in late Egypt. Her jewels and sandals are based on Egyptian models. At her feet lies a leopard, symbol of Mafdet, the goddess who refers to royal power. The painter also added new and imaginary elements in order to accentuate the image of decadence, seduction and death, such as the garments and veils of Cleopatra.

The choice of a historical subject that spoke to the imagination, the mingling of correct details and fantasy, and the technically refined execution according to academic rules are characteristic of *l'art pompier*. Cabanel painted this work in 1887 for the museum of the academicians. This museum, an initiative of the Antwerp Academy (1852), encompassed around one hundred paintings, sculptures and drawings that constituted a sampling of the once highly popular academists.

Dorine Cardyn

James Tissot

Nantes 1836 - Nantes 1902

Embarkation at Calais
Canvas, 141 x 98 cm
Gift of Paul Leroi 1903
Inv. 1406

The *Embarkation at Calais* is part of the unfinished series *L'étrangère*, which in turn belongs to the great 'pictorial narrative' of *La femme à Paris*. After taking part in the Paris Commune, James Tissot left the French capital and settled in London. After the death of his companion, Kathleen Newton, he returned to Paris. With his 'pictorial narrative' *La femme à Paris* he tapped into the spirit and charm of the elegant 'Parisienne', an image that was especially popular in the eighties and nineties of the nineteenth century.

Worldly beauty and a modern temperament were close to Tissot's heart, and formed the medium of an oeuvre that is characterized by modern mythology and history painting. During the last quarter of the nineteenth century, 'woman' was the object of study in philosophy, psychology, history and art. Women from various milieus and of different ages, represented in divergent situations and activities constitute the subject of the series in *La femme à Paris*. Tissot puts shop girls, society ladies, women of the *demi-monde*, girls and circus acrobats on stage, enmeshed in the uninterrupted agitation of the city. One is only 'Parisienne' if one is born and raised in Paris; one cannot become one. The 'Parisienne' is a creation in which the artificial dominates over the natural, the paragon of utmost elegance, at once lovely and imposing.

In terms of subject and execution, these works are a continuation of Tissot's London oeuvre. He conveniently joins the plastic language of contemporary, progressive artistic tendencies with his conservative vision, which is characterized by the depiction of the outcome of events and their moral implications and draws from Victorian painting. By means of complicated formal solutions he chooses a scale in proportion to his search for the monumental. His palette and brushwork draw on those of the late-impressionists. This is attested to by the densely applied brushstrokes, lively colors and reproduction of richly decorative elements.

L'étrangère, together with other works from the series *La femme à Paris*, was exhibited in the *Exposition J.J. Tissot: Quinze tableaux sur la 'Femme à Paris'*, at the Galerie Sedelmeyer in Paris (April - June 1885). A woman descends the steps as the ship departs. Waiting on the landing or a departing ship were subjects that had already appeared in works Tissot made in London. As in other paintings with 'woman' as their theme, all eyes in the painting are turned toward the 'Parisienne', while her gaze seems to encounter nothing. Tissot's works are usually characterized by a radical typology of character. His female types are probably based on the facial features of his companion Kathleen Newton. Even after her death he worked with various photos he had made of her. The clothing of the Parisienne, by contrast, corresponds entirely to the latest fashion. The woman's expressionless face against a very 'contemporary' decor, animated by the glances directed toward her by the seamen and workers, has a hallucinatory quality about it.

Greta Van Broeckhoven

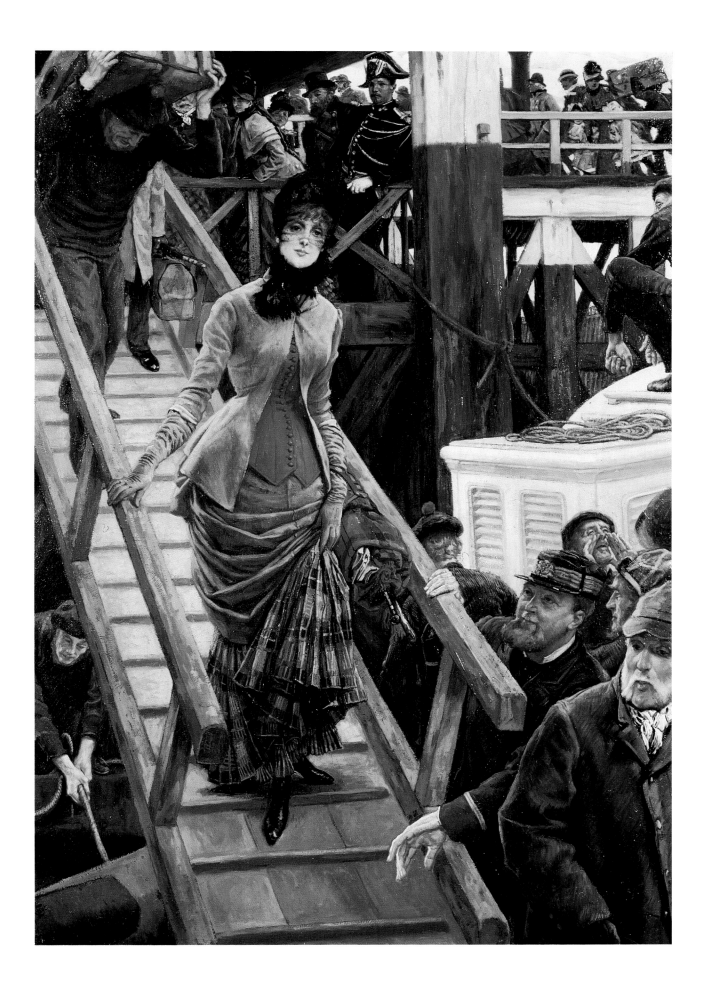

James Ensor

Ostend 1860 - Ostend 1949

The mystical death of a theologian or
Agitated monks fight over the body of the theologian Sus-Ovis in spite of the resistance of bishop Frito
Graphite, black chalk and charcoal on paper, 970 x 830 mm
Lower right: *James Ensor 1880*
Purchase 1953
Inv. 2786

During the last decades of the nineteenth century, artists began to conceive of drawings as independent works of art. Ensor was extraordinarily prolific in this area, particularly in the eighties. Moreover, drawings were of crucial importance for the radical change in direction that his work took around 1885-1886. In those years he drew and etched intensively. In a number of large religious drawings, namely in *The aureoles of Christ*, he returned to a theme that he had only studied at the academy. Stylistically, this drawing is close to *Aureoles*, which dates to 1885-1886. The expressive function of the light, the nervous design and the countless, drolly characterized figures are not encountered in any of his drawings from before 1885. Nevertheless, the drawing is dated 1880. Two things can be ascertained with the naked eye: first, that there is a distinct stylistic difference between the group of dark figures to the right of the centre, and all other figures and motifs, and secondly that the drawing has been enlarged above by the addition of two strips. We know with certainty that Ensor, beginning exactly in 1886, transformed a number of earlier drawings and paintings into unreal, fantastic and grotesque representations. Undoubtedly, this is what has happened here. In a biographical note, Ensor relates that he made these compositions during his study period at the academy in Brussels and that the director, Jean Portaels, liked this drawing very much and kept it in his office for a while. Probably, the group of dark figures does in fact date from around 1880, and Ensor enlarged the sheet a few years later and placed the group of figures in a large gothic church interior opposite a procession, led by a bishop who enters from the left. In the front, under the cross, there lies a dying man (?).

The composition strongly recalls Louis Gallait's *The plague in Tournai in 1092*, which can be viewed as the last great history painting in nineteenth-century Belgian painting. Gallait showed this colossal canvas at the Triennial Exhibition of 1884 in Brussels. Whether Ensor was already familiar with the composition by Gallait from earlier on and also borrowed the group of dark figures in monk's habits from him is not certain. A 'national' hero like Peter the Hermit, compelling force behind the first bearing of the cross, was represented numerous times as the exalted leader of a group of ragged characters. Perhaps Ensor was struck only in 1884 by the similarity between Gallait's history painting and his own academic work and found it amusing to poke fun at the revival of religious mysticism in the literature and art of his contemporaries, the symbolists, in a grandiose parody *The plague in Tournai*.

Herwig Todts

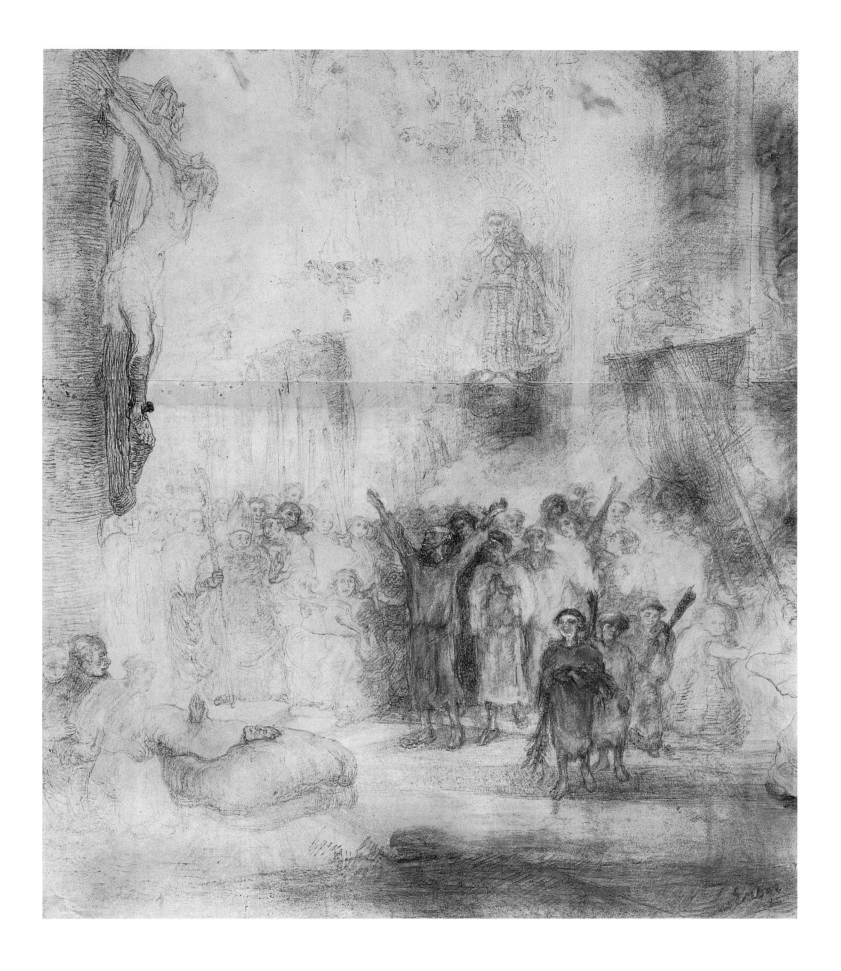

James Ensor

Ostend 1860 - Ostend 1949

Afternoon in Ostend
Canvas, 108 x 133 cm
Lower left: *James Ensor 1881*
Gift of a group of friends of the museum 1921
Inv. 1852

In 1881 Ensor showed a painting entitled *Un salon (impression)* in the Brussels art society *La Chrysalide*. Afterward the painting was named *The middle-class drawing room*. This title was likewise used as the collective name for most of the figural pieces or genre scenes that the young Ensor painted between 1880 and 1882. They usually involve one or two figures in a well-to-do middle-class interior. In comparison to the domestic ideals of today, these interiors seem sombre and Ensor appears to give a depressing view of the middle-class lifestyle. In the painting *La dame en détresse* (1882, Musée d'Orsay, Paris), with the help of the high ceiling, the furniture, and light tempered by the high, heavy curtains he indeed creates an atmosphere that accentuates the young woman's general collapse. But then again, a painting like *The oyster-eater* is conceived as a festive tribute to the good life: a young woman enjoys oysters, wine, flowers, affluence ...

We encounter the woman who sits at the table in *The oyster-eater* in a majority of the so-called middle-class drawing rooms. She is Ensor's younger sister Mariette, or Mitche, as she was called. Here, she poses in her going-out clothes at a table in her parents' house, in the company of her mother, Catharina Haegheman. Usually, the 'middle-class drawing rooms' are regarded as biographical documents. In the nineteenth century this sort of representation was in fashion throughout Europe. Ensor avoids the use of amusing or sentimental anecdotes but they do involve fictional representations that narrate the trials and tribulations of the young middle-class lady. Here, she is clearly visiting the home of an older woman for coffee after the mid-day meal. Originally, the painting was even called *Une après-dînée à Ostende*.

Ensor sketches the situation but does not tell us what the relation is between the two silent figures or what is going through the mind of the young woman looking at the viewer. He called *The middle-class drawing room* an impression. Clearly he was aware of the newest artistic tendencies from France, which were then already known under the name impressionism. Indeed, friends and enemies alike called Ensor an impressionist in those years. And years later, Ensor would again emphasize his groundbreaking interest in the effects of light. Nevertheless, he did not hesitate to admit that he was in fact wrongly classified as an impressionist. In the grotesque paintings, drawings and prints that had become the trademark of'le peintre des masques' from 1886, he handles light as an expressive quality. But in the earlier middle-class salons, still lifes or marines, Ensor remains true to the approach of realism, or rather pleinairism. However sketch-like, luminous and colorful the paintings may be, Ensor does not, in contrast to the French impressionists, reduce painting to the registration of a pure optical play of light and colour. (He probably knew the French impressionists by reputation but was hardly familiar with their painting, or not at all.) With an extremely sensitive gaze and virtuoso confidence, Ensor shows how light reveals, reshapes or conceals forms, colours, substances.

Herwig Todts

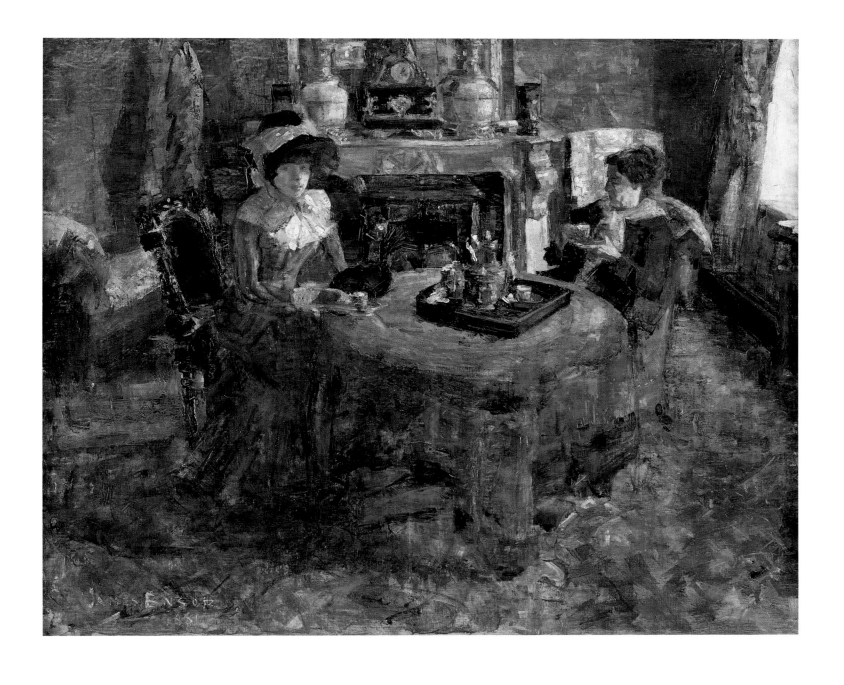

James Ensor
Ostend 1860 - Ostend 1949

The oyster-eater
Canvas, 207 x 105 cm
Lower right: *J. Ensor 1882*
Purchase 1927
Inv. 2073

The oyster-eater belongs, like Wouters' *Drunken violence*, among the few really legendary works in which the history of modern art in Belgium is particularly rich. In the course of the month of July 1882, a local Ostend paper called attention to the fact that the young artist James Ensor would send a painting entitled *The oyster-eater* to the Triennial Exhibition in Antwerp. In the catalogue of this exhibition, only the painting *Au pays des couleurs* (In the land of the colours) is mentioned. Probably, Ensor wanted to exhibit *The oyster-eater* under this evocative title. Rumor has it, however, that the painting was refused by the organizers of the Antwerp exhibition. In 1883, Ensor's colleagues in the exhibition society *L'Essor*, a circle of former students of the academy in Brussels, would again reject *The oyster-eater*. Ensor and the progressive members of *L'Essor* later resigned from the association and established *Les XX*, and there *The oyster-eater* was of course welcome.

In 1907 the purchase of *The oyster-eater* was placed before the municipal council of Liege for its city museum. Friends of the artist and art lovers there defended the purchase, but a majority of the council members rejected the proposal. An attempt to sell the painting to the Musées royaux des Beaux-Arts de Belgique, Brussels in 1909 was again unsuccessful. Doctor Albin and Emma Lambotte, who lived in Antwerp but were originally from Liege, bought the painting. They were among the most enthusiastic lovers of Ensor's art and assembled a splendid collection, of which the most important works were purchased by the museum in 1927.

Emile Verhaeren called *The oyster-eater* the first 'clear' painting in the history of Belgian art. The controversy that arose around the work in 1882-1883 and again after 1900 centered in the first place on the supposed immorality of the representation. Some viewers found it inappropriate to show a young middle-class lady who, as Ensor himself defined it, sits all uncomplicated enjoying the good things in life: oysters and fine wines. "Perhaps", he said, "I should have painted a democratic and poetic mussel eater."

The oyster-eater belongs, like *Afternoon in Ostend* or *Russian music*, to a group of paintings named after *The middle-class drawing room*. These are paintings in which Ensor explored the possibilities of realism, or rather *plein-airisme*, extensively, radically, and with virtuosity.

Herwig Todts

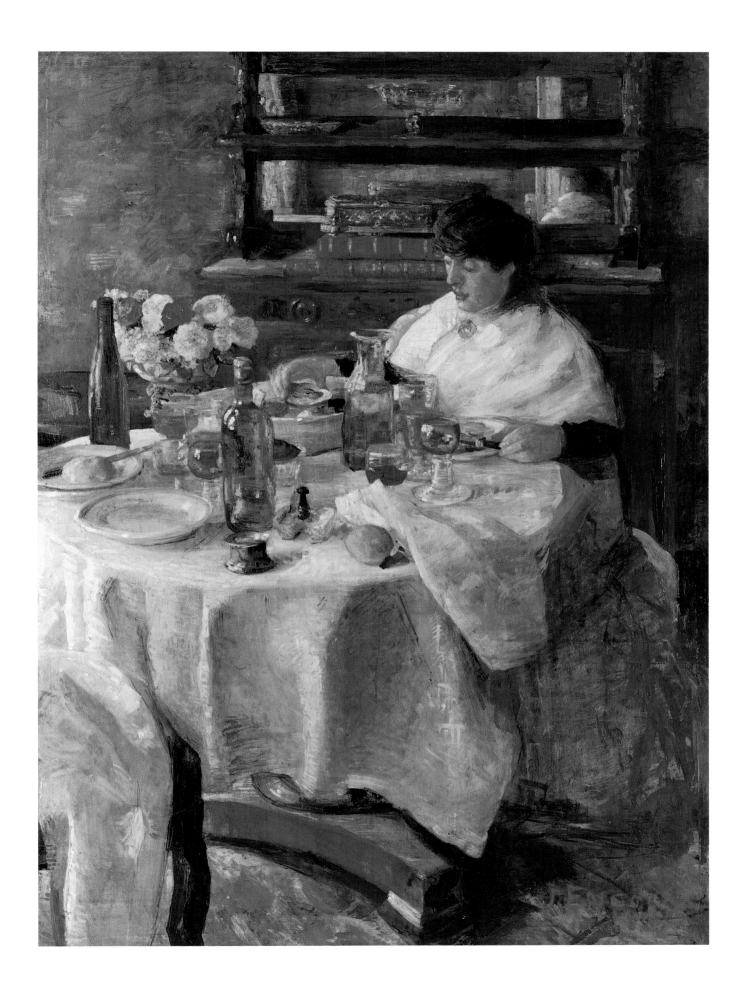

James Ensor

Ostend 1860 - Ostend 1949

Astonishment of the mask Wouse
Canvas, 109 x 131 cm
Lower right: *Ensor 1889*
Purchase 1926
Inv. 2042

The oyster-eater, Ensor's 'middle-class drawing rooms' and some of his marines undoubtedly belong to the best of what was painted in Europe during the last quarter of the nineteenth century in the realist, or rather *plein-airiste* style. In 1886, however, Ensor bid farewell to realism, or the attempt to realize a depiction of reality that was faithful to nature. In the Brussels art association *Les XX*, he became acquainted with the irrational symbolism of Odilon Redon and other innovators. In turn he investigated the possibilities of the unreal and the irrational, competing with and mocking his confreres. Inspired by Rembrandt, Goya, Japonism and the attitude of the caricaturists, he explored new themes, compositions and expressive possibilities in drawings. He often went about his work in a mystifying fashion, using real and reportorial motifs and procedures to stage a hilarious imaginary spectacle.

Astonishment of the mask Wouse is a perfect illustration of Ensor's manner of working. The interior is undoubtedly based on the atelier in the attic of his parents' house in Ostend. On the floor lie articles of clothing, head coverings, musical instruments, masks – in short, the attributes of carnival, and a death's head. It could be a still life of objects placed so that they equally recall living beings. But elsewhere in the representations the masks do in fact come to life: on the left and right they dive into the image. The main figure itself is avowedly unreal: its visage could be a mask, but could just as well be a horribly deformed face. The figure is an ugly woman who makes herself ridiculous by behaving coquettishly like the winsome lass she can never be. She is intended as a parody of the ladies that figure in the paintings of Toulmouche, Alfred Stevens and naturally also in Ensor's *Lady with fan* or *Lady with red parasol*, and in the 'middle-class drawing rooms'. Ensor has moreover borrowed the character from the popular culture of his time. Who Wouse is, Ensor did not make clear. Is it the grotesque woman or is it the 'black woman' who enters the room on the left? Do the creatures at the feet of the grotesque woman symbolize men, musicians, artists? Do they not simply lie at her feet literally, or has their encounter been fatal to the men? The skeleton in front could be snuffing out his last candle.

Masks first appear in Ensor's work in a painting of 1883, which he later gave the title *Angry masks* (Musées royaux des Beaux-Arts de Belgique, Brussels). In that painting, two models in carnival clothing pose at a table in the atelier of the artist, as if they have landed in a dark and dirty tavern. Crucial to the typical Ensorian use of masks is the dubious reality-value. Reality undergoes a grotesque metamorphosis. Mask-creatures play tricks with the logical and natural order of things; the image is surprising, humorous and sinister

Herwig Todts

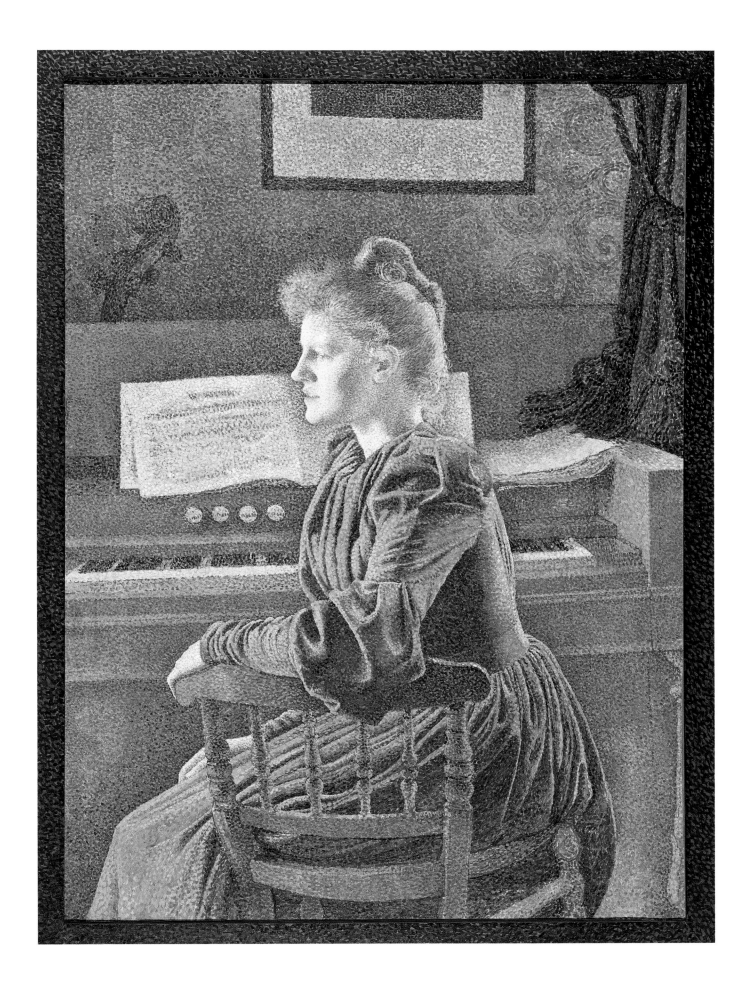

Périclès Pantazis

Athens 1849 - Brussels 1884

On the beach
Canvas, 70 x 108 cm
Lower left: *Pantazis*
Purchase 1947
Inv. 2617

This charming work by Pantazis draws the eye of the viewer by means of its playful, informal subject and attractive colouring. One of the strolling women peers through a telescope at two boats in the distance. Three children amuse themselves with a little sailboat. Périclès Pantazis was a Greek who spent his student years in his own country and Paris, only to end up afterwards in Brussels. In France he admired the paintings of Manet and Boudin. He made the transition from realism to impressionism early on and was as a result one of the forerunners of that trend in Belgium. He was friendly with Guillaume Vogels, a Belgian impressionist, for whom he worked as a house painter. The artist was well-integrated into Belgian artistic life and regularly took part in exhibitions. The progressively inclined Pantazis was, together with colleagues Vogels, Ensor and Khnopff, one of the founders of *Les XX*, but because of his early death he would not be able to grasp the importance of this artistic movement.

With its blue sky, whitish-grey clouds, blue-green sea with white-crested waves and a beach populated by a few strollers, the painting draws its expressive strength from the tangible atmospheric moisture, play of light and liveliness of the colours. Here, Pantazis makes an immediate attempt to register the visual stimulus of this fact. Direct observation of a chance occurrence is recorded with a swift hand. Hence he makes grateful use of the puddle left behind by the retreating sea, in which the elegant crinolines of the ladies are reflected. The strollers and playing children on the beach along the North Sea are necessary anecdotes that bring colour to the canvas. The movements of the air, light and water, with all their possible changes, were precisely the elements that excited the impressionists. He uses a loose touch and one can easily see the broad sweeps of the brush, which demonstrate how quickly such a work was in fact painted. He seems to master the material with ease and in translating his direct observation into paint leaves linear execution behind in favor of a sketch-like mode of depiction.

Pantazis seldom dated his works, so it is difficult to order his oeuvre chronologically. He mainly chose marines, landscapes, still lifes and portraits of children as his subjects. There is a small preliminary study for this work which he probably painted in the open air and afterward worked up into a painting with a few changes. Both works show the playing children with the boat and the strolling ladies. But the somber tones of the children's heads and clothing were replaced in the definitive version with livelier flecks of colour. The pink parasol has become red, and the originally dark sails of the toy boat have become white.

Els Maréchal

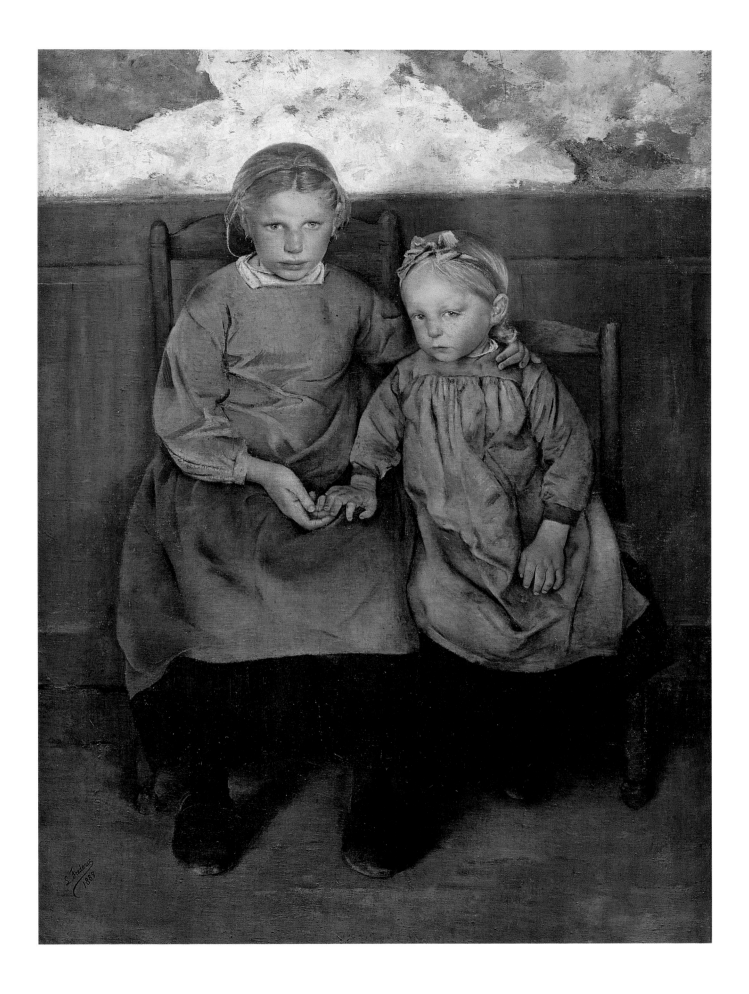

Henri Van de Velde

Antwerp 1863 - Oberageri (Switzerland) 1957

Woman by the window
Canvas, 111 x 125 cm
Purchase 1944
Inv. 2589

Woman by the window belongs to a series of eight village scenes, *Faits du village,* which Henri Van de Velde painted in 1889. Van de Velde was then active as a painter in the Antwerp Kempen. He lived there for a while in the artists' colony at Wechelderzande. The painting was first exhibited together with three others from the series in Brussels in 1890, at the salon of *Les XX*, the group of Brussels avant-garde artists of which he was a member from 1888.

In 1887 he had visited the fourth salon of *Les XX* and there greatly admired the exceedingly fine pointillist canvas by Georges Seurat, *Un dimanche après-midi à la Grande Jatte*. With this canvas Seurat announced his new theory and technique: neo-impressionism, also known as pointillism or divisionism. He combined contemporary colour theory with a modernist theme: the Sunday stroll of the Paris bourgeoisie. Seurat's monumental, stylized figures, frieze-like composition and painting technique make an ephemeral social event into something timeless. The pointillist manner of painting is characterized by the use of unmixed, complementary colours that are applied in small dots next to each other on the canvas. The mingling of colours occurs only in the eye of the viewer. In this way, not only are local, reflected and absorbed light depicted, but also simulaneous and successive light contrasts.

In *Woman by the window* Van de Velde covers the canvas with pointillistic dots of colour. The village view is bathed in an internal light heightened by yellow, purple and orange dots that flow into one another. Their clarity is supplanted by the cool light of the room. The light that streams in through the window envelops the seated woman so that her profile is reproduced in light and shadow. The pure and primitive existence of the peasant woman is expressed in the simple surfaces of her form and her Flemish peasant's clothing. The oppositions of pink and green create an unusual result, whereby the field of vision from the room is transformed into a meditation on eternity. Her pivotal position and stylized form make of Van de Velde's seated peasant woman the transitional element between the spiritual world within the room and the factual material world outside.

The representation of a woman at a window was a favorite theme in the art of Northern European countries. The scene recalls Henri De Braekeleer's *The Teniersplaats in Antwerp* of 1878, also to be admired in the museum's collection. Perhaps *Woman by the window* is meant as an homage to this Antwerp painter, who died in 1888. Van de Velde simplifies both the figure and her surroundings and thereby departs from the descriptive character of De Braekeleer's work. The compositional simplification and absence of narrative details are combined with an artificial colour scheme and load the scene with symbolic meaning. The village view is what he saw from his studio in Wechelderzande, but is not a description of it.

Nele Bernheim

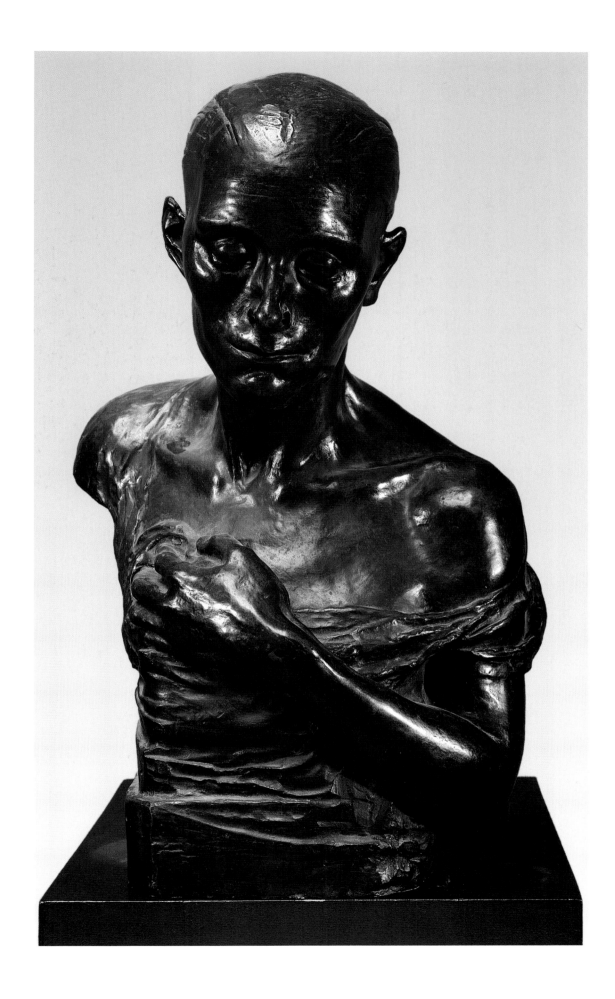

George Hendrik Breitner

Rotterdam 1857 - Amsterdam 1923

Women on the Rokin
Canvas, 98 x 148 cm
Lower left: *G.H. Breitner*
Purchase 1928
Inv. 2020

In 1886 Breitner moved from The Hague to Amsterdam. It was in this city that he emerged as a true impressionist, sensitive to colour and movement. Amsterdam became his muse, an inexhaustible source of motifs: the bustling, hectic street imagery of a growing metropolis. He immersed himself in its atmosphere. This city related to his passionate, irascible artist's nature. Armed with a sketchbook and camera he paraded through its streets, at once part and observer of the crowd.

At the end of the 80s, the hand-held camera made its appearance. Technical improvements now enabled the amateur photographer to take a number of photographs one after the other and also to record movement. Breitner photographed intensively in the early 90s. He was fairly impulsive and impatient: he was less inclined to draw models from life or finish something detailed. Photographs offered compromise. Breitner never literally copied photographs. They had the same use-value as sketches, preliminary drawings and oil studies. They helped with details and perspective problems, served as an aid to memory. The artist made the final compositional choices. He interpreted the original pictorial material. Elements were changed, combined, rearranged, selected or omitted.

Around 1885-1896, Breitner made a number of paintings of the Rokin and surroundings. This work is one of them. It gives the impression of being the spontaneous depiction of a chance moment. This, however, is a studied compositional effect, worked out in the atelier. He achieved the impression of coincidence, of spontaneity, by means of a loose, free manner of painting and the adoption of photographic effects. He painted with sturdy, rough streaks, sometimes almost sketch-like, which emphasizes the unfinished quality of the work. For him it was clearly not a matter of the detail, but of the impression. The row of houses in the background is in its overall form still recognizable as such, although its surface is scarcely indicated further.

The unrecognisable heads of these middle-class ladies recalls the blurred faces of passers-by in photographs. The point of view is fairly low and from so close by that the ladies, as in a close-up, almost fill the entire height of the picture plane. Breitner sometimes photographed from a squatting position or held the camera at hip-height. He has translated this point of view on canvas. Another element from photography is the abrupt cropping of the lower bodies of both women by the edge of the picture. This also enhances the snapshot-like character of the work. The use of colour is sober: white, black, red and brown tints dominate. Breitner liked to work with strong contrasts between light and dark. The contours of the women stand out sharply against the background. The end result is a dynamic image in which the figures seem to wander in and out of the picture.

Peter Rogiest

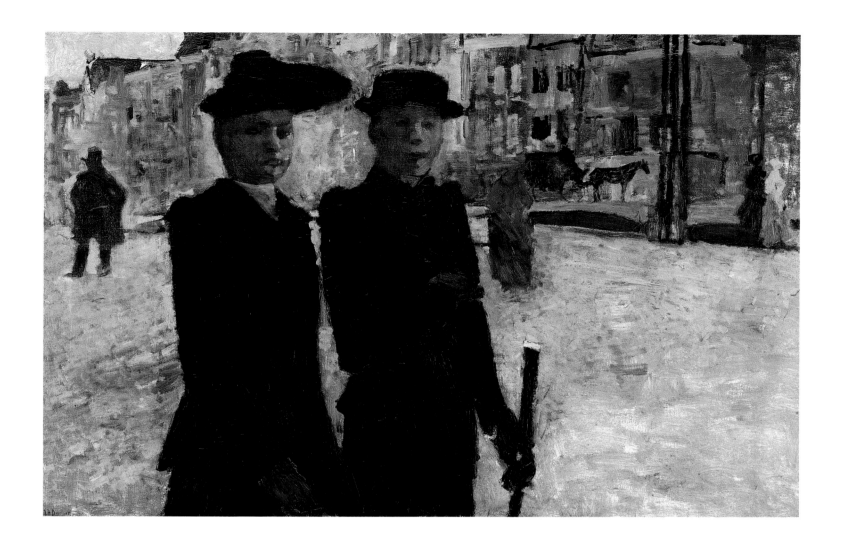

Jan Stobbaerts

Antwerp 1838 - Schaarbeek 1914

Dredging in the Woluwe
Canvas, 47 x 70 cm
Lower right: Stamp of atelier Stobbaerts 1914
Gift of museum friends mediated by François Franck
Inv. 1801

In a rural area two men stand on a stone bridge; they stir the bed of a small river with sticks. A third man looks on and helps from the bank. The side of a house with a red tile roof and the nearby river between the trees fill in the background. This is what Jan Stobbaerts saw in Sint-Lambrechts-Woluwe, where he painted in the neighbourhood of the Mussenhoeve.

The activities in and around farms always inspired the artist. He made this work around 1896, when he had already been painting for forty years. This is one of the few works by him without animals. The fields, stables and kitchens are usually populated with cows, horses, livestock or dogs. Particularly characteristic of Stobbaerts' work is his great craftsmanship. As a child he worked in a woodworker's atelier; he subsequently worked for a house painter and later with a decorative painter. Regard for the material aspect of painting would remain one of his major preoccupations until the end of his life.

Jan Stobbaerts was apprenticed to the animal painter Emmanuel Noterman and at the same time followed evening courses at the Antwerp Academy. Initially he sought subjects in Antwerp and in 1857 – he was then only nineteen years old – he presented two works at the Brussels Salon. He made fairly small works, preferably painted on location, contrary to the then-current academicism. He painted dogs in rear kitchens and scenes in slaughterhouses in a hard style that comes across as rough, fairly dark and heavily outlined. His work stirred up a goodly amount of controversy and more than once he had to endure sharp criticism on account of his bloody and raw scenes. But he continued along his chosen path and found support from Henri Leys, with whose nephew, Henri De Braekeleer, he was befriended. In 1886 he moved to Schaarbeek, where he continued to paint new farms in his familiar style. When he went to work in Sint-Lambrechts-Woluwe from 1893 onward, he developed a new style.

In *Dredging in the Woluwe*, the way in which Stobbaert admits light into his work as an independent phenomenon that affects everything in the vicinity becomes clear. Here, what is perhaps at first glance anecdotal is completely drowned out by his regard for light. Stobbaerts' manner of painting is very subtle and almost tangibly slow in a way that causes one to forget the fixed character and naturalistic directness of his stable scenes. With broadly sweeping brushstrokes he permits the light to reduce the painting to a flat surface. Figure and ground run together, overlap one another. What is seen almost begins to waver, and only after longer viewing does form begin to emerge again. The painting was never finished; Stobbaerts continued to work on it until his death.

Nanny Schrijvers

George Minne

Ghent 1866 - Sint-Martens-Latem 1941

The small relic-bearer
Marble, 68 x 16 x 26 cm
Right side: *G. Minne*
Purchase 1926
Inv. 2049

A kneeling, nude boy bends his head and supports a relic resting on his left shoulder with his hands. It is one of the primary motifs in the oeuvre of George Minne. The ascetic, strongly stylised bodily form accentuates the posture of uncertainty and introversion.

Regard for the direct and telling gesture is characteristic for the sculptures and drawings of Minne. We see this for the first time in *Grieving mother with two children* of 1888 (bronze, Museum Boijmans Van Beuningen, Rotterdam). Shortly afterward, his first kneeling figures were created: the *Kneeling man and woman*, dated 1889 (granite, Museum voor Schone Kunsten, Ghent), and *John the Baptist* of 1895 (bluestone, Museum voor Schone Kunsten, Ghent). In 1896 the *Kneeling boy* followed (marble, Museum voor Schone Kunsten, Ghent), a sculpture of a nude boy who bends his head and closes his arms protectively around his shoulders. In subsequent years, Minne would take up this type of isolated, maturing boy who anxiously closes himself off from his environment in different variants. The *Small relic-bearer* of 1897, a sculpture executed in both marble and bronze, also belongs to this type. Its strongly linear character, build-up of taut planes, angular lines and repeated parallel movements are defining, and underline posture and gesture.

The motif of a figure bearing a burden on its shoulders is not new, as is evident in works like *The fallen caryatid* of 1881 by Auguste Rodin (bronze, Koninklijk Museum voor Schone Kunsten, Antwerp). What is new is the manner in which Minne works out the motif. From the pessimistic atmosphere of the fin-de-siècle he created the type of the closed, inward-turned figure as an expression of his own unrest and angst. Around 1898 this led to one of the high points of symbolist sculpture, *The fountain of the kneeling*, in which Minne repeated the motif of the uncertain, self-protective boy five times in an identical fashion (plaster model, Museum voor Schone Kunsten, Ghent; marble version, Folkwang Museum, Essen). "Minne incarnated feelings of uncertainty and angst in dream-like figures", wrote Emile Verhaeren, "in primitive beings or figures that were born somewhere outside of our reality."

The type of the vulnerable, immature boy as symbol of uncertainty can also be found in the work of other artists in the late nineteenth century, including that of the painter Ferdinand Hodler. The influence of Minne is evident in the emaciated children's figures that Oskar Kokoschka drew in 1907 and in the elongated figures of the sculptor Wilhelm Lehmbruck. In the twenties and thirties Minne often returned to his typical motifs. In these late versions, however, including *The large relic-bearer* of 1929 (bronze, Museum voor Schone Kunsten, Ghent), the hardness, strongly linear character and feelings of angst and isolation, so characteristic of his earlier work, have vanished.

Dorine Cardyn

Xavier Mellery

Laken 1845 - Laken 1921

The soul of things
Drawing in white and black chalk, 930 x 670 mm
Lower left: *X. Mellery*
Purchase 1923
Inv. 2923

For Mellery art must at once be analytic and synthetic. He depicts his subject, a stairwell in his own house, in a highly realistic manner. The central theme is intensely observed and analysed and is portrayed in a meticulous and detailed way. Near the staircase we see the marble sculpture *La Poverella* by his friend, the sculptor Paul de Vigne (currently in the Musées royaux des Beaux-Arts de Belgique, Brussels), and on the wall above the stairs we recognize another work by Mellery, *Design for the Belgian Pandects*. But this realism is more a means than an end. His extremely accurate depiction has an inverted effect. The familiar suddenly becomes strange.

The desolation of the interior, the dimmed light (light source outside of the picture) and the trembling shadows, the dizzy, unstable outlines of things, whereby they seem to dissolve into their surroundings ..., all of this has a strongly suggestive effect. A mood is called up, a feeling evoked, a genius loci. This is actually the subject. Material is spiritualised. What is depicted becomes the mirror of the inner self of the artist. Mellery sees the essence of the things in his environment: the memories, dreams and premonitions with which they are loaded in his mental world. In the artist's subjective vision the things that surround him daily are transformed into symbolic bearers of connections and harmonies perceived by him. His everyday surroundings become the externalisation of his emotions, the laying bare of a network of connections. Mellery tries to transfer this feeling to the viewer.

He uses a dark, monochrome palette, with subtle shifts between light and dark and superbly controlled light effects. The grainy effect of chalk rubbed on the paper melts things into an identical whole, a synthesis. The repetitive cadence of steps, spindles and corresponding shadows, together with their turning movement, expresses at once movement and rigidity, progress and stasis. The stairs that lead upward, into the darkness, can be seen as symbolizing the quest for the Ideal. The darkness above the stairs gives the threatening feeling of an 'au-delà'. *La Poverella* appears as a sphinx-like sentinel in the twilight, a figure sunken in a deep, dreamy sleep, almost alive in the rays of light that fall on her. The face with its closed eyes resembles an empty shell, completely folded in on itself.

Mellery is seen as a pioneer of Belgian symbolism. This drawing is part of a group that bears the same title as the work shown here (*L'Âme des choses*). In these drawings of abandoned interiors and beguinages, Mellery unites symbolist and intimist tendencies.

Peter Rogiest

Josuë Dupon

Ichtegem 1864 - Berchem 1935

Diana
Ivory and bronze, 92 x 25 x 40 cm
Lower right side: *J. Dupon*
Purchase Triennial Exhibition Antwerp 1897
Inv. 1263

With Josuë Dupon we mostly think of his monumental bronze animal sculptures, like the *Vulture defending its prey* (1898) erected in the square in front of the museum, the *Camel driver* (around 1900) on the façade of the Koninklijke Maatschappij voor Dierkunde in Antwerp and the bronzes above the entrance of the Antwerp zoo, *Two vultures on an elephant's head* and *Two Dalmatian pelicans on a shipwreck* (1905). All of these sculptures are striking in their dynamic and realistic treatment, while a romantic imagination persists in the preference for 'wild' animals.

Diana shows a very different facet of Dupon. The delicate and refined statue depicts the Roman goddess of the hunt. She stands on the skull of an elk between its broad, up-turned antlers, and is clearly recognizable by her attribute, a bow and arrow. The depiction of an elegant female nude, often under the guise of a Greek or Roman goddess, was quite current at the end of the nineteenth century.

The combination of various valuable materials gives the sculpture a very distinct and refined radiance. The soft, almost transparent ivory emphasizes the delicacy of the supply tensed female body. The bronze veil, which reveals more than conceals her naked body, accentuates the upward-flowing movement. The gilt bow, which she draws, also strengthens the upwardly directed line. The play of waves and soft curves is also continued in the round marble socle.

Diana is a fine example of chryselephantine sculpture (ivory combined with precious metals), which saw a short but striking flowering in Belgium in the last decade of the nineteenth century. The voluminous traffic in ivory, which was shipped to Antwerp from Congo, lay at the basis of this sudden interest in the art of ivory. In 1893, secretary of state Edmond Van Eetvelde called on sculptors to work with ivory. One year later, in 1894, a few ivory sculptures were exhibited in the Congo pavilion at the World Exhibition in Antwerp. At the World Exhibition in Brussels in 1897, some eighty ivory sculptures were erected in the hall of honour of the Congo pavilion, all by Belgian artists. Symbolist elements and decoratively undulating art-nouveau lines melt together in these particularly refined sculptures, which are a reflection of the luxurious world in which the middle class was dreaming away during these years of social tension. Dupon's *Diana* was also on view at the World Exhibition in Brussels. Earlier that year, the sculpture was exhibited at the Triennial Exhibition in Antwerp, where it was purchased by the museum.

Dorine Cardyn

Eugène Laermans

Sint-Jans-Molenbeek 1864 - Brussels 1940

The blind woman
Canvas, 134 x 174 cm
Lower right: *Eug. Laermans 1898*
Purchase 1923
Inv. 1941

A woman in dark clothing draws our attention. We see her from behind as she steps into the landscape, leaning on a young girl who turns her head toward the woman's steps. The clogs, their clothing and the bags they carry reveal that they are simple, folkish people. With her head slightly raised toward the light and with a walking stick in her left hand, the woman feels her way, a typical pose for a blind person.

The lyrical landscape stretches out underneath a dark, cloudy sky. The path in the foreground is bordered by a strikingly white wall and leads the gaze to the right, to a village, sheltered between rows of trees. One also sees a hamlet to the left, while in the middle a flat landscape with winding roads stretches out into the distance. The composition is built up evenly by means of a horizontal and slightly diagonal progression from the lower left to the upper right, whereby the wall functions as a strong pictorial element. Diametrically opposed to it is a progression from the upper left to the lower right, formed by the heads of the woman and child and the truncated post, accentuated by the walking stick, winding roads in the plain and narrow incidence of light from a sunbeam. In a distinct language of light, somewhat drab colours and sharp lines the artist creates a melancholy world around a social theme.

In order to understand the scene fully, we must deal briefly with the artist and his oeuvre. Born and raised in a peripheral community of Brussels, he always remained true to his homeland. Because of illness, he was already deaf as a young boy, which led to a speech impediment and social isolation. He sought inspiration in long walks through nature. The farmer, the drifter, the pariah attracted his attention. But he also characterized the factory workers in their misery as the exploited masses of the advancing city in the turbulent social period at the end of the nineteenth century. Nevertheless, Laermans took part in intellectual life, read a great deal and had contact with prominent writers. He also took part in exhibitions both at home and abroad, and achieved distinction as an artist. *The Blind woman*, for example, took the silver medal at the World Exhibition in Paris in 1900. At the end of his life the artist himself went blind, which led to even greater social isolation.

The art of Laermans is difficult to characterize as belonging to one tendency or another. One could in fact speak of a sort of discreet symbolism. Hence, the posture of the blind woman is one of fear, which causes her to feel her way through life. In this she does not trust in strong people, but in a child. Silently she seeks the way to the safety of a village, enclosed in her silhouette like the artist in his silence.

Wim Decoodt

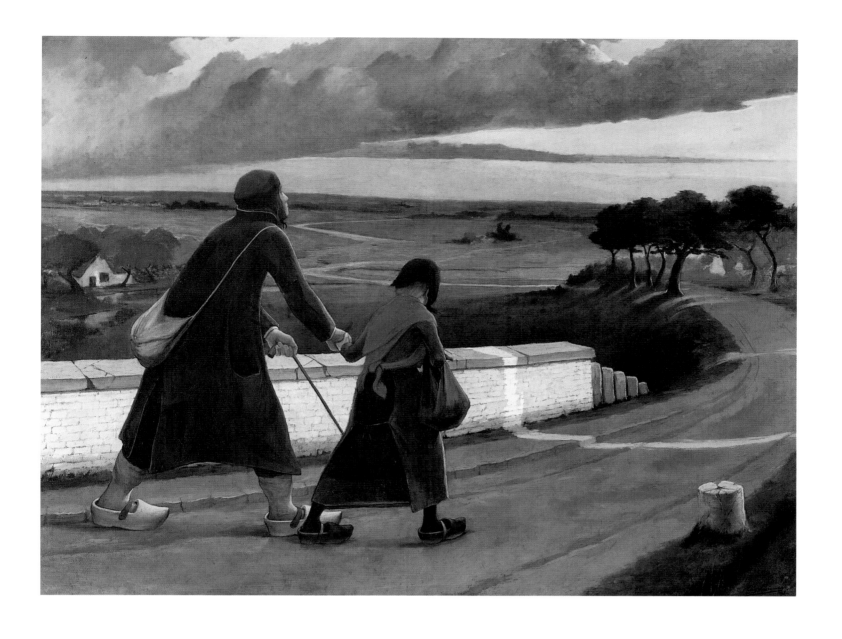

Leon Spilliaert

Ostend 1881 - Brussels 1946

Self-portrait with blue sketchbook
Watercolour on paper, 490 x 360 mm
Right side: *L. Spilliaert 1907*
Purchase 1950
Inv. 2697

Leon Spilliaert's debut as an artist coincided with the turn of the century, a time in which various artistic tendencies with divergent but also complementary subjects and plastic languages first saw the light. In studying the work of Spilliaert it is easy to refer to the dialectic between symbolism and expressionism in the work of Munch. One of the themes that both artists have in common is the expression of the fear and loneliness of the individual, executed with increasing abstraction and a colourful palette. Spilliaert's style, to which the achievements of artistic developments between the years 1885-1925 are not alien, is difficult to classify under one rubric. Spilliaert's preference went to fragile techniques and materials like watercolour, gouache, diluted India ink, pastel or coloured chalk, which he often combined in a subtle way. With these not wholly opaque materials, he was able to awaken an atmosphere of immateriality, of spiritualization.

Major themes in Spilliaert's oeuvre include interiors, landscapes, with a preference for the sea and at a later stage the forest, and finally self-portraits. All of the self-portraits date from the period 1902-1908. Together, they give a 'report' of the path he took in self-examination and perception.

In his life Spilliaert was not so much marked by the major events of the outside world, but rather by what occurred in his inner world. In the painted self-portrait, the self-knowledge one acquires by introspection is unavoidably bound to long contemplation of one's own appearance in the mirror. Spilliaert's self-portraits are expressive evocations of the dialogues he carried on with his 'I' in this observing reflection. In his paintings the nature of this dialogue is determined by the relationship between narcissistic feelings and self-destruction and the ideas that he had about the way in which he was perceived by the outside world.

In 1907 Spilliaert painted a few portraits in which he stands erect in the familiar rooms of his parents' house. Depicted from the knees up in the centre of the composition, he is literally and figuratively the centre of his subject. His 'penetrating' gaze makes the viewer a participant in the complex process of introspection. Spilliaert views his pronounced facial features as the vehicle for his inner excitement and nervous, quick-tempered character. In *Self-portrait with blue sketchbook*, painted in 1907, the expressive transformation (enlargement and accentuation) of the thick stand of hair, protruding eyes and sharp cheekbones is minimal. The high, white standing collar and unnatural white light that falls from above his face contribute to the characterization. Self-satisfaction and belief in the future characterize this self-portrait. It exudes the severity of black and white and a few dominant colours.

Greta Van Broeckhoven

Albert Servaes

Ghent 1883 - Lucern 1966

The dying man
Panel, 99 x 88 cm
Lower right: *a.servaes./1910*
Purchase 1988
Inv. 3281

Albert Servaes is known as a transitional figure between the first and second Sint-Martens-Latem groups, who embodies religious symbolism and Flemish expressionism, respectively. He is considered an exponent of religious expressionism, characterized by a simplified formal language and dark palette as an expression of a deeply experienced emotion connected to nature and rural life. This early, fairly colourful work is rather the exception than the rule. In 1909, the year in which he made the preliminary study for *The dying man,* Servaes completed *The potato-eaters* (Musées royaux des Beaux-Arts de Belgique, Brussels), one of his most renowned works, viewed by many as the first expressionist painting in Flanders.

In the period 1907-1910, along with *The dying man,* Servaes painted a few other works with a somewhat lighter palette but with deep blacks: the *Burial among the poor* (1907, private collection) and *At the grave* (1908, Provinciaal Museum voor Moderne Kunst, Ostend). They bear witness to the importance of the universal theme of death that is embodied here by the Christian mystery of life and death. *The dying man* is sometimes also called *Last rites,* which clearly refers to the administration of the sacrament of the sick and the dying. The presence of a sexton with a candle was customary at the administration of extreme unction. The scene symbolizes the transition from earthly to heavenly life and is bathed in an atmosphere of humble devotion. The simplicity and at the same time difficulty of life on the land, and above all the intense devotion of the rural people of Sint-Martens-Latem, formed the nourishing substrate of Servaes' pictorial oeuvre.

In terms of colour, the painting can be divided into two contrasting parts. Below, darker colours prevail; above, the lighter colours, with a predominance of white, take the upper hand. Thus a certain tension is created which adds strength to the seriousness of the scene represented. At the same time, this is strikingly interrupted by the small black cross, which repositions the centre of the painting to the centre of the actual representation. The sacrament takes place between the priest, symbol of God's presence and consolation, and the dying man. The other figures, in their seclusion, give expression to their humble belief.

The influence of Jakob Smits (see page 228) is noticeable in *The dying man* in the fresco-like composition, grainy facture and schematic figures. The interior likewise refers to the typical Smits interior, with whitewashed walls, a low ceiling with wooden beams and a little window with small subdivisions.

Dieter Lampens

Ossip Zadkine

Smolensk (Russia) 1890 - Neuilly-sur-Seine (France) 1967

The misery of Job
Elm, 123 x 84 x 139 cm
Gift of the artist 1936
Inv. 2338

At the age of sixteen Zadkine left for London in order to study there. After a brief return to Russia, he settled in Paris in 1911. There, he studied at the Ecole des Beaux-Arts and sought his way from within a milieu of young avant-garde artists like Marc Chagall and Alexander Archipenko. In 1914 he made four sculptures in which the frustrations and problems of the young sculptor are reflected. Zadkine takes his inspiration from the book of Job in the Old Testament. He consciously chose the passage in which Job's friends Elifaz, Bildad and Sofaz went to him in order to support him during the many disasters that struck him: "So they sat down with him on the ground seven days and seven nights, and no one spoke a word to him, for they saw that his grief was very great". Zadkine called this sculpture *Job and his friends*. Later it acquired the title *Job*, and after its acquisition by the museum, *The misery of Job*.

Zadkine does not treat the figures as one closed group but as separate individuals. The inward-looking figures, each isolated in his own doubt and incomprehension, recall the memory of the sculptures of George Minne (see page 186). After the First World War, the four individual sculptures were permanently installed on low ground. Zadkine saw this unconventional manner of handling a group in the work of Auguste Rodin (see page 172), for whom he had great admiration.

The monumentality and power of the sculptures springs immediately in view. The material, wood, and the technique used, taille directe, play an important role in this immediacy. Zadkine reduces the figures to their most summary and telling forms. Postures, gestures and graphic carving are determined by the form of the wooden blocks and follow the grain of the wood. The influence of primitive African statues, which also greatly influenced the cubists and expressionists, is overly prominent. Also characteristic is the great sensitivity that this work radiates, which is certainly in part a consequence of the warm colour of the elmwood and the play of the grain in various brown tints. The manner in which Zadkine has handled the figures also creates a sense of closeness. He rounds out the figure of the squatting man with bent lines, and softens the narrow upward line of the standing figures by means of the soft curves of their bowed heads.

During the interbellum years Zadkine had a great deal of contact with the Belgian art world. In 1919 he had his first individual exhibition at the Brussels art gallery *Le Centaure*. In the years 1920-1930 he was regularly invited by the Antwerp artistic society *Kunst van Heden*, where *Job* could be seen in 1933. In that year there was also a large Zadkine retrospective installed at the Palais des Beaux-Arts in Brussels. In 1936, shortly before his trip to New York (1937), where he settled in 1941, the sculptor gave the group *Job* to the museum.

Dorine Cardyn

Rik Wouters

Mechelen 1882 - Amsterdam 1916

Resting woman
Paper, 430 x 530 mm
Lower left: *Rik Wouters 1912*
Gift of Nel Wouters 1933
Inv. 2264

Nel seduced her husband Rik Wouters with her body, but she also stimulated the imagination of the passionate artist and incited him to action. Time was then stopped, so that the artist got the chance to record every impression, movement, light reflection or colour intensity. Wouters' biography cannot be separated from his oeuvre. In her book on the life and work of Rik Wouters, Nel tells of how he followed her around throughout the whole house. He rummaged from life as if from a large treasure chest. Life for him meant painting, sculpting and drawing. He wished to draw as he wrote: with a sober line. He took only nature as his example, but it was immense and had to be structured. But the results are not solidified moments because Wouters' spontaneity and vision kept everything lively. Without the least hesitation and with unbelievable swiftness, subjects took form on paper. He made countless drawings, often of fleeting moments, simplified and in this way arrived at a synthesis.

Walther Vanbeselaere rightly noted that Wouters was just as important as a painter as he was as a sculptor and draughtsman. He reached for one means of expression after the other without recognizing any hierarchy among them. What the eye perceived the accurate hand shaped with clay, brush, pastel or pen, independent of what was available or what circumstances permitted. With a minimum of means, a fresh, clear narrative of well-being is told about independently moving light playing with a bouquet of flowers, a mirror or a resting woman. He experimented with different materials, was particular about the type of canvas or paper used. He looked for just the right paper and placed orders abroad. Wouters worked in watercolour and pastel, went from transparent watercolour to opaque pastel.

The *Resting woman*, a work from 1912 which Nel gave to the museum in 1933, is not a watercolour in the true sense of the word. Wouters began to experiment with watercolour beginning around 1911. Here, the medium does not really come into its own. A few lines of force suggest the entire volume of the resting body. It is rather a drawing that has been coloured in. The position of the body is laid in with the brush and watercolour applied over it, whereby the transparent body acquires a lightness and liveliness. The surroundings are scarcely indicated and consist of spots of colour. Even his oil paintings sometimes give the impression, because of the thin, almost transparent layers of paint, of being watercolours.

Els Maréchal

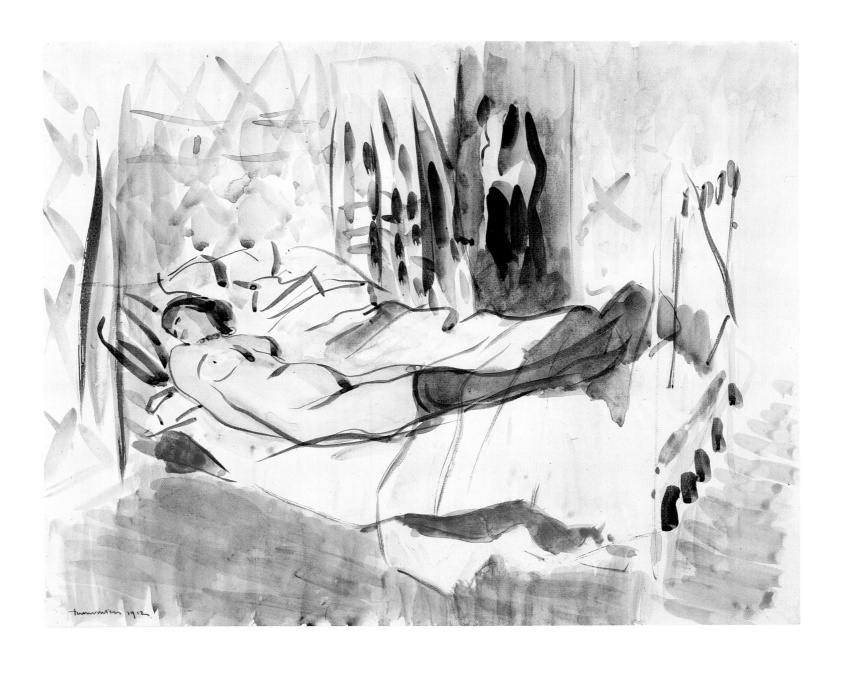

Rik Wouters

Mechelen 1882 - Amsterdam 1916

Rik with a black eye patch
Canvas, 102 x 85 cm
Dr. Ludo van Bogaert-Sheid Bequest 1989
Inv. 3297

Beginning in 1912, Wouters was plagued by a knawing headache that was the harbinger of a fatal sickness. At the outbreak of the First World War, he received orders to defend his father-land. At the taking of Antwerp by the Germans, part of the Belgian army withdrew across the border. Wouters was interned as a prisoner of war in Amersfoort and Zeist in the Netherlands. He continued to believe in life and set to work again. Released from his prisoner of war status, he occupied an atelier in Amsterdam from 1915 on. A series of works was created there, includ-ing colourful watercolours of life on the water and in the house with Nel. But three operations in short succession that failed to produce results robbed him of his remaining vitality, and at the age of thirty-three the life of the young artist ended.

War and painful illness not withstanding, Wouters allowed little sombreness to show in his work. In November 1915, after the second operation, he painted himself as Rik with the black eye patch. The sitter sits before a warm red curtain in greenish-blue pyjamas, propped up against a checked blanket. He inclines backward into the background, which creates a certain reserve with respect to the viewer. The eye patch hides his damaged right eye. The massive, posed figure is placed diagonally and is held in equilibrium by the diagonal of the edge of the curtain.

The use of colour is more restrained in comparison to *Ironing*, which does not mean that he uses genuinely sombre tones here. The fresh, illuminating green of the pyjamas against the warm red curtain are still radiant colours. There are rich nuances of red and pink, and the white ground of the canvas contributes to keeping the surface light. The paint is thinly spread across the finely woven canvas. His head, assembled from multiple flecks of colour, is striking in its contrast to the rest of the work. The canvas is built up of large, nuanced spots of colour, whereby the paint-ing acquires a unity and differs sharply from the early works, which sometimes exude an impression of fragmentation. In the interior in which the figure is represented, there are no more recognizable details.

The portrait of *Rik with a black eye patch* hung in the cabinet of doctor Ludo van Bogaert, who was one of the most enthusiastic admirers of Wouters' oeuvre. This work is part of the gener-ous gift Van Bogaert-Sheid bequeathed to the museum in 1989, which comprises more than fifty paintings, sculptures, watercolours and drawings. A few curiosities were included in the bequest, among them a scrap of the palette used for this portrait, smeared on a newspaper of November 1, 1915. In 1932, the painting was offered to the museum for sale by Nel. Since a large number of works by Rik Wouters were already present in the museum's collection, the board of directors at that time did not take up her offer.

Els Maréchal

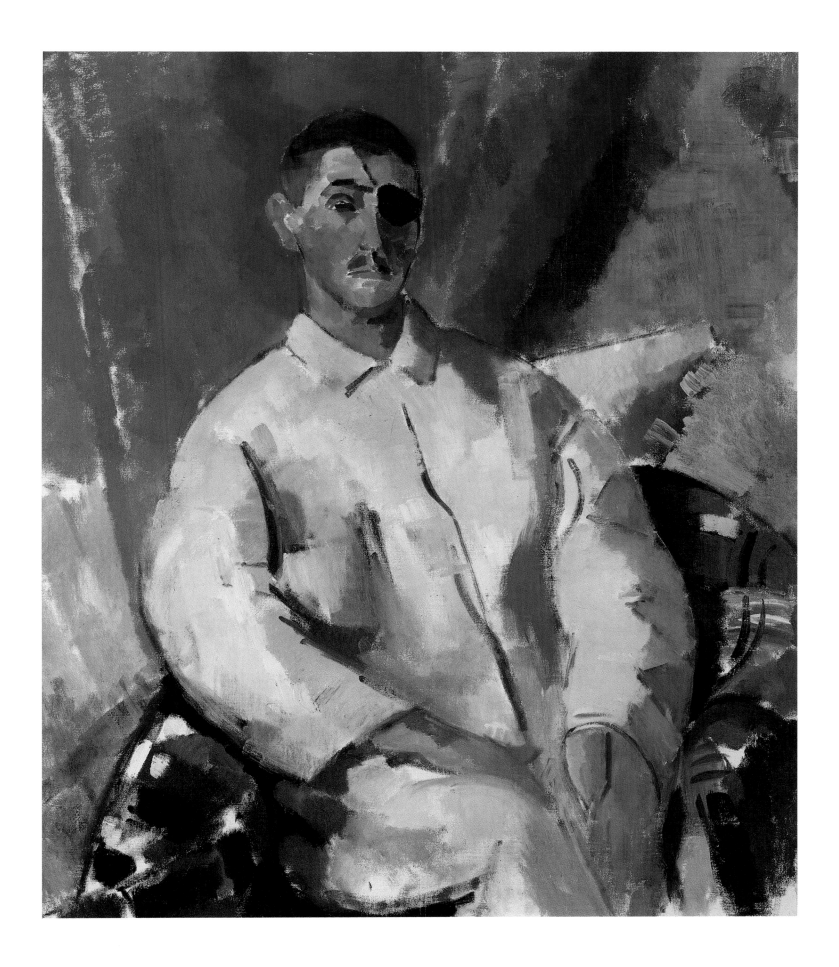

Jules Schmalzigaug

Antwerp 1886 - Delft 1917

Light
Canvas, 98 x 27 cm
Lower left: *J. Schmalzigaug*
Gift of Walter Malgaud 1928
Inv. 2100

With his feel for atmosphere and changes in colour, Jules Schmalzigaug sought affiliation with the futurist movement. In 1912 he first saw the work of Italian futurists like Balla, Boccioni and Severini at the exhibition organized by Félix Fénéon at the Bernheim/Jeune gallery in Paris. The depiction of motion, as well as the personal experience of it, was one of the most important goals of the plastic artists in the movement. They reacted to the *Manifesto of Futuristic Poetry* that Tomasso Marinetti published in *Le Figaro* on February 20, 1909. In it, Marinetti cultivated violence, action and aggressive movement, among other things. Speed was for him an ideal of beauty. In the beginning of the twentieth century, the bicycle, auto, tram, train, airplane, telephone and new forms of going out like cafe terraces, cabarets, dance halls and theaters transformed public life in the cities. With the introduction of new pictorial techniques like photographs, film, publicity, illustrated dailies and journals, new image makers manifested themselves alongside plastic artists.

After a trip to Italy, which he undertook together with Walter Vaes, Schmalzigaug settled in Venice in 1912. In this new environment he found his own method of working and technique for the reproduction of motion and polychromy. He rejected perspective and applied different elements, which simultaneously determine the whole atmosphere in different layers placed over and above each other. Precision of form is completely subordinated to lines of force, spots of colour and optical vibrations that bring about the play of light on the objects and figures depicted and to the general dynamic that proceeds from it. His work is clearly influenced by the theory of simultaneous reproduction of moods and by the ideas of Boccioni concerning lines of force and the energy they express, whereby each object reacts to light and shadow in order to generate a relationship between lines of force and colour.

Schmalzigaug's paintings and sketches are abstract compositions of lines and spots of colour that do not answer to any single visually recognizable reality. They evoke an entire 'ambience' in an environment governed by light and motion in combination with the mood of the artist while registering transient moments full of atmosphere in plastic form.

In *Light*, painted in 1914, various atmospheric sketches are brought together in a rotating movement by which a 'central space' is created in the composition. The dynamism of the coloured planes and dots of colour determine the direction of the motion. For him, as for the other futurists, pointillism and divisionism, characteristic of the technique of the neo-impressionists, were a means of representing movement. Schmalzigaug, who was interested in the modifications that the object assumed under the influence of changing light and in the reproduction of a mood or atmosphere, was inspired by Signac and his analyses of plastic language as drawing, tone and tint – the means for bringing about harmony in the painting between composition and the expression of his concept of representation. Thus, a cheerful atmosphere reigns in *Light*, which is characterized by upwardly directed lines and rounded corners, and by a variety of warm and light colours.

Greta Van Broeckhoven

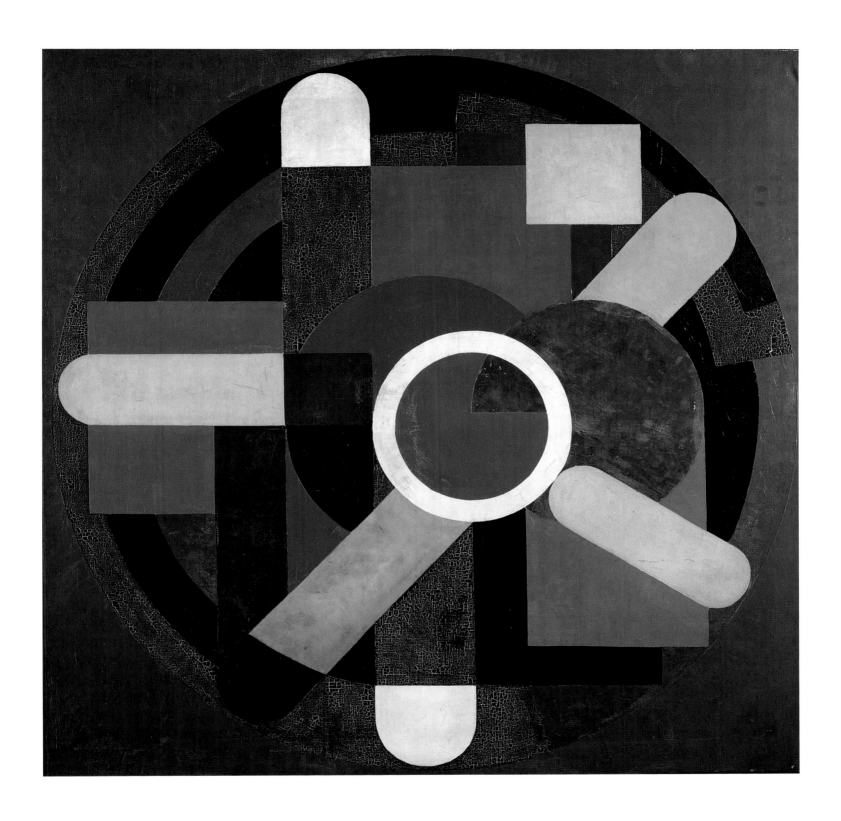

Victor Servranckx

Diegem 1897 - Vilvoorde 1965

Opus 20
Canvas, 70 x 45 cm
Lower left: *1922 Servranckx*
Purchase 1975
Inv. 3142

A new time, a new vision and a new pictorial language. Victor Sevranckx, a member of the Brussels avant-garde, did not remain insensitive to the new ideas that arose in Europe and also ensured that art changed around the time of the First World War. Servranckx was one of the first artists in Belgium who defended abstract art in word and deed. In his work we see a turn toward the non-figurative fairly early on. In 1917 he took part in a group exhibition in the Giroux gallery in Brussels and showed abstract work there. From 1920 on his work was overwhelmingly geometrical and two-dimensional because perspective had been left behind and there was no longer any question of a fore- and background. Factories, motors and machines expanded into a new canon that expressed itself in a technological language of form.

Nevertheless, his experiments did not sustain any strict, established laws. He evolved from a cold, analytic abstraction with angular lines and colourful planes to a lyrical abstraction with curves and arabesques and back again, from static to dynamic, from modernist, constructivist structures to cosmic, vegetal and even surreal ones. He expressed it in the following words: "I strive for pure and complete representation, without naturalistic value, but also without the ballast of some of the rules and so-called laws, discovered by the all-too diligent business travelers in modernist imports."

The museum possesses two works by Victor Servranckx which each represent an aspect of the duality in his oeuvre. In *Opus 2*, or *The domain of water* of 1927, nature seems to be viewed through a microscope. It shows a surreal dreamworld where natural elements flow together into a fantastic space, and where the support forms an essential part of the work. In the canvas *Opus 20* of 1922, belonging to his early period, the abstract geometrical forms that evoke the image of a mechanical world have won the upper hand. It is a strictly built-up composition, balanced and disciplined, in muted colours realized with an almost technical accuracy. Nevertheless, it acquires a frivolous note through the use of a fine silver line that partially outlines every rectangle. Geometrical order is processed in a warm manner, without rigidity, and reminiscences of life and the environment are still present.

In 1922, the year in which this painting was created, Servranckx wrote the manifesto *L'Art Pur* together with René Magritte. He had gotten to know Magritte in the wallpaper factory where they had both worked as draughtsmen. Servranckx was actively involved with various art journals. He wanted to share his avant-garde message with other artists. Thus, during his tour of the United States he came into contact with Marcel Duchamp who encouraged him to exhibit there.

Els Maréchal

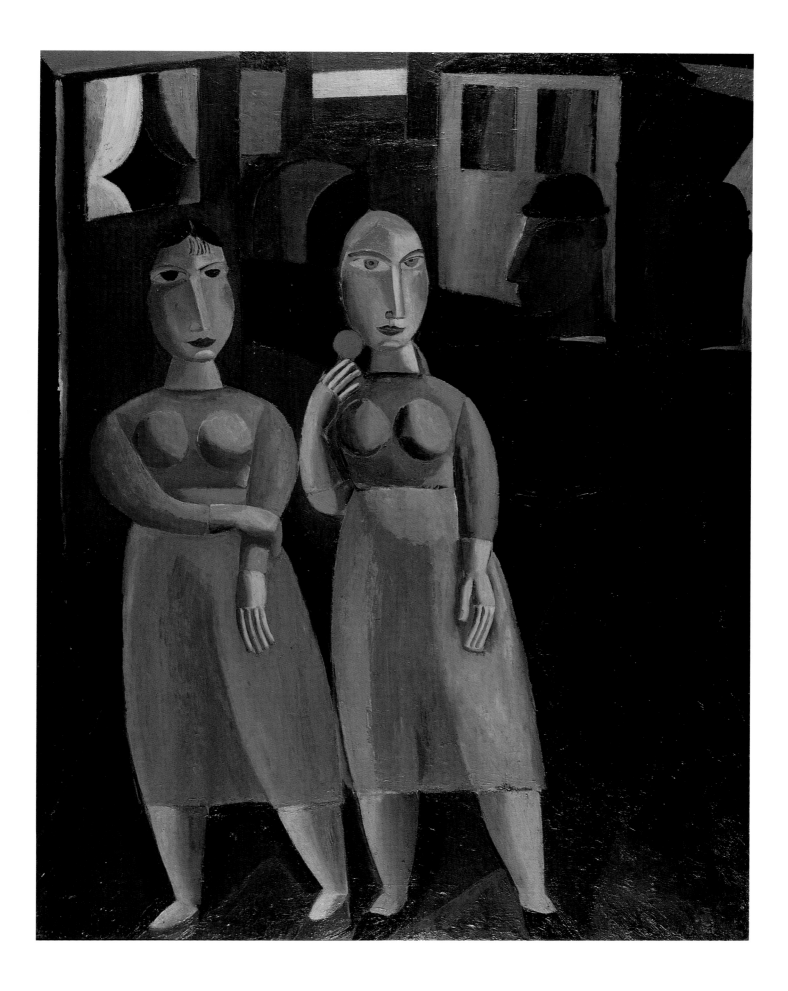

Gustave De Smet

Ghent 1877 - Deurle 1943

The mussel-eaters
Canvas, 93 x 123 cm
Left: *Gust De Smet*
On loan from the administration since 1930
Inv. 2160

It is not exactly convivial in *The mussel-eaters* by Gustave De Smet, nor does it look very appetizing. In the twenties of the previous century, popular enjoyments like kermisses and village festivals were often depicted by the artists active in or around Sint-Martens-Latem. Going out to eat mussels is moreover still a typical outing, but in spite of the light-hearted subject this is not a joyful painting. *The mussel-eaters* is characteristic of the works that De Smet made when he lived in Astene, where he was caretaker of the country house of Paul-Gustave Van Hecke, connoisseur, gallery owner and patron.

Nine figures, all in their Sunday best, sit at a rectangular table and take up nearly the entire surface of the canvas. Behind them are two glimpses of figures sitting in another part of the restaurant. In the lower left corner sits a dog. The table is shown parallel to the picture plane, not in perspective but viewed from above, like the plates. The mussel platters and glasses are seen head-on but from a higher position. The same point of view is used for the company: four figures are seen from behind, four head-on, and one, the man on the left at the head of the table, in profile.

Everything is reduced to a minimum: mussels, plates and glasses but no silverware. Just sufficient to tell the story, and that in a particularly clear manner: a glass is best seen from in front; a plate, by contrast, from above. It is not about what one sees and how one sees things, but how one represents it in one's mind.

In this work it is possible to find more than one point of view. Reality as seen here is broken up, as it were, and put back together again anew. The building blocks or volumes are carefully arranged on the surface of the painting, without attempting to evoke a three-dimensional, illusionist spatiality. The use of colour, with alternating earth-tones and complementary colours like green and red, strengthens the cohesiveness of the whole.

After 1919 De Smet specifically dedicated himself to wood- and linocuts. The influence of these techniques, which do not permit fine details, is clearly visible in this painting. He chooses compositions with a straight, simple construction, with clear execution of line and bounded planes of colour. The mussel-eaters only sit stiffly by; they are silent and they do not eat. The painting says more about painting itself than about the assembled company.

Nanny Schrijvers

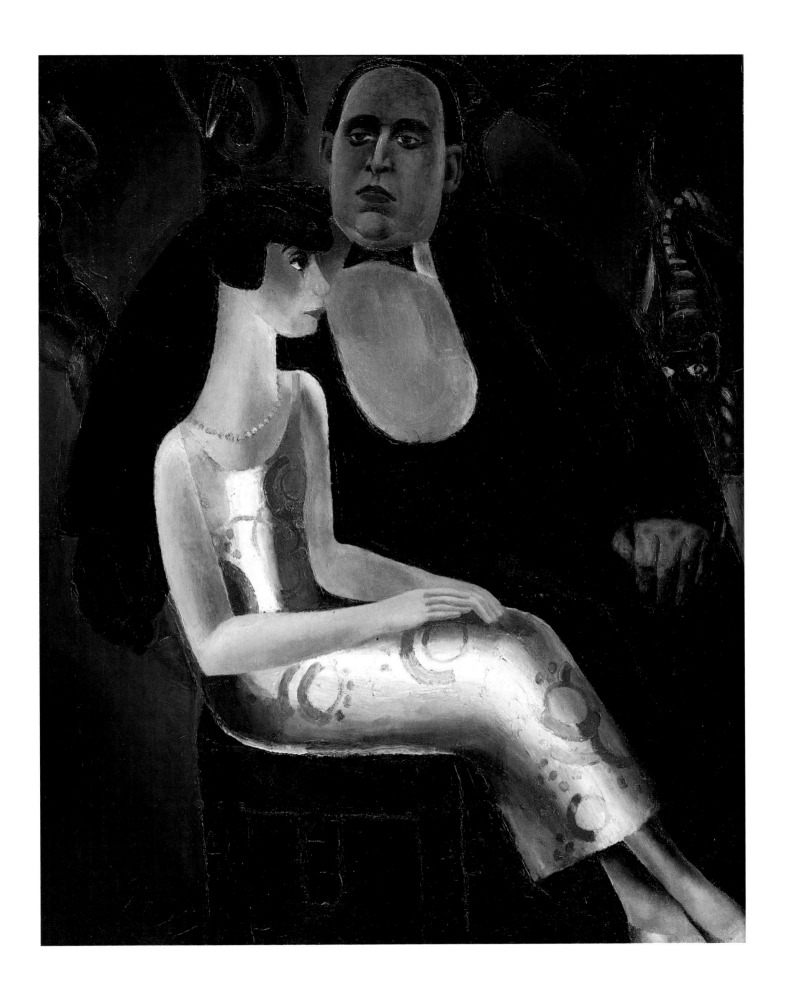

Frits Van den Berghe

Ghent 1883 - Ghent 1939

Tree in bloom
Canvas, 146 x 115 cm
Lower right: *F. v. Berghe*
Purchase 1940
Inv. 2473

In 1928 the artistic career of Frits Van den Berghe took a crucial turn. His expressionist phase and ties to rural Sint-Martens-Latem and the Leie were clearly behind him. From then on, he concentrated only on the representation of the invisible world of the subconscious and the visualization of a psychologically experienced reality. As a painter of the human soul, the way to a self-willed surrealism was open from then on. More than ever, the reactions of art critics were strongly divided over the new direction in his work. His highly personal metaphysics – which was supported by an interest in psychoanalysis, affinity with surrealism, knowledge of world literature, mythology and folk art, and in which the human being appears to be subordinated to the subconscious – was insufficiently understood and often mineralised or traced back to motifs or stylistic means borrowed from literature. When even his defender of the first hour, Paul-Gustave Van Hecke, did not see much in *Tree in bloom* and wrote it off as a symbolist work, Van den Berghe answered him thus: "For me, painting 'from nature' means painting very simply 'from life'. [...] The world of the imagination, the world of illusions and chimeras, the lyrical universe of the poet, the abstract world of the thinker, do they have less weight, less worth than the world of physical phenomena? Everything here below is life, a reality just as bright, just as valuable, in short just as real as the reality of the waking condition" (Georges Marlier, 'Nos interviews – Un quart d'heure avec Frits van den Berghe', *Le Centaure*, Brussels, I, 1927, no. 7, pp. 135-139).

Tree in bloom is in fact an isolated universe of difficult to define forms and figures. It is an eruption of ever uncontrolled, mutating life. A surprising world, constructed around a central enigmatic figure, crystallized in rich colours. Van den Berghe's friend and biographer Emile Langui did not hide his admiration for this painting: "The light, miniature-like stippling technique, which creates a wonderful material, would be applied almost exclusively by the painter from then on, in flower pieces as well as in the figures and fantastic compositions. The most powerful canvas in this series and with this technique is *The tree in bloom* of 1930, an extraordinary work on account of its dimensions as well as on account of its qualities. All of the flowers, bouquets, trees, masks and phantoms are bundled together here in a gigantic bouquet, like an enormous tropical tree with death's heads, monks, women and beasts nestled among its poisonous flowers. In this impressive canvas Frits Van den Berghe plays, exceptionally, the whole keyboard of the wealth of colour, and that with a brio and sense of harmony and contrapunto in which he seems to surpass himself. Here, we are standing before an undisputed masterpiece."

Dieter Lampens

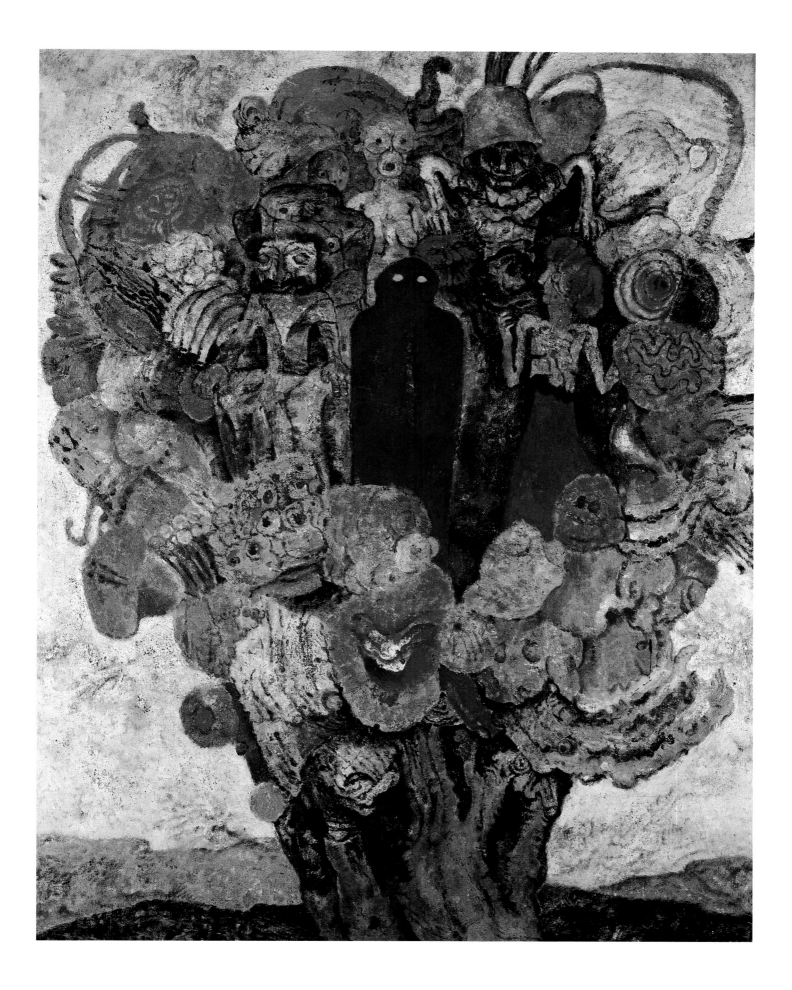

George Grosz

Berlin 1893 - Berlin 1959

Portrait of Walter Mehring
Canvas, 90 x 80 cm
Purchase 1939
Inv. 2454

Both Grosz and the writer Mehring (1896-1981) were scandalous figures in the Berlin of the Weimar Republic. As dadaists of the first hour, agitators against the established order, poisonous hecklers of the middle class, they already knew each other in 1918, when they worked together on the journal _Dada_ and in the cabaret 'Schall und Rauch'. Mehring was feared and famed for his satirical songs and texts, and Grosz expressed his dislike of corruption, anti-semitism and militarism in paintings and scathing drawings in journals. Their revolutionary spirit and brutal pictorial language brought them numerous lawsuits and judgments. But Grosz and Mehring were also the crazy clowns who together fought a battle between a sewing machine (Grosz) and a typewriter (Mehring).

Around 1926, Grosz painted his friend sitting against a background of storm clouds and a ruin. Did he see it as a sign of what would happen some time later? This painting, known in Belgium after being published in the journal _Variétés_ in 1929, was confiscated by the Nazis in 1937 in the Kunsthalle in Hamburg. Indeed, both Mehring and Grosz, along with many other artists, were denounced and rejected as 'Kulturbolschewisten'. Mehring's books were burned in 1933 and Grosz' paintings had a starring role in the exhibition _Entartete Kunst_ of 1937. At that time, both of them had already fled to America, where Mehring was forgotten in poverty and Grosz evolved into a visionary artist. After the war they returned to Germany and remained in correspondence with one another the entire time.

The 'history' of the portrait of Mehring is well documented. After confiscation it shone at the famous exhibition of _Entartete Kunst_ in Munich. Although the Nazis abhored anything that didn't answer to the fascist ideal of Germanic greatness, they were nevertheless shrewd enough to have a large auction of 'degenerate' artwork in Lucern in 1939. An international public of museum conservators and connoisseurs purchased avidly. The then-director of the museum, Arthur Cornette, and Isidoor Opsomer, member of the purchasing commission, travelled to Lucern and bought the portrait for 280 Swiss francs (another work by Grosz, the _Metropolis_ of 1916-1917, went to Curt Valentin of the Buchholz gallery in New York for 700 Swiss francs). The portrait of Mehring was Antwerp's least expensive purchase: a portrait by Lovis Corinth cost nearly twenty times that price, while two other paintings by Karl Hofer and Jules Pascin entailed a serious investment.

Leen de Jong

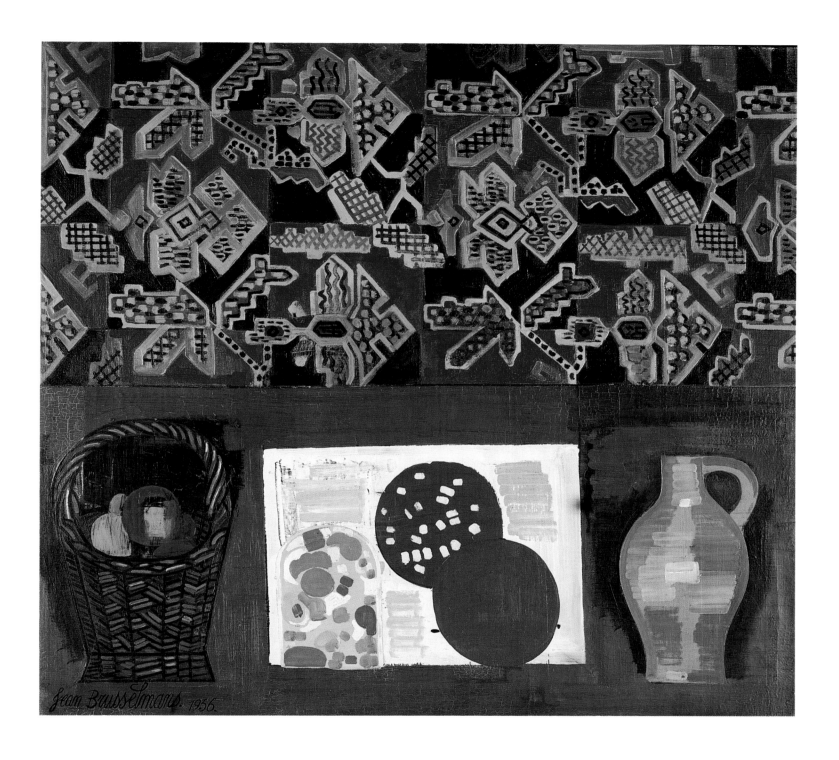

Paul Delvaux

Antheit (Huy) 1897 - Veurne 1994

The pink bows (Les nœuds roses)
Canvas, 121.5 x 160 cm
Lower right: *P. Delvaux 2-37*
Purchase 1957
Inv. 2850

Paul Delvaux seeks to introduce the viewer to an unfamiliar world, in which recognizable elements from reality are assigned a new place. He also tries to keep the viewer enthralled. He accomplishes this not through sentiment, but through the power of silence. In the motionlessness, lifelessness and indifference of his detached, mysterious figures, who wander aimlessly through astonishing dream landscapes, he captures the perpetual "moment" of silence.

His favorite actors are nude women. In this work they roam like the living dead through an oasis of classical ruins in a nocturnal and uninviting landscape. This was not only the first time that Delvaux painted women with bows around their upper bodies, but here, for the first time too, he adds a skeleton to the scene (in the uppermost gallery of the building on the right). Jacques Sojcher defined Delvaux' painting as a "theater of disturbing strangeness", which certainly applies in the case of the present picture. Delvaux' continually returning motif of the impenetrable woman is an icon of crystallized beauty and motionless perfection. He paints a stereotypical woman, banal and ideal, a woman who seems not to breathe, who stares through almond-shaped eyes that do not see.

During the search for his own pictorial language, Delvaux looked to Gustave De Smet, Constant Permeke and James Ensor (the skeletons), but at the same time genuinely admired the art of Jan van Eyck, Piero della Francesca, Titian, Jean Auguste Ingres and Georges de la Tour (the light). The discovery of the 'Spitzner museum' at the Brussels South kermiss in 1932 was the catalyst for a new direction in his work. One entered the museum through a red velvet curtain, behind which was a lugubrious, morbid collection of anatomical casts in wax. At this kermis attraction Delvaux also became obsessed with a girl mannequin, which was moved by mechanical means: at once beautiful and grotesque. This mechanical little girl became a source of inspiration for his sleeping Venuses.

In 1934 Delvaux visited the exhibition *Minotaure*, with eight works by Giorgio De Chirico, six by Salvador Dalí and five by Magritte. The melancholy, poetic atmosphere and the desolate landscapes of the works by De Chirico appealed to him enormously. Beginning in 1935, he oriented himself toward surrealism, although it would be difficult to call him a 'true' Belgian surrealist after the fashion of Magritte. Magritte was a cerebral painter, a painter of the idea, but also a protagonist in Belgian surrealism. Delvaux did not like categorizations and -isms, and consequently held himself aloof from groupings and artists' collectives. Magritte mockingly referred to him as 'Delboeuf', 'Delvache'. Delvaux' painting does come across as rather academic, but it is a sort of 'intensified academicism' (J. Sojcher). It is an art of the motionless gesture, of repetition, of frozen eroticism, of the memories of youth.

Sofie Van Loo

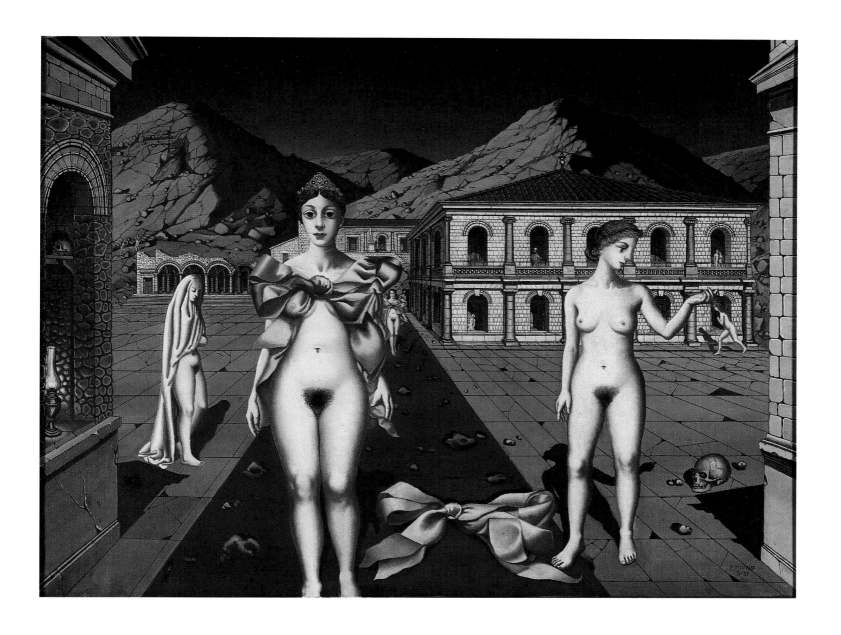

René Magritte

Lessines 1898 - Brussels 1967

September Sixteenth
Canvas, 115 x 88 cm
Lower right: *Magritte*
Purchase 1957
Inv. 2843

Magritte was trained at the academy in Brussels. When he became acquainted with the work of Giorgio De Chirico in 1923, his ideas about art changed, and he chose in favour of surrealism without reservation. In Brussels he belonged to the surrealist group that came into being parallel with that of André Breton in Paris. The musician and artist E.L.T. Mesens, the writers Camille Goemans, Marcel Lecomte, Paul Nougé and Louis Scutenaire and the composer André Souris also belonged to the Brussels circle. Magritte was a contemporary of the other well-known Belgian surrealist painter, Paul Delvaux.

Magritte's subject is not the unconscious, painting as pure psychic automatism as defined by Breton. With his 'images' (often inspired by the distinctions of a biased system of perception) Magritte seeks out our 'unbiased' perception of familiar elements from our everyday life and searches for the connotations that we automatically (and unconsciously) attach to these objects. He does this by asking himself questions regarding their functions, contexts, and their natural relationships in reality, thereby creating new associations or disrupting a generally accepted concept.

In his pictorial creation, characterized by the displacement or transformation of form and the relationships of objects, admiration, poetry and mystery stand side by side. Not the vagueness of dreams or states of mind, but a 'beautiful' idea is the basis of his images, which shake our minds into wakefulness. These 'brilliant' ideas are sometimes created out of the association of words and objects. Like De Chirico and so many other modern artists from the twenties, Magritte's pictorial method of association is that of the 'collage'. In correspondence with this method of working, his style is characterized by clear outlines and an emphasis on a flat mode of representation that refers to advertising illustrations, which were an important source of information for the surrealists. The suggestion of space by means of perspective is that of the Renaissance and hence traditional.

In the landscape *September Sixteenth*, painted in 1956, a crescent moon rests '*in*' a tree and not '*in*' the heavens. The crescent moon, along with the sphere, the pipe, the flute, water, clouds, and other things, belongs among Magritte's themes that continually turn up in his work. Here, the depiction of an atmospheric landscape by moonlight is an illusion. *September Sixteenth* is an 'accurate depiction of reality' in which the moon has been placed before the crown of a tree. By shifting the moon high '*in*' the heavens, Magritte has up-ended the natural order of things. This has a wonderful visual effect in which our sense of reality is disturbed and in which the old question 'Who are we?', the question with which his published lecture in the Koninklijk Museum voor Schone Kunsten in Antwerp in 1938 began, is central.

Magritte loved to ask his friends questions about his paintings, and it was they who often came up with titles for his paintings, at his instigation. He thus writes that he painted the moon on a tree in greyish-blue colours and that Scutenaire thought of the lovely title *September Sixteenth*.

Greta Van Broeckhoven

Karel Appel

Amsterdam 1929

Flying man
Canvas, 145 x 114 cm
Lower right: *K. Appel 58*
Purchase 1959
Inv. 2897

In March 1949 the first issue of the journal *Cobra* (an acronym derived from Copenhagen, Brussels, Amsterdam) appeared. Asger Jorn and the Belgian poet Christian Dotremont were the primary editors. For Karel Appel, a founding member of *Cobra*, contacts with this movement were of fundamental importance for the whole of his artistic oeuvre. Appel had no desire to be a theoretician, but rather an intuitive artist who tried to lay bare the actual creative drive. He saw it as essential that he deliver himself over to the creative act of painting without any preconceived ideas, completely and spontaneously and without prejudice. The spontaneous activity of painting constituted part of the subject. His gestures during the handling of the paint are clearly recognizable and are an expression of an intuitive, quasi-primary inner force. He uses unmixed, glaring colours. Applied in warm and cool contrasts, they are the expression of a state of mind. Although Appel never started from a preconceived concept, his art is in no sense nonfigurative. These are representations of childlike beings with large, round heads, masks, birds, fantastic animal figures, stars and flowers, which seem to live in his subconscious. He recognizes them in the 'chaotically' applied paint surface and brings them out.

Although the Flying man was created a few years after the Cobra adventure, in 1958, it shows the essential stylistic traits of that period. The thick layer of paint and bright, contrasting colours (red, yellow, blue) dominate. The black contours make the colours stand out against each other even more shrilly. The layer of paint forms a relief, as it were. In addition to these large spots of colour, there are restless, capriciously formed flecks of colour and oscillating lines in yellow and white, and again in red and blue. They break through the broad spots and move in quick, nervous colour annotations from the lower right corner in a diagonal upward motion toward the peaceful blue-black spots in the upper left corner. A second movement runs from the right side, along a red diagonal, toward the lower corner. From there, a yellow stripe pushes the red central mass upward again. In following this play of lines, the active viewer detects an essential form in this apparently chaotically applied mass of paint. A head is formed by the describing white line, and the black spots on the red plane can be seen as eyes. The head is adorned with a little hat and ribbons that hover in the blue space. To the right, we detect a bird with blue, yellow and red feathers. The title *Flying man* furthers the legibility of the painting.

In 1958-1959 Appel condemned the commercial success of tachism in Paris. Through this one is better able to understand his pronouncement that he "would like to be a bird", because birds cross all borders. For Appel, the bird incarnates individual freedom and acting across the borders of chauvinism and narrow-mindedness. This idea also formed the basis of a performance in the Netherlands. Fastened to a helicopter, Appel flew through the air like a bird. The idea of the *Flying man* was thereby made into a concrete act.

Greta Van Broeckhoven

Roger Raveel

Machelen (Zulte) 1921

The stroll
Canvas and wood, 200 x 300 cm
Lower right: *R. Raveel 64*
Purchase 1978
Inv. 3159

The stroll raises many questions. It is a painting full of medium-related effects, but it is in equal measure a drawing, with emphasis on the execution of line and a great deal of white. The wooden box in the left foreground makes of it a three-dimensional object, and through the addition of real objects it is also an assemblage. The viewer can be surprised at this combination, can take distance, but then arrives at the discovery that he himself is part of it and determines that it is actually about very common things.

Like many artists in Belgium who grew up during the war, Raveel asked himself how painting fits into this world. Many wanted to begin completely anew. He started out in the village where he was born, Machelen aan de Leie, where he lived, where everything was familiar and quite normal. Even in a village modernity can slip in, but in a very different way than in an urban environment, and Raveel wanted to show this without nostalgia or sentimentality. This investigation of artistic possibilities free from prescriptions led to an extremely personal and recognizable style.

In this work the artist allows a number of components of rural life to be seen. He has a different way of looking at things than previous generations of artists who worked in the region around the Leie and who viewed paintings as finished and autonomous, with a frame around them, isolated from the reality around them. The world of Raveel is never finished. The viewer is not served up a total image, but must complete it and take a position with respect to it.

There is a great deal of interaction between the painting and the world that surrounds it. The work of art is not flat, and a white box protrudes from it; there is a groove in it that arouses curiosity but is without a solution. Here, the depth is real, but the white bordered by the Belgian tricolour has the pronounced effect, perhaps contradictory, of creating space.

The contrast between figurative and abstract elements is exciting to look at. The cat stepping into a red spot outlined with black and the green dotted line formed with broad brushstrokes that stops by the watercourse are particularly intriguing. The same can be said for the uniform spots of colour and more or less naturalistically painted parts. The vertical white strip with a light blue border and the yellow pole combine surface and depth. This work of art is a barrel of pictorial contrasts.

This plethora of elements and artistic solutions is brought into equilibrium in a peaceful way, brightened with striking accents like the man's mosaic head. The figure, seen from behind, is also looking. The viewer sees what the man sees, and more, even. The figure is like a repetition, a step further which indicates that this painting is not an enclosed whole but that it already begins in the actual world.

Nanny Schrijvers

Antoine Mortier

Sint-Gillis (Brussels) 1908 - Watermaal-Bosvoorde 1999

The third pair
Canvas, 195 x 140 cm
Lower right: *Mortier 9.66*
Purchase 1968
Inv. 3047

The third pair is one of the many variations that Antoine Mortier painted on this theme in the sixties. The confrontation with the oeuvre of Rouault, characterized by the execution of black lines in reference to glass painting, marked the plastic language of Mortier deeply.

Mortier, who was educated as a sculptor, developed a manner of painting all his own. The instigation to do so was supplied by drawings in which he was able to capture what was essential in the pose of the figure with a minimal selection of lines of force and planes, which he borrowed from the real figure. This method (giving his own plastic synthesis of reality) presents itself in the form of increasing abstraction, in which depiction reduces itself to a plastic sign for concepts formed in the combination of impressions from the outer world and his inner reality.

Mortier always starts from perceptible reality, primarily the human figure, with which he proceeds toward a symbiosis with his emotional world. He works on his subject, which he allows to coincide with his continually moving psyche, for a long period of time. As an individual he was influenced by interactive emotions, thoughts, memories and anecdotes. This complexity of states of mind is determinant for the investigation of formal solutions. With broad brushstrokes Mortier creates a synthetic, condensed image of a snapshot of the inner processing of the subject: the couple. The emotional, loaded brushwork, resulting from his humour and emotions during the act of painting, is thus also a substantial element in his oeuvre, and the directions of the broad brushstrokes are essential constructive components of the painting. The direction is recognizable in the structure created by the bristles of the brush, the division of the paint which begins with the application of the brush and the irregular pressure of the hand. One could say that, with a certain sense of the theatrical, Mortier brought something of his closed inner world out into the open in a monumental image.

Background and brushwork have an equal value. For him it was never about traditional depiction, but about the reproduction of subjective emotions. In this way, Mortier took a short-cut in terms of depiction. He always applies lines of force, coloured planes as well as structures that he selects from visible reality, and analyses them in function of the desired expression. To this end he chooses his materials and methods carefully (among other things, the thickness of the paint, breadth of the brush and intensity of the colour). He chooses a few natural and chemically-produced colours. Colour is chosen in function of expression.

Mortier has reduced the first impressions of the couple to an insight of his own. The painting *The third pair* is completely abstract. Only the title refers to the reality of this work, which is open to interpretation. The 'imprisoned colour structures' in broad black brushstrokes can be read as a hermetic body, to which the 'other' does not gain access and in which, because of the impossibility of communication, each goes his own way.

Greta Van Broeckhoven

Günther Uecker

Wensdorf (Mecklenburg) 1930

Nail-object
Wood, linen and nails, 150 x 150 x 18 cm
On the reverse, left: *Uecker 79*
Purchase 1981
Inv. 3205

Heinz Macke and Otto Piene had been the editors of the journal *Zero* since 1958. After 1961, the two Düsseldorf artists were joined by Günther Uecker. In *Zero*, they laid the theoretical basis for their ideology of art and society. In it, every form of cultural or societal inheritance was rejected. According to their views, an 'objective thought' filled the spiritual emptiness that was created in aversion to every frame of reference. They believed in a symbiosis between art, nature and technology within a transparent ideology, free of propositions and dogmas. Uecker went so far as to believe that this symbiosis would metamorphose into a second nature, as it were.

With his *Nail-object*, Uecker gave form to his personal vision concerning communal life and art, and to his ideas on art's relationship to space, pure beauty, the immaterial, absolute truth, to the unending and the timeless. Time, space and the incidence of light are simultaneously theme and form-giving element. According to a particular structure, Uecker hammered mechanically identical nails into a panel or object with a basic geometric shape. With these banal materials and an equally banal technique, borrowed from the world of building construction, he creates an anonymous art that is stripped of every element of personal style or signature. Uecker proposes that the nature of colour is expressive and that colour is intrinsic to the character of an object; for his series of nail-objects, he thus chose monochrome.

Because the positional direction of each nail differs slightly, the surface acquires an irregular and rhythmically assembled character. This is no univocal, bounded object, but an 'open' work of art that always takes shape anew in the permanent interaction between the work of art, space and the viewer. The play of light upon its surface and the displacement of the viewer in front of the nail-object cause an optical vibration to be created in the eye. The monochrome comes to life because it shows various tonal values under the influence of light. Monochrome, light and structure give rise to shadows that virtually create an up and down movement. The virtual trembling of the nail-object in turn brings to life the space around it and gives shape to the immaterial light that governs it. Actual space – an impartial factor – becomes a full participant in the aesthetic experience of the work of art.

The concept of time is at the same time an important element. The work of art is not taken in at a single glance. With his perception, the viewer plays an active role in the realization of the work, with its active elements. The movement through space in which the work of art finds itself is insistent. The passage of time thereby becomes evident; each moment is different in its perception.

The *Nail-object* was made in 1979 with identical nails that Uecker had specially made for his own use. The structure is that of parallel horizontal lines, which cover the entire surface uniformly. The position of the nails varies between left and right.

Greta Van Broeckhoven

Index of artists